the next, + great variety in section

Trees (Tree trunks) shew principles of growth + strength
of joints, with easy passing of one section into the next —
They show the ideal for wood sculpture, upward twisting
movement,

Shells show natures hard but hollow form (metal sculpture)
+ have a wonderful completeness of single shape.

Nature has an illimitable variety of
shapes + rythms (the telescope + microscope
have enlarged the field for us.) + observation
of them enlarges the sculptors form vision —
But to copy them is no better than merely
copying anything else.) But it is what
use the artist makes of them in giving expression to
his personal vision — + from the study of them laws
of balance

But along with away from these abstract or formal qualities
there are qualities of vision + expression (which
are of even greater importance)
Through ones attitude to life, ones character, +
psycological make-up certain qualities in
work become of fundamental importance —
For me a work must first have vitality of its own
I do not mean a reflection of the vitality of
life; movement, physical action, frisking dancing
figures + so on.) But I mean that a work can have in it a pent
up energy, an intense life of its own, independent of the object it may
represent; an alert tension between its parts.
When a work has this powerful vitality we do
not connect the word beauty with it.
Between Beauty of expression + power of expression there is
a difference of function. The first (aims at) pleases the
senses, the second has a spiritual vitality, which for
me is more moving. It goes deeper than the
senses.

[In my work.
I do not aim
at beauty in the
later Greek or
Renaissance sense.

Henry Moore on Sculpture

Henry Moore on Sculpture

A collection of the sculptor's writings and
spoken words edited with an introduction by

Philip James

A Studio Book

THE VIKING PRESS　NEW YORK

Library of Congress Catalog Card Number: 66–20426

Published in 1967 by The Viking Press, Inc.
625 Madison Avenue, New York, N.Y. 10022

Reprinted 1968

Designed by E. F. Timberlake
Printed and bound in Great Britain

4

Acknowledgments

Without the most generous expenditure of time and trouble on the part of Henry Moore himself and his secretary Mrs. Betty Tinsley this book could never have been written. Grateful thanks are offered to the many authors, editors, interviewers, institutions and publishers who have kindly allowed quotations to be made, or more extended passages to be taken from books, articles and catalogues, details of which will be found in the bibliography: these include the editors of *American Horizon, Atlantic Monthly* (Boston), the *Listener*, the *Magazine of Art*, the *New York Times, Partisan Review*, the *Sunday Times*; the directors of Messrs. Jonathan Cape, Cassell & Co., Faber and Faber, Grossman (New York), Heinemann & Co. and of the University of California Press; the authorities of the Arts Council of Great Britain, the British Council and UNESCO; and H. Burnett, Sir Kenneth Clark, Warren Forma, Donald Hall, J. P. Hodin, Tom Hopkinson, the Very Rev. Walter Hussey, Carlton Lake, F. H. Man, J. D. Morse, Ernest Mundt, G. Rainbird, E. Roditi, Sir John Rothenstein, John and Vera Russell, Graham Sutherland, Denys Sutton, J. J. Sweeney, David Sylvester, and Huw Wheldon.

Others who have given valuable help in obtaining or supplying information or photographs are: Michael Ayrton, Alfred Barr, Martin Davis, William Fagg, Maurice and Judith Goldblatt, Nicolette Hallett, Sir Philip Hendy, H. D. Molesworth, Bryony Orme, A. Scott-Elliot, Rosemary Wood.

I acknowledge with deep gratitude the gracious permission of Her Majesty the Queen to reproduce a drawing by Leonardo da Vinci in the Royal Library, Windsor Castle. The names of owners of works illustrated (except private owners of bronzes of which several casts exist) are given in the captions and their courtesy is much appreciated.

The greater part of the photographs for the illustrations have been supplied by the sculptor himself; for the rest acknowledgments are made to the following photographers and institutions – Alinari, 4, 22, 41, 42, 64; Anderson, 23; Arts Council of Great Britain, 39, 73; Bath Academy of Art, 24; C. Bevington, 60; British Museum, 50, 53–55, 57–59, 61, 67; Chevojon, 68; Crispin Eurich, 119; John Hedgcoe,

96, 97, 99; Errol Jackson, 5, 56; F. L. Kenett, 10; Basil Langton, 46; Lidbrooke, 106, 107; London, Imperial War Museum, 84; London, National Gallery and French Reproduction Rights Ltd., 69, 70; London, Tate Gallery, 80, 120; Manchester, City Art Gallery, 12; Mansell Collection, 51, 62, 63, 65, 66; Marlborough Fine Art, 6, 7, 36, 48, 71, 98; New York, Metropolitan Museum of Art, 125; New York, Museum of Modern Art, 77; Paris, Musée de l'Homme, 76; Philadelphia Museum of Art, 17, 72, 75; SOFAR, 8; L. Osman and Raymond Wilson, 74.

Contents

List of Illustrations

All works are by Henry Moore if no other provenance is indicated

Introduction by Philip James

The literature on Henry Moore in the form of books, articles, introductions to exhibition catalogues, and transcriptions of interviews now amounts to a considerable bibliographical edifice. Here and there an occasional quotation from his *obiter dicta* is to be found, or a more extended passage from his writings. So the origins of yet one more volume on Moore lie in the belief that these scattered pronouncements, as well as a large amount of hitherto unpublished material, should be brought together and that one who indubitably stands among the world's great sculptors of all time should be allowed to speak for himself and join the company of the great creators of the past who have recorded their 'commentaries', their 'treatises' and their 'dialogues'. Moore has said 'It is a mistake for a sculptor or a painter to speak or write very often about his job. It releases tension needed for his work.' He adds, however, that 'It is likely that a sculptor can give, from his own conscious experience, clues which will help others in their approach to sculpture. His clues to not only his own work but to art and sculpture in general from the earliest times to the present day are the subject of this book, and they convince us that almost anything which a great artist says about art is worth saying.

Moore's determination, when a schoolboy, to become a sculptor, the early influences of his surroundings, his relationship with his father – a Yorkshire miner – and the sympathetic support of his teachers all emerge clearly. He speaks with candour of the training he received at the School of Art in Leeds, where his discovery of Roger Fry's *Vision and Design* and his access to the Sadler collection of modern art had a profound effect on his outlook, and also of the new regime at the Royal College of Art, under Sir William Rothenstein. But it is the impact of the British Museum to which he returns again and again in his recollections of his early years in London and in his impassioned championship of primitive, tribal, and in particular, Mexican art of the Pre-Columbian period in which he found a 'common world-language of form.'

His first visit to Italy in 1926 on a travelling scholarship resulted in a severe mental conflict. He was deeply impressed with the paintings of Giotto – 'Giotto's painting is

the finest sculpture I met in Italy' – and above all with the frescoes of Masaccio. He made an almost daily pilgrimage to the Brancacci Chapel when he was in Florence. But Renaissance sculpture at this period left him cold, with the exception of Michelangelo's late work. At this time Greece and the Renaissance were 'the enemy', and the 'removal of the Greek spectacles from the eyes of the modern sculptor' was essential if he was to 'realise again the intrinsic emotional significance of shapes instead of seeing mainly a representation value'. It was only later that he began to realise 'how wonderful the Elgin Marbles are' and that Michelangelo was 'an absolute superman.'

If in his sculpture of the late twenties, after his return from Italy, Moore reaffirms his complete dedication to archaic and primitive art, and especially to Pre-Columbian sculpture, he also shows his ability and determination to endow his work with a deep and moving humanism which is reflected in the pervasive and obsessive choice of the two themes which were to remain a perennial source of inspiration to him, the *Mother and Child* and the *Reclining Figure*. Like a noble ground-bass, these archetypal images support the counterpoint of innumerable variations expressed sometimes with an easy, natural, monumental grandeur and sometimes in a disturbing repertory of elemental forms dredged up from the depths of the subconscious. The humanist approach is reflected not merely in the choice of these two essentially human themes but also in the identification of the human figure with elements of the landscape and with the purposeful transformation of parts of the body into images deriving from the various natural objects which have always attracted Moore and which throng his studio – pebbles, bones, rocks, shells and the like. It is this use of formal substitutions rather than formal inventions, as Sylvester has so aptly pointed out [Bibl. 18, p. 8], which marks Moore's affinity with surrealism at this period, that is in the mid-thirties when he contributed to the several manifestoes such as *Circle*, *Unit One*, and *The Painter's Object* in which the protagonists of the rival avant-garde movements of constructivism and surrealism advocated their causes. The last of these contained a reprint of Moore's first and most frequently reissued statement *The Sculptor speaks* (1937). Here are to be found his often quoted remarks on 'truth to material', a doctrine the rigidity of which he was later to modify, and his well-known passage on the hole in sculpture as a means of 'connecting one side with the other' and thereby revealing the thickness of a form and increasing our awareness of its three dimensions. During the previous five years he had explored this new direction in his sculpture in a number of small and medium-sized pieces, some of them far more abstract in form than anything he had done previously, but it was in 1936 and then in a reclining

14

figure – now at Wakefield – that he was able to advance beyond 'connecting one side with the other' and achieve a full realisation of his desire to 'open out' the mass and thus make a decisive contribution to the sculpture of this century with which his name will always be linked. The Wakefield figure is significantly in wood (elm), a material which permits, more easily than stone does, the handling of the structural problems involved. Two years later Moore achieves the opening-out of a stone figure now in the Tate (**25**) and the following year he reaches complete mastery in an even more complex system of penetration in the Detroit reclining figure (**1** and **2**) again in elm wood, which recalls another often-quoted *dictum* of his, 'the mystery of the hole – the mysterious fascination of caves in hill-sides and cliffs'.

Once again we see how Moore advances with growing experience and moves on from a position when the holes 'were made for their own sakes, the solid body was encroached upon, eaten into, and sometimes the form was only the shell holding the body', to a more sculpturally profound solution in which he is able 'to give form and space an equal partnership, to make them inseparable, neither being more important than the other'. His *Reclining Figure* of 1951 (**37–8**), commissioned by the Arts Council for the Festival of Britain, is a striking illustration of this point.

Yet another extension of the opening-up process, the desire to create space within sculpture, is to be seen in a group of stringed figures, 'the most abstract side of my work', done in the two years immediately preceding the war. These were inspired by a visit to the Science Museum when Moore came across the plaster forms representing a three-dimensional realisation of mathematical equations.

With the outbreak of war, the consequent physical and economic difficulties of making sculpture were great, and after the air-raids on London had begun he took to drawing for the next two years and produced, in the shelter drawings, one of the most powerful and poignant records of 'an extraordinary and fascinating and unique moment in history'. He filled two sketch-books[1] and made about a hundred large drawings. Many of them show the platform of the tube stations filled with recumbent figures, mostly women with children – a coalescence of the two Moore themes – looking like corpses laid out in a vast communal graveyard. The Underground had become the underworld. These intimations of mortality, in which the daily experiences of thousands of people were sublimated, seemed 'to get through to a much

1. A selection was published in facsimile. *Shelter Sketch Book*, London (Poetry London), 1944.

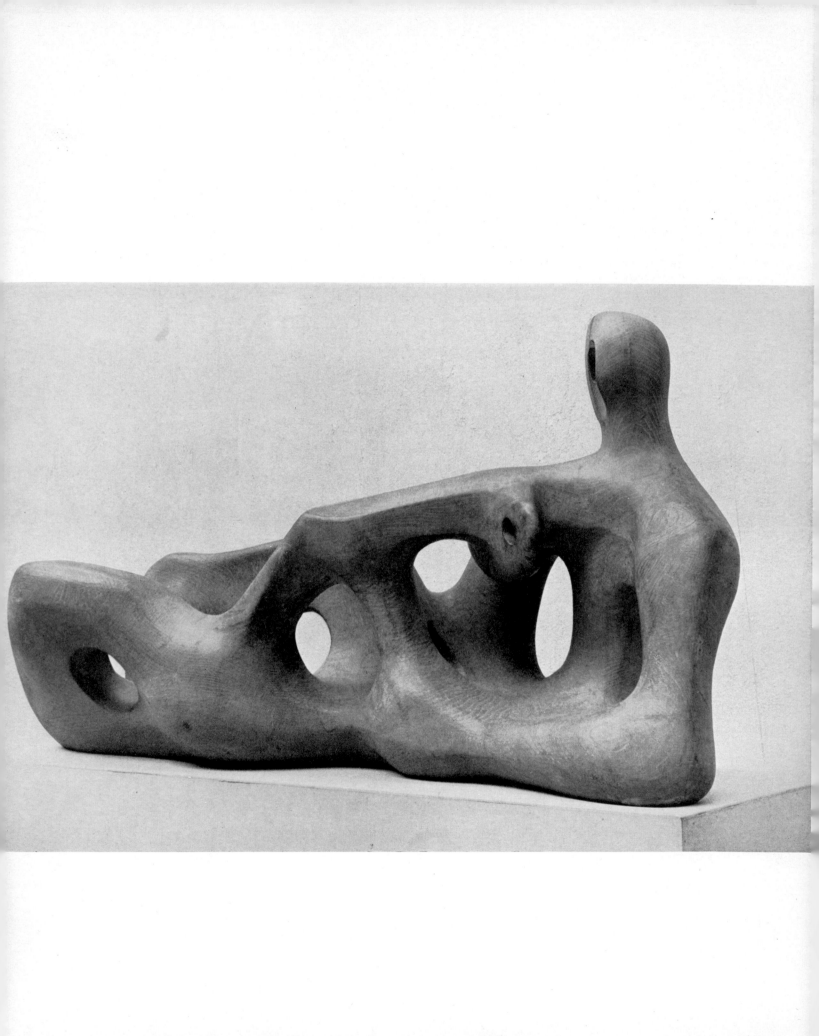

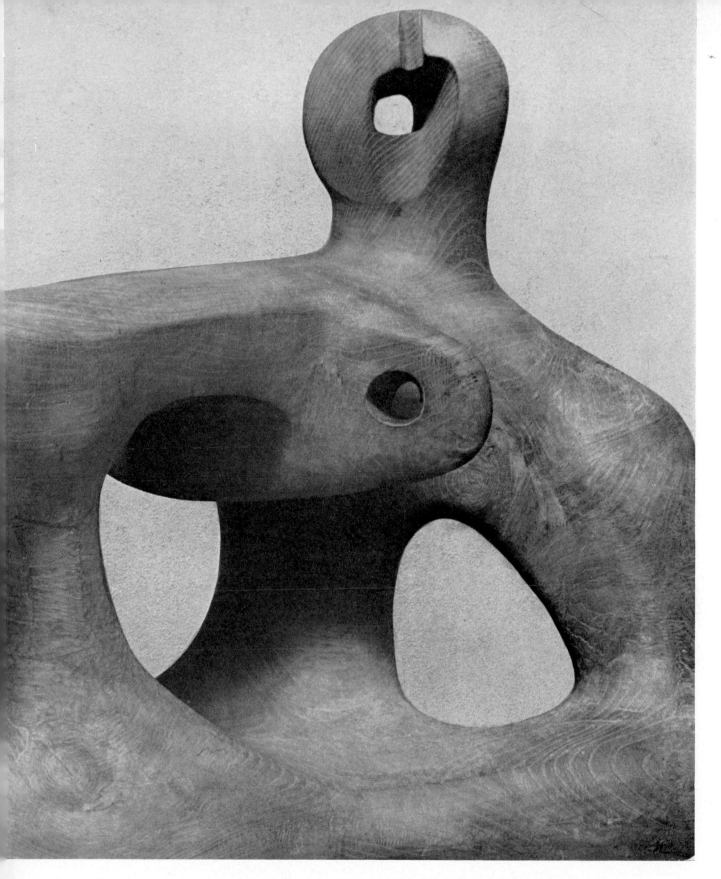

1 *and* **2** RECLINING FIGURE, *1939. Elm wood, l. 81 in.* Detroit Institute of Arts.

B

larger public' than he had reached before. For the first time he could earn his living without recourse to teaching.

It may well be that the success of the shelter drawings in which, as we have seen, his impressions gained on the visit to Italy 'surfaced' – notably in the inclusion of drapery and the return to a solid, monumental treatment of the figure[1] – was the determining factor in the style of what is probably his most popular piece of sculpture, the *Madonna and Child* which was commissioned for the church of St. Matthew at Northampton.

Although for many years now Moore has been a public figure with a world-wide reputation he has never been a public sculptor in the sense that he has received many public commissions for monuments or effigies. This is not only because he is not a figure sculptor or portraitist, but chiefly because he has never found it easy to accept a commission. 'I hate commissions' he has said! In 1928, when he was making his way in a difficult period before the *floraison* of abstract painting and sculpture in the thirties, he had carved the *North Wind* for the headquarters of the London Underground at St. James's Park Station. Epstein did his *Night* and *Day* for the same building.

Six years later there followed an abortive attempt to provide panels on the London University building in Malet Street. Some preliminary drawings of six seated figures in relief were done but there the matter ended.[2] The commission from Northampton came from an unexpected quarter and one which in the present century has produced little but mediocrity – the Church of England. With great courage and conviction the Vicar of St. Matthew's, the Reverend Walter Hussey (now Dean of Chichester), commissioned not only the *Madonna and Child* from Moore, but also a painting of the *Crucifixion* from Graham Sutherland, and a Festival Cantata (*Rejoice in the Lamb*) from Benjamin Britten. The occasion was a Jubilee Festival to celebrate the fact that the living had been held for 50 years successively by father and son; and the Vicar's father, Canon J. Rowden Hussey, presented the *Madonna and Child* as a thank-offering to the church. Moore has written of his difficulty in undertaking the task and of his approach to a religious subject.[3]

Undoubtedly the simplicity of the treatment in this noble carving and its more naturalistic appearance won him many new admirers, and his success in blending a

1. Sylvester has, however, pointed out that Moore was doing drawings of this kind in 1938 and a return to this style was not necessarily the result of his experiences in the shelters. Bibl. 18, p. 17.
2. Bibl. 18, pl. 10.
3. See p. 220.

contemporary outlook with a time-honoured subject resulted in four further works in a similar style. In an outburst of productive energy during the years 1946–9 he carved a *Draped Reclining Figure* as a memorial to Christopher Martin, the art administrator at Dartington Hall,[1] another *Madonna and Child*, on this occasion for St. Peter's Church, Claydon, the *Three Standing Figures* now in Battersea Park (**28**) and the *Family Group* (**89**) for Barclay School, Stevenage. In the *Madonna and Child* at Claydon (**3**) his return to the European tradition is particularly noticeable, for John Russell has called attention to the fact that there is more than a casual likeness in the face of the Madonna to the Madonna in Florence (**4**) by Arnolfo di Cambio.[2] And if further evidence of the disappearance of any youthful prejudice against what is best in Italian sculpture were needed it is to be found in the presence of a marble figure attributed to Tino di Camaino (**5**) in Moore's own collection.

The stone group of *Three Standing Figures*, 'the three ladies of Battersea' as they have been called, was acquired by the Contemporary Art Society and presented to the London County Council after its dramatic appearance in the Council's first open-air sculpture exhibition in Battersea Park. These disturbing figures, half human and half otherworldy, a synthesis of the abstract and the organic, with their 'outward and upward stare into space' are the expression in sculpture of what Moore has described as the 'group feeling' of the shelter drawings. The 'group sense of communion in apprehension' of the shelterers has given place to a sense of release from catastrophe. Sculpturally they represent the successful solution of the problem of creating a unified composition out of three separate figures.[3] In the *Family Group* there is a different, more closely knit treatment of three figures, and here for the first time Moore adds the male figure, the father, to the Mother and Child. This was his first major work in bronze, which he had now come to use more and more since about 1944, and has continued to use since it enables him to do things he 'couldn't do in stone'.

Two years later, in 1951, Moore made his first belated visit to Greece, and what had been, in the five works just enumerated, a tentative feeling for drapery now

1. See p. 101.
2. See Russell's essay on Moore's carvings (*Henry Moore, stone and wood carvings*. London (Marlborough Fine Art) 1961, p. 10).
3. Sir Kenneth Clark refers (*The Nude*, p. 355) to Picasso's well-known drawing *Une anatomie* (1933) as a source for Moore's way of 'presenting his figures in groups or rows of three'; but Moore is well aware of the significance of the triad as a motif in religion, mythology and art, and its appearance in such subjects as the Trinity, the three Graces, the Fates, Cerberus, etc.

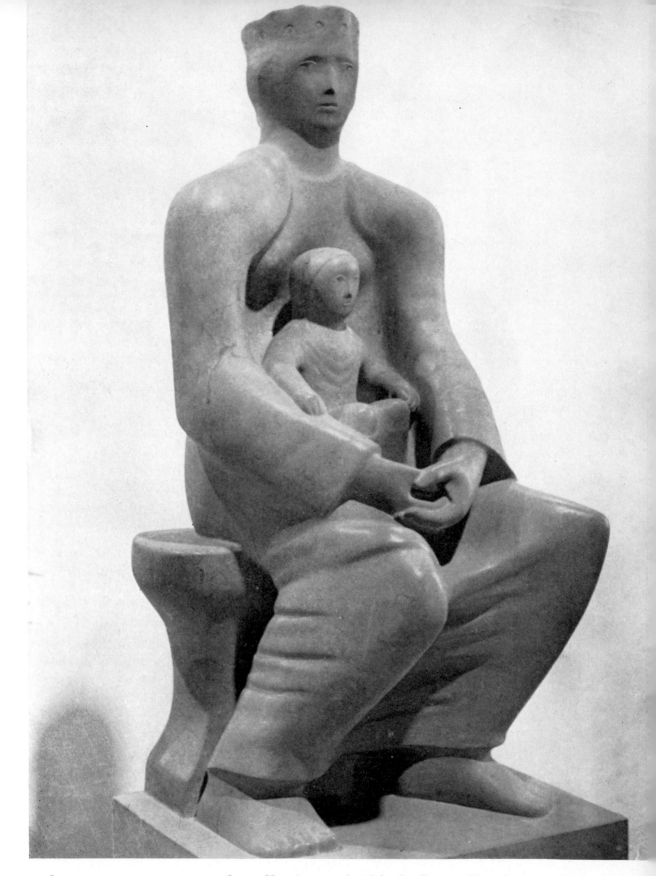

3 MADONNA AND CHILD, *1948–49. Hornton stone, h. 48 in.* St. Peter's Church, Claydon, Suffolk. *Made after a maquette of 1943, the date of the Northampton* Madonna and Child *with which it is stylistically connected (see* **86**).

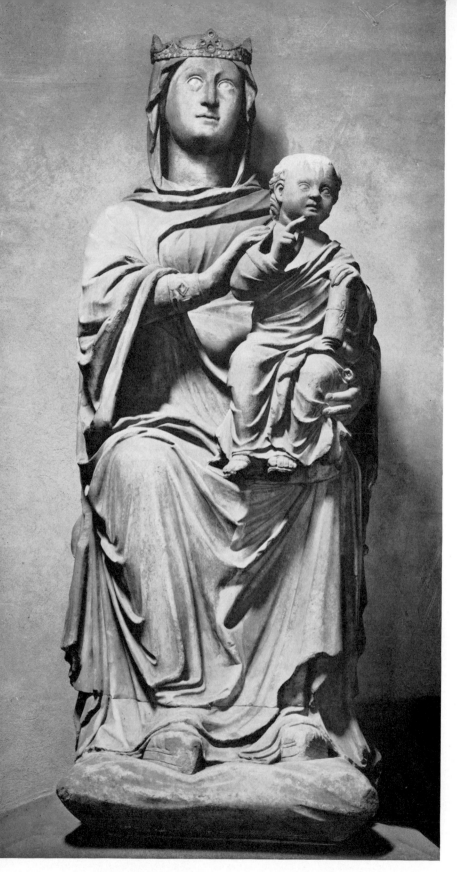

4 *Arnolfo di Cambio*. VIRGIN AND CHILD. *Marble*. Museo dell
Opera del Duomo, Florence. *From the lunette above the central
doorway of the Cathedral at Florence the façade of which was
decorated with sculptures by Arnolfo between the years 1296 and
1302, the year of his death. In addition to the similar treatment of the
head in Moore's Claydon Madonna there is a comparable austerity
and proud bearing in the figure of the Virgin.*

developed into a deliberate determination to use drapery 'not as just "a decorative addition" but to emphasise the tension and stress the sculptural idea of the figure'. So when very shortly after his return from Greece he was asked to do the stone screen for the façade of the Time-Life building in Bond Street and a free-standing figure for the terrace, he chose once again his favourite subject of the reclining figure but a figure in which the drapery became as important a feature as it had been in the shelter drawings. He wanted to 'connect the contrast of the sizes of the folds, here small, fine and delicate, in other places big and heavy, with the form of mountains which are the crinkled skin of the earth'.

It is entirely characteristic of Moore's view that there is no reason why 'realistic art and purely abstract art can't exist in the world side by side at the same time, even in one artist at the same time', that he chose to work simultaneously on the screen and the figure, the one the most severely abstract work he had done since the thirties to be carved in stone and the other a most tender, human, figurative work to be cast in bronze.

Another by-product of the Greek visit was the first separate, single male figure, the *Warrior*. It evolved from a pebble found on the shore which suggested 'the stump of a leg, amputated at the hip'. The negative aspect of Moore's treatment of the male is striking. The body is mutilated; the head has a feeling of 'dumb animal acceptance and forbearance of pain'; the only weapon is a shield, a symbol not of virile aggression but of defence. The same feeling informs his *Falling Warrior* which is none the less one of the most thrilling sculptural compositions with yet another backward glance to Italy in the legs which must reflect a visual memory of Christ's legs in the Rondanini Pietà of which Moore has spoken so movingly.

The stump-like shapes of the *Warrior*, not unlike chunks of meat, are carried over into two projects of this date which were intended to be integrated in an architectural setting. One, the reliefs in brick on a wall in the Bouwcentrum at Rotterdam, was carried out; but the other, for the courtyard of the Olivetti building in Milan, was dropped. From the maquettes for the latter, however, Moore proceeded to make a series of upright motives including the *Glenkiln Cross* as it came to be called after it had been bought for a site on a Scottish moor. The power to disturb which he can wield when he turns to abstract organic shapes is immense and in this group with their vague suggestions of totemic, ritualistic symbols he adds a truly fearsome impact to images with an extraordinary plastic presence (**108**).

The choice of such a superb site for the *Glenkiln Cross* on the moor where his *Standing Figure* of 1950 and the *King and Queen* are also placed, is a reflection of

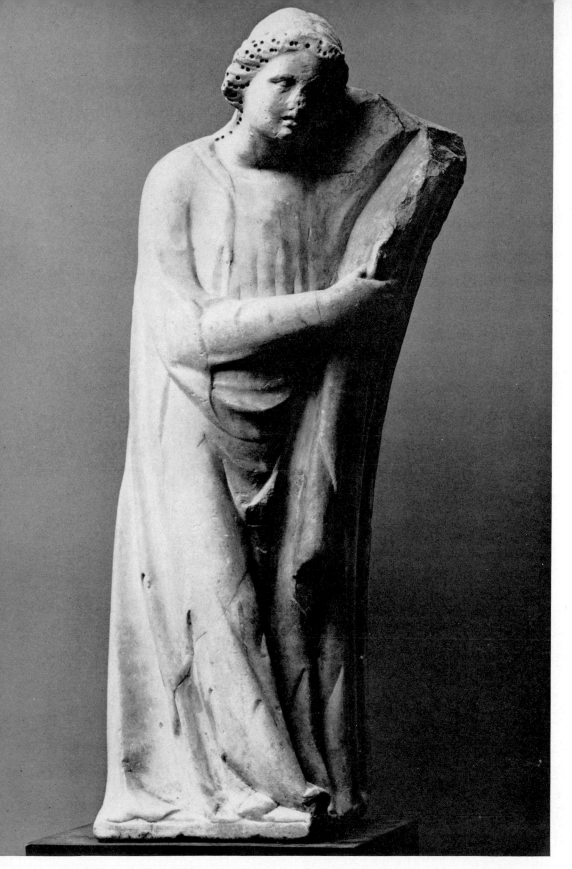

5 *School of Tino di Camaino (d. 1337).* FIGURE DRAWING A CURTAIN. *Marble,
h. 33¾ in.* Mr. and Mrs. Henry Moore. *In the opinion of J. Pope-Hennessy by a
Neapolitan follower of Tino.*

strongly felt views on the placing of his sculpture 'in a landscape, almost any land-scape' rather than 'in or on the most beautiful building I know'.

The relationship of Moore's sculpture with buildings is perhaps most dramatically achieved in the monumental and stark *Reclining Figure* he made in 1957 for the head-quarters of Unesco in Paris. After many preliminary sketches, he chose not some allegorical interpretation of Unesco's aims, not some sermon in stone on the brother-hood of man but the inevitable reclining figure. The largest he has ever done, it is over sixteen feet in length and weighs thirty-nine tons. He used Roman travertine, the whiteness of which makes it stand out against the glass curtain-wall of the building in the background. This piece 'stretched his ideas of size'. His scale, usually just over life-size, here moved up to twice life-size; and ever since he has been able to distinguish between strength and mass and to make images which are 'not merely big and heavy but full of vitality'.

One sees this in his majestic series of seated women begun in 1957 (**44**) in which there is a more sensuous rendering of woman's flesh and body and a more highly developed feeling for tactile quality which, in one instance, derives from actual memories of his mother's rheumatic back which he rubbed as a boy. Nobility of scale is seen, too, in the *Reclining Figures in Two Pieces* (**117** and **122**) which perhaps have a more potent impact from every viewpoint than anything he had achieved before. The space between the two forms gives an added tension and is part of the sculptural whole. 'They are still one unit, not two or three separate figures . . . If somebody moved one of these parts one inch, straightaway I'd know. The space would be different . . . All the relationships would be changed.' Another aspect of these figures is the blending of the dual techniques of carving and modelling, which one had seen earlier in the *King and Queen*. Moore is always at heart a carver, and even when a figure is to be cast in bronze the plaster is worked on with a knife and even an axe.[1] In this case the fusion of the two historic, traditional techniques of sculpture is matched by a similar fusion between figure and landscape in his treatment of the subject. But Bryan Robertson has made an acute comment on this equation of figure and landscape when he says 'In the earlier reclining figures we were shown a figure that was also a landscape. The heavy, earthbound forms were opened up and

1. See **15** and **16**.

24

explored but the figure came first with its own structure leading us into the interior sensation of a vast enclosed landscape. In two very large recent sculptures . . . there is a strong feeling of a reclining figure emerging from the landscape mass itself. The process is reversed.'[1]

In the last few years Moore has continued to work on the grand scale, and the feeling of energy waxes rather than wanes. The humanist quality has receded and at the moment the tough and even the brutal is in the ascendant. His forms suggest sometimes visceral, sometimes bone-like structures. The origins, in the great *Locking Piece* and the *Standing Figure – Knife Edge*, of the cruel, sawn-off shape in the one, like something 'saved out of the stewpot', and the light-weight fineness of a knife-blade in the other, lie on his own admission in 'the sculptural principles to be learnt from bones' (**48** and **127**).

In these titanic pieces, as in all else he has done, Moore is the spokesman of his generation. 'Moore has not only created a corpus of great works of art but is helping a new age into being'.[2]

While only a little of his now substantial *oeuvre* has been mentioned, enough has now been said to indicate that the whole course of his development so briefly outlined here can be filled in by what follows in these pages from his own writings or, more often, his own lips. He has spoken a good deal more than he has written. The freedom, the loose grammar, the impromptu interjection, the use of the vernacular have all been allowed to stay. The division of the material into various sections has meant that passages on the same subject have been gathered from different articles or interviews. Only by such a method has a good deal of repetition been avoided. Even so, some covering of the same ground has been inevitable if only because the sense and coherence of a passage would be destroyed by ruthless excisions on the grounds of consistency. For the same reasons the important statements, especially those which were issued in the thirties, have been left intact. Thus the passage on abstract art in the contribution to *Unit One* has not been extracted and placed in the section on *Abstract Art*. Such inconsistencies will, it is hoped, be countered by the provision of an index.

1. *Museums Journal*, February 1961, p. 275.
2. E. Neumann, *The archetypal world of Henry Moore*. London, 1959.

Biographical

Boyhood

I think I was probably about eleven when I first decided I wanted to be a sculptor. I remember quite clearly the instant. As a boy, at school, I liked the art lessons, I liked drawing. I used to get my elder brother to draw horses and other things for me from as early as I can remember. But the little incident that clinches the thing in my mind was that our parents used to send me and my younger sister to Sunday school on Sunday afternoons – to get rid of us I think mainly – and the Sunday school we went to was a Congregational chapel although we were Church of England. The superintendent every Sunday used to give a talk which always had some little moral. And one Sunday he told us about Michelangelo carving the head of an old faun in the streets – in his studio in the streets of Florence – and that a passer-by stood watching Michelangelo carving this head. And after watching two or three minutes he said to Michelangelo, 'But an old faun wouldn't have all its teeth in.' Michelangelo immediately, said the superintendent, took his chisel, knocked out two of the teeth, and there, he said, was a great man listening to the advice of other people even though he didn't know them. Now this story didn't stick in my mind for its moral but merely that there was someone – Michelangelo, a great sculptor. So instead of saying as most boys might, that one wanted to be an engine-driver and so on, this pinpointed something in my mind and I knew from then onwards.

I remember a church about two miles from our home,[1] a Gothic church, I think, between 1300 and 1400. I drew there as a little boy of nine or ten and always looked in there when I went to visit my aunt. That's about the earliest time I noticed sculpture around me.

My first serious lessons were when I went to grammar school, a co-educational grammar school. We had an art teacher – a Miss Gostick, half French, and she was wonderfully enthusiastic about the art lessons. Most of the boys and girls didn't seem to care about it, but I found that once I went to the grammar school I knew it was the one lesson of the week that I looked forward to. She was wonderfully helpful in

1. At Methley.

asking me to tea every Sunday, and showed me copies of *Colour* magazine and so on. I owe a great deal to her enthusiasm.

I was the seventh in the family. By the time I came along, one brother and two sisters had already become teachers, and this was the sort of path carved out for the rest of the family. So there was no question of me going down the pits. My father really was a remarkable man. Very ambitious for us children, and had taught himself, although I was told that he had no schooling and earned his living first of all at nine. In his youth I think there was very little public education, and by the time I remember him very clearly he could help me in my homework from the grammar school. He seemed to know the whole of his Shakespeare. He knew his Bible pretty thoroughly and he taught himself enough trigonometry, mathematics and so on to pass his exam as a manager for the coal mine. So I think it was he who really helped the family. He was absolute boss, a complete Victorian tyrant. I got on with him, but at the same time one had to keep away from his chair in the corner of the room, I remember. And homework, everything else, was done on the kitchen table after the meal was cleared away. His little corner was absolutely sacrosanct. Nobody was allowed to nudge him or bump him in any way whatever. I had a great respect for Father. I knew that his opinions had real foundation. For instance, when I came to want to be an artist, he said, 'First become qualified as a teacher like your brother and sisters have done and then change to art if you wish. Be sure that you have some living in your hand.' Well this was very intelligent and very sensible, but by the time I got to that age I knew that I wasn't going to be a teacher, that I was going to study art.

There were two other boys at the school who ran neck and crop with me for favour with the art mistress, Miss Gostick, and we were given in turn the jobs of designing the school programme for the school concert, or the scenery, and there came a time, when the war began – I was still then only, what? fifteen – and it was decided to have a school Roll of Honour for the old students who were joining up. So I carved a scroll and a little scene on the top of it. This was the first real start to my proper carving career. I believe it's still there. [1964/Bibl. 3].

Leeds School of Art

It was in those two years of war [1917–18] that I broke finally away from parental domination which had been very strong. My old friend, Miss Gostick, found out about ex-servicemen's grants. With her help I applied and received one for Leeds School of Art. This was understood from the outset merely to be a first step. London was the goal. But the only way to get to London was to take the Board of Education examinations and win a scholarship . . .

Leeds School was very proficient in teaching tricks of getting through examinations. The instruction concentrated on modelling busts in the most academic fashion conceivable. [1947/Bibl. 50].

There was the sculpture teacher at Leeds . . . who was new there and who had just come from the Royal College of Art. There hadn't been a Sculpture School at Leeds. In my first year I just took drawing then I said I wanted to do sculpture – and I was the only one. I think they started the sculpture department purely and simply because I asked to do sculpture. This man, Cotterill his name was, came fresh from college to Leeds. His one full-time student was me, and so he could concentrate entirely on teaching me all the tricks he knew . . . What was ordinarily supposed to be a two year examination course I squeezed into one year and on it won a Royal Exhibition, which was a scholarship (with some ninety pounds a year attached to it) for a place at the Royal College of Art, South Kensington. In this examination I modelled a hand which was later sent around to other art schools as an example of how it should be done. In that way I was lucky, having a whole department and a whole staff entirely concentrated on me . . .

There was a time . . . when I was a bit troubled by not liking the sculpture which the teachers there expected us to like. We were set to draw from the antique such things as the *Boy and Goose* which is a late Roman copy of a Greek work, and we had to draw the *Discobolus*. Now I didn't have the slightest bit of interest in these sculptures, and there was a stage when in the first week or two at the School of

Art I thought 'Well, is it me that doesn't know what sculpture is? Is there something wrong with me that I don't like these pieces?'

Now I know that I was quite justified in not liking them because, besides not being very good pieces of sculpture in themselves, they'd been whitewashed every year for twenty years and had a thick coat, nearly a quarter of an inch, of whitewash on top of them, which was blurring all the surface sensitivity and the form. But still we were expected to draw them. [1960/Bibl. 9].

I was very glad I didn't go to an art school till I was twenty-one. Art schools, then, and especially in the provinces, had a terribly closed, academic outlook. When I got to Leeds School of Art in 1919 there were students who'd gone there at fourteen or fifteen, as you could in those days, and any excitement or freshness they might have had, had been deadened and killed off by humdrum copying from the antique, just making very careful stump-shaded drawings with no understanding whatever of form.

I'd had the luck to know Michael Sadler, who was then Vice-Chancellor of Leeds University, a man who had bought Cézanne and Gauguin before 1914, and translated Kandinsky, and really knew what was going on in modern art. [1961/Bibl. 47].

The Royal College of Art

For the first year I was in a dream of excitement. When I rode on the open top of a bus I felt that I was travelling in Heaven almost, and that the bus was floating in the air. And it was Heaven all over again in the evenings in my horrid little room in Sydney Street, when I could spread out the books I'd got out of the library and know that I had the chance of learning about all the sculptures that had ever been made in the world.

With my £90 a year in scholarships I was one of the real rich students at the College, and I had no worries or problems at all except purely and simply one's development as a sculptor. And, as to that, there were a whole lot of things that one found out for oneself very simply and easily. Once you'd read Roger Fry the whole thing was there. I went to the British Museum on Wednesday and Sunday afternoons and saw what I wanted to see [1961/Bibl. 47].

One room after another in the British Museum took my enthusiasm. The Royal College of Art meant nothing in comparison. But not till after three months did things begin to settle into any pattern of reality for me. Till then everything was wonderful – a new world at every turn.

That is the value of the British Museum; you have everything before you, you are free to try to find your own way and, after a while, to find what appeals to you most. And after the first excitement it was the art of ancient Mexico that spoke to me most – except perhaps Romanesque, or early Norman. And I admit clearly and frankly that early Mexican art formed my views of carving as much as anything I could do.

But my aims as a 'student' were directly at odds with my taste in sculpture. Already, even here a conflict had set in. And for a considerable while after my discovery of the archaic sculpture in the British Museum there was a bitter struggle within me, on the one hand, between the need to follow my course at college in order to get a teacher's diploma and, on the other, the desire to work freely at what appealed most to me in sculpture. At one point I was seriously considering giving up college and working only in the direction that attracted me. But, thank goodness, I somehow

came to the realisation that academic discipline is valuable. And my need to have a diploma, in order to earn a living, helped.

I now understand the value of an academic grounding: modelling and drawing from life. All sculptors of the great periods of European art could draw from life, just as well as the painters. With me, at one moment, it was just touch and go. But finally I hit on a sort of compromise arrangement: academic work during the term, and during the holidays a free rein to the interests I had developed in the British Museum. Mixing the two things enabled one to continue drawing from life (**6** and **7**) as I have always done. And it also allowed me to win my travelling scholarship to Italy on academic grounds.

There, although I came almost immediately to the Masaccios in Santa Maria del Carmine, I was no more able to use the frescoes directly for my work than I was able to make an accurate copy of the *Chacmool* (**10**) from a halftone reproduction. Still, as I see it now, both were to have an equally lasting influence . . .

The Italian trip, as I say, was a turning point. But it was really not until the blitz in London had passed that I began to realise how deep-rooted the Italian influences had been [1946/Bibl. 50].

But the College itself must have meant something to you?

Till Sir William Rothenstein became Principal, in the year I went up as a student, it had been just a training college where teachers taught students to become teachers and teach more students, and so on for ever. But Rothenstein brought an entirely new outlook into the College. He'd known Degas and he'd known Rodin, and he didn't regard the College primarily as a teachers' training college.

Not only that, but he would ask one or two of us students in on Sunday evenings, when he kept open house. He had an enormous and very distinguished circle of friends, and I remember meeting Walter de la Mare, for instance, and the then Prime Minister, Ramsay Macdonald.

In fact meeting Macdonald was another bit of education for someone like me. I remember being left alone with him and standing waiting for him to begin the conversation. He did say one or two words to me, and I remember feeling that it was all perfectly ordinary and natural. I wasn't awed or anything, and so Rothenstein gave me the feeling that there was no barrier, no limit to what a young provincial student could get to be and do, and that's very important at that age.

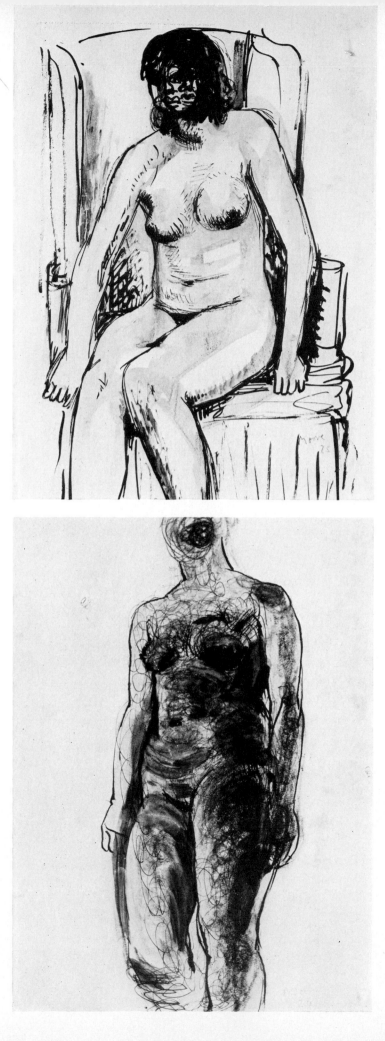

6 SEATED GIRL, *1925.*
Drawing from life. Indian ink
and wash, 16½ × 12½ in.
Marlborough Fine Art Ltd.

7 STANDING FIGURE,
1924. Drawing from life. Indian
ink and wash, 14½ × 10½ in.
Stephen Spender.

But the curriculum was still rather archaic?

Yes, it was. For instance there was a compulsory thing called 'the monthly comp' and on the last Friday of the month one or other of the professors would go into the lecture theatre, where all the work was pinned up on the wall, and say what he thought of them. One day a professor called Pite, quite a well-known architectural theorist in his day,[1] picked out my drawing and gave it a terrible slating.

Rothenstein was in the front row when Pite said, 'This student has been feeding on garbage – anyone can see that.' There was a bit of Etruscan or Negro influence in it – I forget which. Anyway, he really let himself go, and the next day Rothenstein called me into his office and said, 'I hope you weren't too upset – these things are bound to happen, you know'. [1961/Bibl. 47].

1. A. Beresford Pite (1861-1934).

Italy

I have until now been moving with the speed of an American tourist – the first week of being out – spent in Paris – has sunk into the very distant past, but the Guimet Museum (the Indian sculptures in the entrance hall, and the room on the ground floor – and the sculptures and paintings from Antinoe) stands out like – like cypress trees in an Italian landscape – Paris itself I did not like – and after the Louvre and the Guimet Museum the few exhibitions of contemporary work which I saw seemed almost rubbish.

I've made stops at Genoa, Pisa and Rome, before coming on here to Florence. In Italy the early wall paintings – the work of Giotto, Orcagna, Lorenzetti, Taddeo Gaddi, the paintings leading up to and including Masaccio's are what have so far interested me most. Of great sculpture I've seen very little – Giotto's painting is the finest sculpture I met in Italy – what I know of Indian, Egyptian and Mexican sculpture completely overshadows Renaissance sculpture – except for the early Italian portrait busts, the very late work of Michelangelo and the work of Donatello – though in the influence of Donatello I think I see the beginning of the end – Donatello was a modeller, and it seems to me that it is modelling that has sapped the manhood out of Western sculpture, but the two main reasons are, don't you think, the widespread avoidance of thinking and working in stone – and wilful throwing away of the Gothic tradition – in favour of a pseudo Greek – I believe that even mediocre students at college or anywhere, had they been lucky enough to have entered a sculptor's workshop, later would most probably have been doing work which we should now admire – in Italy of the 14th century, in one small town of 20 or 30 thousand inhabitants there must have been living and working at the same time 50 or 60 painters, each of whom were he doing his same work now would be accounted a genius! . . . The only hope I can see for a school of sculpture in England, under our present system, is a good artist working carving in the big tradition of sculpture, who can get the sympathy and admiration of students and propagate good as Dalou and Lanteri spread harm.

I have been seeing rather than doing until now – and I think I have seen examples of most of the Italians – Giotto has made the greatest impression upon me (perhaps

partly because he's the most English of the primitives). My present plans are, the Giottos at Assisi, and at Padua, then out of Italy via Ravenna and Venice and on to Munich – from Germany home via Paris so that I can finish up at the Guimet Museum.

I am beginning to get England into perspective – I think I shall return a violent patriot. If this scholarship does nothing else for me – it will have made me realise what treasures we have in England – what a paradise the British Museum is, and how high in quality, representative, how choice is our National Collection – and how inspiring is our English landscape. I do not wonder that the Italians have no landscape school – I have a great desire – almost an ache for the sight of a tree that can be called a tree – for a tree with a trunk[1] [1924].

I remember going to Pisa as a student to see the Giovanni Pisano figures (**8**) on the top of the Baptistery but about all I could get from them was that they represented a change away from Byzantine towards Renaissance. They were too high, they were just silhouettes against the sky and it was impossible, at that distance, to see the form inside the silhouette. These figures (because they were weathering too rapidly and some were becoming unsafe) have since been taken down from the Baptistery and put into the museum at Pisa where, four years ago, I saw them again. They are set up on eye level and on turntable stands and I now think they are some of the world's greatest sculptures. Now that one can go near them one can respond to them as sculpture, as bumps and hollows, as volumes and taut compressions, and as humanist expression, and not merely as decorative architectural features. In my opinion you can't really react to a normal life-size piece of sculpture unless you can get to within ten to fifteen feet of it – that is, at a man-to-man distance – at a human communication distance, for that is the distance at which the sculptor makes his sculpture. [1955/Bibl. 56].

It would be true to say, wouldn't it, that Giovanni Pisano drew as fruitfully on the art of the past, and did as much to enhance and reinvent the idiom of living sculpture as the modern artists whom we've just talked of?

1. From a letter dated 12 March 1924 to Sir William Rothenstein, then Principal of the Royal College of Art. In bibl. 46.

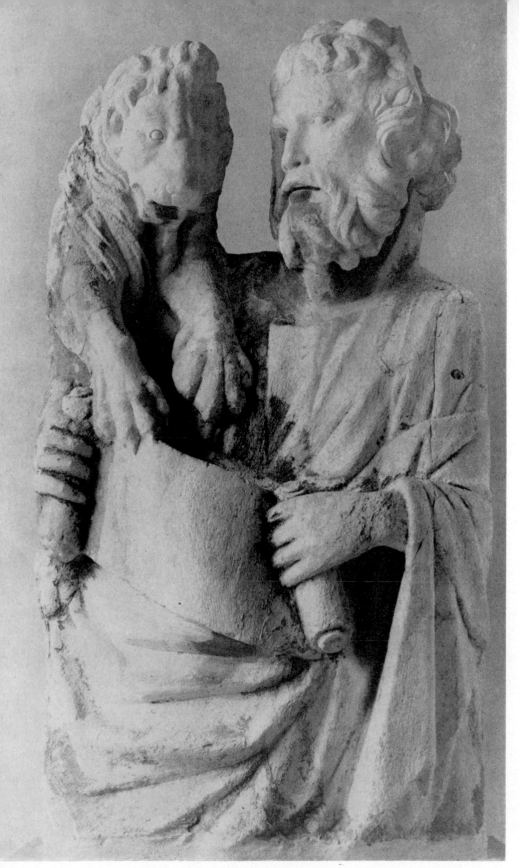

8 *Giovanni Pisano.*
ST. MARK THE EVANGELIST.
*Marble, h. 67½ in. About 1284. One of
the series of half-length Evangelists
and Prophets from the principal tier of
niches surrounding the outside of the
Baptistery at Pisa, now shown inside
the building. Giovanni perhaps
collaborated with his father Nicola
on this work. From the Pisano
workshop at the end of the 13th century
came a revolution in sculpture which
is the counterpart of Giotto's
contribution to painting. Both
Giovanni and Arnolfo were pupils of
Nicola Pisano and Tino was closely
associated with Giovanni. A new
vitality and expressiveness in the
delineation of the human form is seen
and in Giovanni's work in particular
his figures have a dynamic quality which
reflects the new found knowledge of
trans-alpine Gothic art.*

Yes, it's amazing how much he contributed – how different any one of his figures is from one by Nicola Pisano, his father, how they are static and dynamic at the same time, how he makes you see that the pelvis can move in an opposite direction from the thorax, and that the neck is not just an extension of the body, and so on. And yet beside all this sculptural originality there's a warm human dignity and a kind of grandeur and nobility in his figures that bring him, to my mind, into the same world as Masaccio. When I saw these sculptures I realised that here was someone putting into the stone everything that the human figure can teach us, and yet at the same time also having just the view of humanity that one most warms to.

Do you think there's anybody working now who has this same quality?

I think socialist realist artists would like to get at it; but of course they can't, because it's done in a superficial academic way and the artists are simply not up to it. It's only a great humanist like Giovanni Pisano, or Masaccio or Rembrandt or Cézanne who can express the tremendous power of goodness that exists somewhere in human nature. Much as one admires Bernini, for instance, I don't believe that he creates wonderful human beings or leads on to the idea that human life could be consistently marvellous. In Picasso, giant as he is, there are lots of things that are unimportant, but there's hardly a stroke of the pen by someone like Rembrandt that's unimportant. [1961/Bibl. 47].

Perhaps that's what makes Picasso's work often seem capricious: a conflict between an interest in the approach illustrated by archaic art and the art of primitive peoples and a respect for the Mediterranean tradition. At any rate, as I look back, I am very conscious of such a conflict throughout my own work, particularly since I went to Italy first in 1925 on a travelling scholarship. Before that time I had associated classical and Renaissance art with academism and those plaster casts I had to copy at the Leeds School of Art and in the Royal College of Art in London. In fact when I learned that my travelling scholarship should be spent in Italy I at once pleaded to have it rearranged for Paris. But nothing could be done; no financial arrangements could be made to permit it; so I had to go to Italy against my will. But thank goodness now I did go.

For about six months after my return I was never more miserable in my life. Six months' exposure to the master works of European art which I saw on my trip had

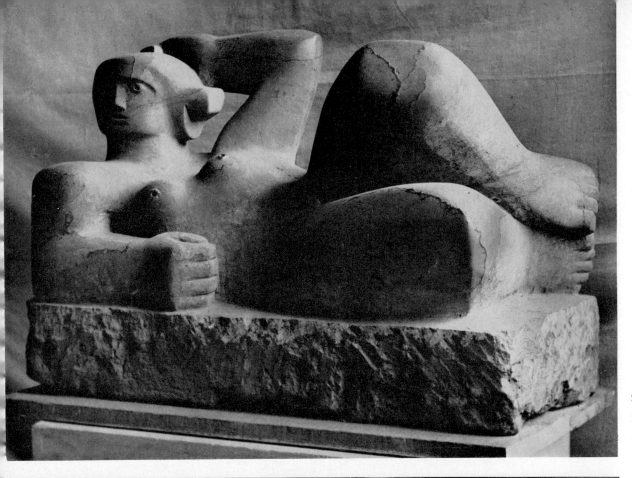

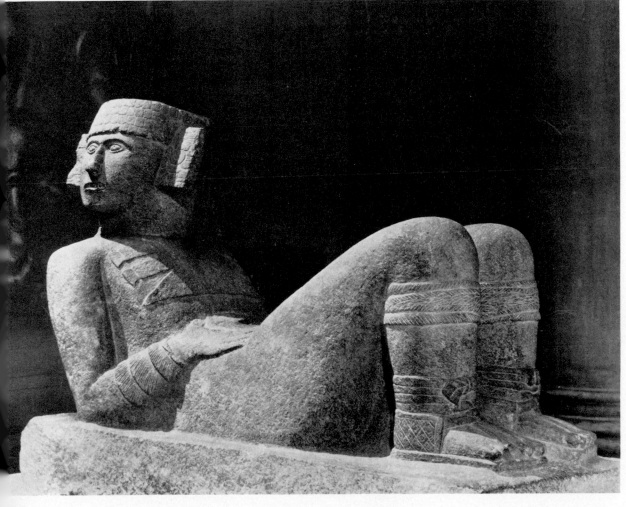

9 RECLINING
FIGURE, *1929.*
Hornton stone, l. 32 in.
City Art Gallery, Leeds.

10 CHACMOOL, *a*
rain spirit. Toltec-Maya
A.D. 900–1000.
From Chíchén Itzá
(Yucatan). Limestone,
41¼ × 58¼ in. Museo
Nacional de
Antropologia, Mexico.

stirred up a violent conflict with my previous ideals. I couldn't seem to shake off the new impressions, or make use of them without denying all I had devoutly believed in before. I found myself helpless and unable to work. Then gradually I began to find my way out of my quandary in the direction of my earlier interests. I came back to ancient Mexican art in the British Museum. I came across an illustration of the *Chacmool* discovered at Chíchén Itzá in a German publication – and its curious reclining posture attracted me – not lying on its side, but on its back with its head twisted around (**10**). Still, the effects of that trip never really faded. But until my shelter drawings during the war I never seemed to feel free to use what I learned on that trip to Italy in my art – to mix the Mediterranean approach comfortably with my interest in the more elementary concept of archaic and primitive peoples. I feel the conflict still exists in me. And I ask myself, Is this conflict what makes things happen? [1946/Bibl. 50].

It seems to me now that this conflict between the excitement and great impression I got from Mexican sculpture and the love and sympathy I felt for Italian art, represents two opposing sides in me, the 'tough' and the 'tender', and that many other artists have had the same two conflicting sides in their natures. Blake, for example, was torn between the two – his *tender* 'Songs of Innocence' and lyrical water-colours, and his *tough* muscular 'Nebuchadnezzar eating grass'. Goya could make beautifully tender portraits of children, and yet painted the violent 'Saturn devouring one of his children'[1] (on his own dining-room wall!) Shakespeare wrote *Romeo and Juliet* and *Macbeth* and *King Lear*. But we easily accept double sympathies in literature, and realise that Shakespeare's tragic and violent side was all the richer and deeper because he had the tender side. Michelangelo's art shows conflict – the bombastic, insensitive swagger of his *David*, and the slow lazy melancholy of *Night* (**63**) and *Day*. Only at the end of a long life, in his greatest and last works are these qualities mixed to become a noble, rich-blooded maturity of strength mingled with melancholy.

And, as I've suggested, what conflicting attitudes don't we find in the work of today's greatest painter, Picasso – in his so-called sweet and sentimental blue period (and his Greek vase loveliness) – and in the violent recent work. And really I see no

1. He refers to *Saturn devouring his child*, one of Goya's so-called 'black paintings' which he did on the walls of his villa the *Quinta del Sordō*. The series is now in the Prado Museum.

42

difficulty in appreciating both sides and finding them in the same artist.

Perhaps an obvious and continuous synthesis will eventually derive in my own work. I can't say – I can only work as I feel and believe at the time I do the work. I can't consciously force it to come. [1960/Bibl. 8].

The first exhibition

You were thirty when you had your first show, weren't you?

Yes, it was at the Warren Gallery, Dorothy Warren was a remarkable person with tremendous energy and real verve, real flair.

She'd shown D. H. Lawrence's paintings, hadn't she?

That's right. I remember all the excitement of that . . . She sold £90 worth of my things – thirty drawings (**11**) at £1 each, several to Epstein, several to Augustus John, and Henry Lamb – it was mostly other artists, and established ones, who bought, and that was a great encouragement to me. I sold several sculptures[1] too (**12**), but in my first four or five shows it was the drawings that kept me going, not the sculptures, and the other artists who bought.

Was there real antagonism to the sculptures?

Well, there was an article in the *Morning Post* that said it was 'immoral', or something of the sort, that a man like me should be teaching the young, and there was one professional body that actually called for my resignation, and one of my colleagues at the College who said, 'Either Moore goes or I go'. But Sir Will sent for me and said, 'I know your teaching is all right. What you do as an artist is your own affair and I don't ever want to see it.'

So that was all right; and there were things like Alfred Barr's first visit to the studio in 1932 or 1933, when he liked a piece that Michael Sadler then gave[2] to the Museum of Modern Art in New York (**13**). Things like that made one forget all the rest. [1961/Bibl. 47].

1. Among them the *Mother and Child*, 1925, illustrated in **12**. It was bought by Henry Lamb and is now in the City Art Gallery, Manchester.
2. There is a confusion in the dates as the sculpture *Two Forms* was made in 1934.

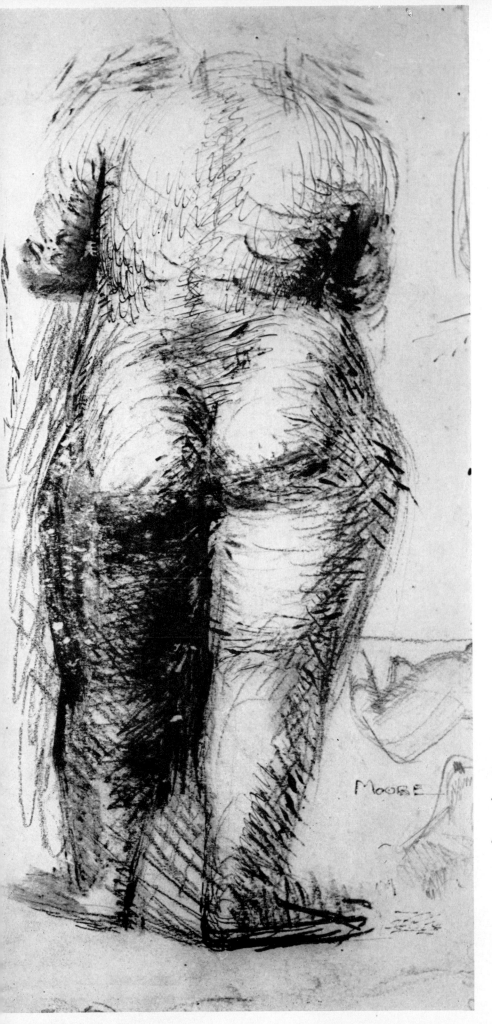

11 FEMALE NUDE, BACK VIEW,
*1926. Drawing from life. Chalk
and pen, 17 × 8¼ in.* The artist.

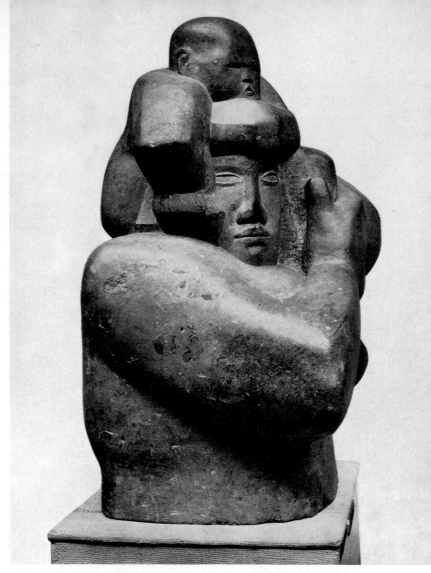

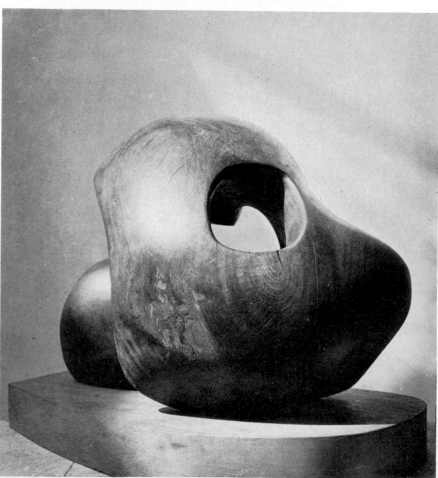

12 MOTHER AND CHILD,
1924–25. Hornton stone, h. 22½ in.
City Art Gallery, Manchester.

13 TWO FORMS, *1934.*
Pynkado wood, h. 22 in.
Museum of Modern Art, New York
(the gift of Sir Michael Sadler).

Greece

My first visit to Greece came late in life – it was in 1951, when I was fifty-three – and I thought before going that I knew about Greek art, because I'd been brought up on it, and that I might even be disappointed. But not at all, of course. I'd say that four or five of my top ten or twelve visual experiences came in Greece.

For example Mycenae had a tremendous impact. I felt that I understood Greek tragedy and – well, the whole idea of Greece – much, much more completely than ever before. And Delphi, though I did find it had a slight touch of theatricality, as if the eagles were flying round to order, and Olympia, with the idyllic sense of lovely living that you get there, and of course the whole of the Acropolis. That too had something I hadn't at all foreseen.

In fact I would say that the Parthenon now is probably much more impressive than when it was first made. You feel the spaces much more, and the openings, and the fact that it's not solid throughout and that the light comes in, makes it into a piece of sculpture and not, as it was before, a building with four external sides. It's completely spatial now – a different object altogether. And the Greek landscape was another revelation to me – that stark, stony quality, with the feeling that the sea may be round the next corner. I can understand why they were sculptors – the stone just had to be used, it was the one thing they had to hand.

Was it a revelation, too, to see your own sculptures in Greece?

The Greek light is, as everyone says, something you can't imagine till you've experienced it. In England half the light is, as it were, absorbed into the object, but in Greece the object seems to give off light as if it were lit up from inside itself. But I think that the element of light can be over-emphasised. The northern light can be just as beautiful as the Greek light and a wet day in England can be just as revealing as that wonderful translucent Mediterranean light. I really don't think that Mediterranean light is the only light, by a long chalk. [1961/Bibl. 47].

There was a period when I tried to avoid looking at Greek sculpture of any kind.

And Renaissance. When I thought that the Greek and Renaissance were the enemy, and that one had to throw all that over and start again from the beginning of primitive art. It's only perhaps in the last ten or fifteen years that I began to know how wonderful the Elgin Marbles are. [1960/Bibl. 9].

Influences

Actually Roger Fry's *Vision and Design* was the most lucky discovery for me. I came on it by chance while looking for another book in the Leeds Reference Library. Fry in his essay on Negro sculpture stressed the 'three-dimensional realisation' that characterised African art and its 'truth to material'. More, Fry opened the way to other books and to the realisation of the British Museum. That was really the beginning. [1947/Bibl. 50].

I wonder if many artists have been affected by a book about art criticism as you have been by Roger Fry's Vision and Design. *Have any other works of art criticism affected you so greatly?*

No. But another book that I found a great help and an excitement was Ezra Pound's book on Gaudier–Brzeska. This was written with a freshness and an insight, and Gaudier speaks as a young sculptor discovering things.

Do you feel a community of aim or purpose . . . with the other sculptors of this century?

Yes with some few, of course – about four or five perhaps. There's no doubt that the stand Brancusi (**17**) took for shape for its own sake, reducing a thing to just a simple egg, was a great help to me who was twenty years younger than him. And the cubist painters, the cubist movement, was an influence.

Do you think there has been an effect upon your work by the work of artists working in other media, like writers and composers?

I don't think that music or poetry, although one has liked and enjoyed so much in both, have made any difference to the direction of my sculpture. My reading was more of a formative influence on my romantic youth. For a whole year of my life Thomas Hardy coloured my outlook; I read every novel of Thomas Hardy when I was around seventeen or eighteen. One lived in that world and it was a big influence

on one's make-up, not as a sculptor but as a person. Then again the same thing happened from twenty to twenty-two; I read the whole of D. H. Lawrence with the same kind of excitement that I had once had over Hardy. And the great Russian novelists – Dostoevsky even more than Tolstoy – meant a great deal to me. Somewhat later I read Stendhal. It's been novelists if anything who have had the biggest influence on me . . . in colouring one's outlook, one's growth.

Do you think it was only visual causes which influenced your immediate acceptance of primitive art? Do you think that possibly you were affected by some of the intellectual movements of your time? I wonder if Freud and Jung and the anthropologists could have encouraged your acceptance of it?

Yes. I should think that the youth of every age is conditioned towards accepting something which the youth of an age twenty years previously would have passed by and wouldn't have seen. [1960/Bibl. 9].

Recently there was a book published on my work by a Jungian psychologist; I think the title was *The Archetypal World of Henry Moore*.[1] He sent me a copy which he asked me to read, but after the first chapter I thought I'd better stop because it explained too much about what my motives were and what things were about. I thought it might stop me from ticking over if I went on and knew it all . . . If I was psychoanalysed I might stop being a sculptor. I don't know, but anyhow I don't want to stop being a sculptor. [1962/Bibl. 54].

You see, I think a sculptor has to be a practical person, – he can't be just a dreamer. If you're going to shape a piece of stone into a sculpture you must handle a hammer and chisel; you must be able to do it without knocking your hand; you must be a workman; you must be somebody with his feet on the ground.

 I don't know whether it is true or not, but in England, north country people are looked upon as being very matter-of-fact, practical, hard-working people. This may have something to do – I don't know; it's just a fanciful idea, probably – but this

1. E. Neumann. *The Archetypal World of Henry Moore*. London (Routledge and Kegan Paul), 1959.

may have something to do with the fact that in England now there are some twenty or thirty young sculptors who've cropped up since the war; four or five of them are certainly Yorkshire. There's me, there's Barbara Hepworth, there's Armitage, there's Ralph Brown and Thornton. Well, I thought of five immediately who come from Yorkshire. There are probably another three or four if I went on thinking, but that may be just a fanciful idea, as I say.

And perhaps there is something about Yorkshire itself. Of course, Yorkshire being a very big county has a lot of variety in it, but although I now live in Hertfordshire and have done so for the last twenty years, I don't think that the landscape around here has influenced my sculpture very much, although the sky and the clouds and the trees are the same wherever you are, and those are the big factors. Perhaps what influenced me most over wanting to do sculpture in the open air and to relate my sculpture to landscape comes from my youth in Yorkshire; seeing the Yorkshire moors, seeing, I remember, a huge natural outcrop of stone at a place[1] near Leeds which as a young boy impressed me tremendously – it had a powerful stone, something like Stonehenge has – and also the slag heaps of the Yorkshire mining villages, the slag heaps which for me as a boy, as a young child, were like mountains. They had the scale of the pyramids; they had this triangular, bare, stark quality that was just as though one were in the Alps. Perhaps those impressions when you're young are what count. [1964/Bibl. 6].

1. At Adel. See pp. 266 and 269 (**119**).

A working day

What was your working day like – in the 30's say?

When we had a cottage near Canterbury, and Bernard Meadows was my assistant, we'd all get up at 5.30 and throw a bucket of water over each other to make sure we were thoroughly awake, and then we'd go on with whatever work we'd been doing the day before. Irina got our breakfast at 6.30 and by 7 o'clock we'd be at work in the open – I had five acres of shelving ground that ran down into a valley with hills on the other side. Any bit of stone stuck down in that field (**14**) looked marvellous, like a bit of Stonehenge, but not so big.

About 11.30 we'd get into our little Standard coupé and go down to the sea and bathe and eat our sandwiches, be back by 1.30 or 2, go on working till tea at 5 and then on again till dark. It often made a fourteen hour day right through the summer, but it was like a holiday, compared with London [1961/Bibl. 47].

Do you have a daily schedule of work?

I try to be in the studio by about 9.30 and I try to have no interruptions in the morning . . . I've found that to keep the mornings completely clear for work is the only way I can feel at the end of the day that I've spent it a bit as I wanted to . . . After lunch I don't mind very much if the afternoon is broken into. I don't mind reading the paper, I don't mind my secretary doing some telephoning with me or for me, or doing a few letters. In fact, up to tea-time I'm quite resigned now that afternoons aren't for proper work. But by the early evening when all that side of the day is finished, I like to be able to go back into the studio from about 6 onwards – either down to the big one if I'm on with a large sculpture that I know exactly what to be carrying on with, or here near the house in the little studio, where I'll either draw in sketch-books, or do the small models until maybe eight, nine or ten p.m. But it's not absolutely hard and fast. It's only that I know that if at the end of the day I haven't had one good spell of work, then I'm dissatisfied. I feel that it's a day that's spoilt . . .

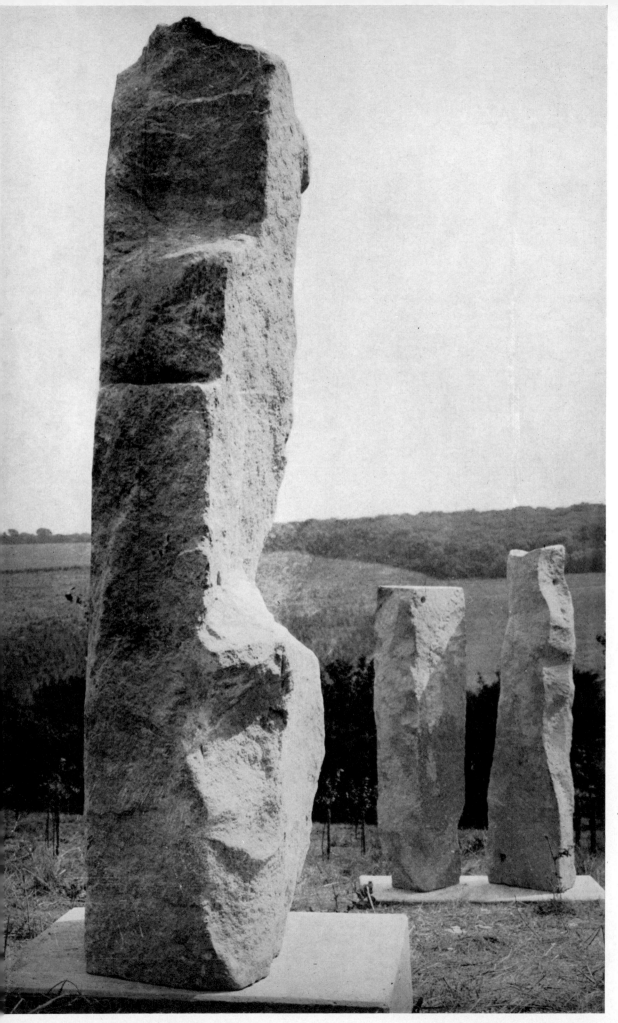

14 STONES *ready for carving in the artist's garden at Kingston, Kent 1937.*

You work on a number of things at once. Is this on principle? Do you work on just one sculpture each day usually? Do you plan ahead which you're going to work on?

I let the morning decide, when I wake. I don't have a plan the day before or anything like that. I've always worked on two or three things at once, but when it's large sculpture – now that I'm able economically to do more large things – there are certain stages which take a long time and which could be tedious. So if you have another piece to work upon, after you have been doing the rather humdrum parts of a large sculpture, it is a help. But apart from that, I actually like taking time over certain pieces of sculpture, the large things, to be sure that I'm not pleased with something which was only a flash in the pan. [1960/Bibl. 9].

On Sculpture

The nature of sculpture

In sculpture the later Greeks worshipped their own likeness, making realistic representation of much greater importance than it had been at any previous period. The Renaissance revived the Greek ideal and European sculpture since then, until recent times, has been dominated by the Greek ideal.

The world has been producing sculpture for at least some thirty thousand years. Through modern development of communication much of this we now know and the few sculptors of a hundred years or so of Greece no longer blot our eyes to the sculptural achievements of the rest of mankind. Palaeolithic and Neolithic sculpture, Sumerian, Babylonian and Egyptian, Early Greek, Chinese, Etruscan, Indian, Mayan, Mexican and Peruvian, Romanesque, Byzantine and Gothic, Negro, South Sea Island and North American Indian sculpture; actual examples or photographs of all are available, giving us a world view of sculpture never previously possible.

This removal of the Greek spectacles from the eyes of the modern sculptor (along with the direction given by the work of such painters as Cézanne and Seurat) has helped him to realise again the intrinsic emotional significance of shapes instead of seeing mainly a representation value, and freed him to recognise again the importance of the material in which he works, to think and create in his material by carving direct, understanding and being in sympathy with his material so that he does not force it beyond its natural constructive build, producing weakness; to know that sculpture in stone should look honestly like stone, that to make it look like flesh and blood, hair and dimples is coming down to the level of the stage conjuror.

A limitless scope is open to him. His inspiration will come, as always, from nature and the world around him, from which he learns such principles as balance, rhythm, organic growth of life, attraction and repulsion, harmony and contrast. His work may be comparatively representational or may be as Music and Architecture are, non-representational, but mechanical copying of objects and surrounding life will leave him dissatisfied – the camera and cameograph[1] have nullified this as his aim.

1. A word of Moore's own invention. He means the pantograph.

He will want his works to be creations, new in themselves, not merely feats of copying nor of memory, having only the second-hand life of realistic waxworks.

Each sculptor differs in his aims and ideals according to his different character, personality and point of development. The sculpture which moves me most is full blooded and self-supporting, fully in the round, that is, its component forms are completely realised and work as masses in opposition, not being merely indicated by surface cutting in relief; it is not perfectly symmetrical, it is static and it is strong and vital, giving out something of the energy and power of great mountains. It has a life of its own, independent of the object it represents. [1930/Bibl. 17].

Sculpture, for me, must have life in it, vitality. It must have a feeling for organic form, a certain pathos and warmth. Purely abstract sculpture seems to me to be an activity that would be better fulfilled in another art, such as architecture. That is why I have never been tempted to remain a purely abstract sculptor. Abstract sculptures are too often but models for monuments that are never carried out, and the works of many abstract or 'constructivist' sculptors suffer from this frustration in that the artist never gets around to finding the real material solution to his problems. But sculpture is different from architecture. It creates organisms that must be complete in themselves. An architect has to deal with practical considerations, such as comfort, costs and so on, which remain alien to an artist, very real problems that are different from those which a sculptor has to face . . . A sculpture must have its own life. Rather than give the impression of a smaller object carved out of a bigger block, it should make the observer feel that what he is seeing contains within itself its own organic energy thrusting outwards – if a work of sculpture has its own life and form, it will be alive and expansive, seeming larger than the stone or wood from which it is carved. It should always give the impression, whether carved or modelled, of having grown organically, created by pressure from within. [1960/Bibl. 45].

You see, I think a sculptor is a person who is interested in the shape of things. A poet is somebody who is interested in words; a musician is someone who is interested in or obsessed by sounds. But a sculptor is a person obsessed with the form and the shape of things, and it's not just the shape of any one thing, but the shape of anything and everything: the growth in a flower; the hard, tense strength, although delicate form of a bone; the strong, solid fleshiness of a beech tree trunk. All these things are just

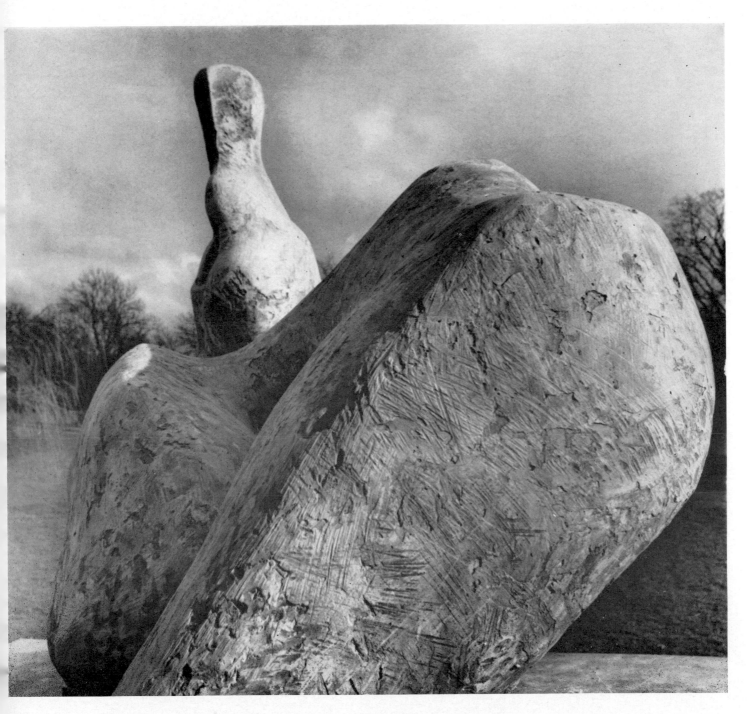

15 TWO-PIECE RECLINING FIGURE NO. 5 (*detail*), *1963–64. Plaster for bronze, l. 147 in. This piece and the plaster for the* Nuclear Energy Sculpture (**16**) *both illustrate Moore's use of carving tools on a form to be cast in bronze.*

as much a lesson to a sculptor as a pretty girl – as a young girl's figure – and so on. They're all part of the experience of form and therefore, in my opinion, everything, every shape, every bit of natural form, animals, people, pebbles, shells, anything you like are all things that can help you to make a sculpture. And for me, I collect odd bits of driftwood – anything I find that has a shape that interests me – and keep it around in that little studio so that if any day I go in there, or evening, within five or ten minutes of being in that little room there will be something that I can pick up or look at that would give me a start for a new idea. This is why I like leaving all these odds and ends around in a small studio – to start one off with an idea (**46**).

One of the things I would like to think my sculpture has is a force, is a strength, is a life, a vitality from inside it, so that you have a sense that the form is pressing from inside trying to burst or trying to give off the strength from inside itself, rather than having something which is just shaped from outside and stopped. It's as though you have something trying to make itself come to a shape from inside itself. This is, perhaps, what makes me interested in bones as much as in flesh because the bone is the inner structure of all living form. It's the bone that pushes out from inside; as you bend your leg the knee gets tautness over it, and it's there that the movement and the energy come from. If you clench a knuckle, you clench a fist, you get in that sense the bones, the knuckles pushing through, giving a force that if you open your hand and just have it relaxed you don't feel. And so the knee, the shoulder, the skull, the forehead, the part where from inside you get a sense of pressure of the bone outwards – these for me are the key points.

You can then, as it were, between those key points have a slack part, as you might between the bridge of a drapery and the hollow of it, so that in this way you get a feeling that the form is all inside it, and this is what also makes me think that I prefer hard form to soft form. For me, sculpture should have a hardness, and because I think sculpture should have a hardness fundamentally I really like carving better than I like modelling. Although I do bronzes, I make the original which is turned into bronze in plaster, and although anyone can build a plaster up as soft mixture, that mixture hardens and I then file it and chop it (**15** and **16**) and make it have its final shape as hard plaster, not as a soft material. [1964/Bibl. 6].

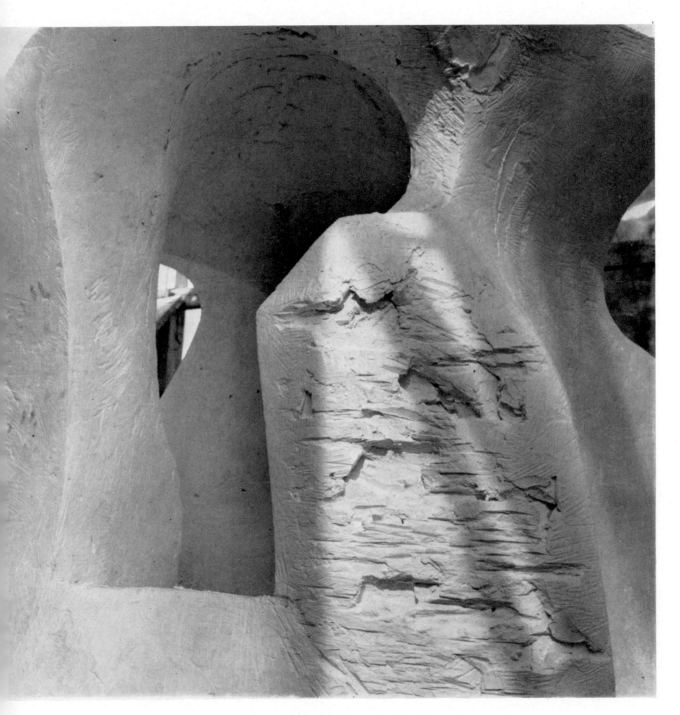

16 NUCLEAR ENERGY SCULPTURE (*detail*), *1964–65. Plaster for bronze, h. 144 in.*

The sculptor speaks

It is a mistake for a sculptor or a painter to speak or write very often about his job. It releases tension needed for his work. By trying to express his aims with rounded-off logical exactness, he can easily become a theorist whose actual work is only a caged-in exposition of conceptions evolved in terms of logic and words.

But though the non-logical, instinctive, subconscious part of the mind must play its part in his work, he also has a conscious mind which is not inactive. The artist works with a concentration of his whole personality, and the conscious part of it resolves conflicts, organises memories, and prevents him from trying to walk in two directions at the same time.

It is likely, then, that a sculptor can give, from his own conscious experience, clues which will help others in their approach to sculpture, and this article tries to do this, and no more. It is not a general survey of sculpture, or of my own development, but a few notes on some of the problems that have concerned me from time to time.

Appreciation of sculpture depends upon the ability to respond to form in three dimensions. That is perhaps why sculpture has been described as the most difficult of all arts; certainly it is more difficult than the arts which involve appreciation of flat forms, shape in only two dimensions. Many more people are 'form-blind' than colour-blind. The child learning to see, first distinguishes only two-dimensional shape; it cannot judge distances, depths. Later, for its personal safety and practical needs, it has to develop (partly by means of touch) the ability to judge roughly three dimensional distances. But having satisfied the requirements of practical necessity, most people go no farther. Though they may attain considerable accuracy in the perception of flat form, they do not make the further intellectual and emotional effort needed to comprehend form in its full spatial existence.

This is what the sculptor must do. He must strive continually to think of, and use, form in its full spatial completeness. He gets the solid shape, as it were, inside his head – he thinks of it, whatever its size, as if he were holding it completely enclosed in the hollow of his hand. He mentally visualises a complex form from all round itself; he knows while he looks at one side what the other side is like; he identifies himself with its centre of gravity, its mass, its weight; he realises

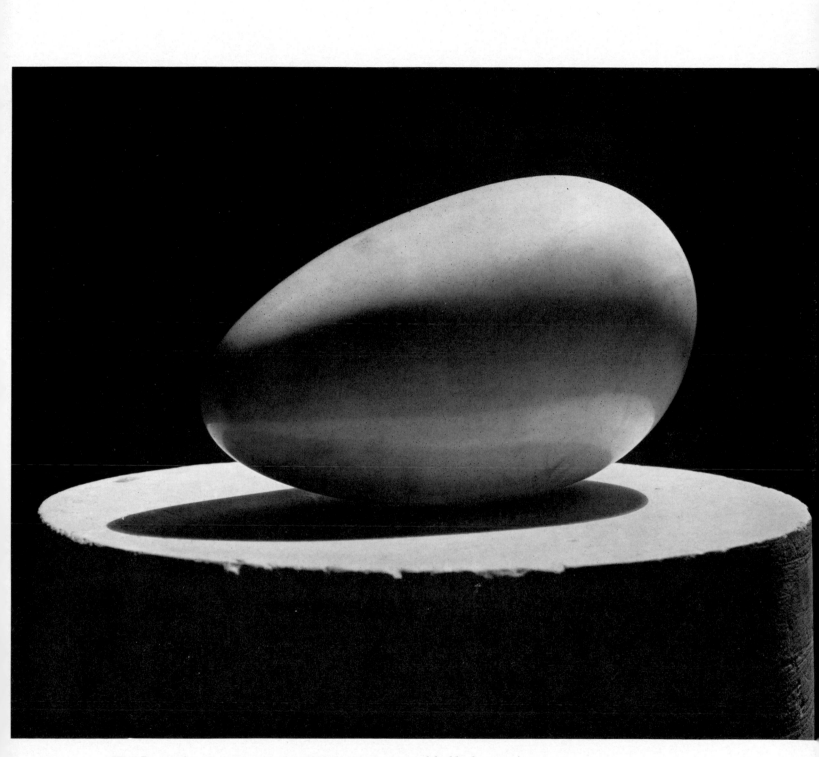

17 *Brancusi.* THE BEGINNING OF THE WORLD, *1924. Marble 6 × 12 in.*
Philadelphia Museum of Art (Louise and Walter Arensberg Collection).

its volume, as the space that the shape displaces in the air.

And the sensitive observer of sculpture must also learn to feel shape simply as shape, not as description or reminiscence. He must, for example, perceive an egg as a simple single solid shape, quite apart from its significance as food, or from the literary idea that it will become a bird. And so with solids such as a shell, a nut, a plum, a pear, a tadpole, a mushroom, a mountain peak, a kidney, a carrot, a tree-trunk, a bird, a bud, a lark, a lady-bird, a bulrush, a bone. From these he can go on to appreciate more complex forms or combinations of several forms.

Since the Gothic, European sculpture had become overgrown with moss, weeds – all sorts of surface excrescences which completely concealed shape. It has been Brancusi's special mission to get rid of this overgrowth, and to make us once more shape-conscious. To do this he has had to concentrate on very simple direct shapes, to keep his sculpture, as it were, one-cylindered, to refine and polish a single shape to a degree almost too precious (**17**). Brancusi's work, apart from its individual value, has been of historical importance in the development of contemporary sculpture. But it may now be no longer necessary to close down and restrict sculpture to the single (static) form unit. We can now begin to open out. To relate and combine together several forms of varied sizes, sections and directions into one organic whole.

Although it is the human figure which interests me most deeply, I have always paid great attention to natural forms, such as bones, shells, and pebbles, etc. Sometimes for several years running I have been to the same part of the sea-shore – but each year a new shape of pebble has caught my eye, which the year before, though it was there in hundreds, I never saw. Out of the millions of pebbles passed in walking along the shore, I choose out to see with excitement only those which fit in with my existing form-interest at the time. A different thing happens if I sit down and examine a handful one by one. I may then extend my form-experience more, by giving my mind time to become conditioned to a new shape.

There are universal shapes to which everybody is sub-consciously conditioned and to which they can respond if their conscious control does not shut them off.

Pebbles show nature's way of working stone. Some of the pebbles I pick up have holes right through them (**18**).

When first working direct in a hard and brittle material like stone, the lack of experience and great respect for the material, the fear of ill-treating it, too often result in relief surface carving, with no sculptural power.

But with more experience the completed work in stone can be kept within the limitations of its material, that is, not be weakened beyond its natural constructive

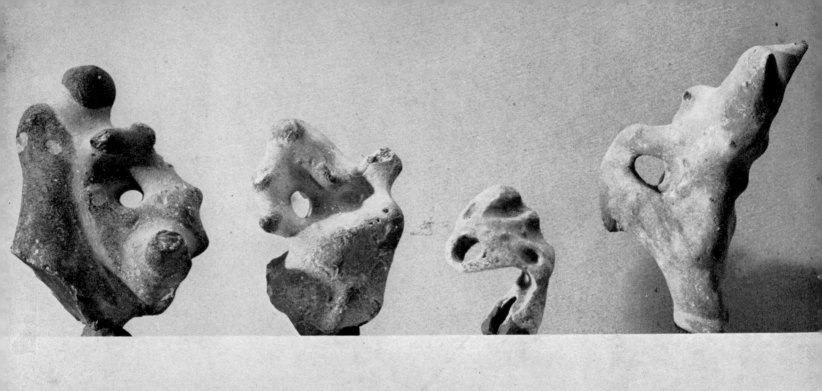

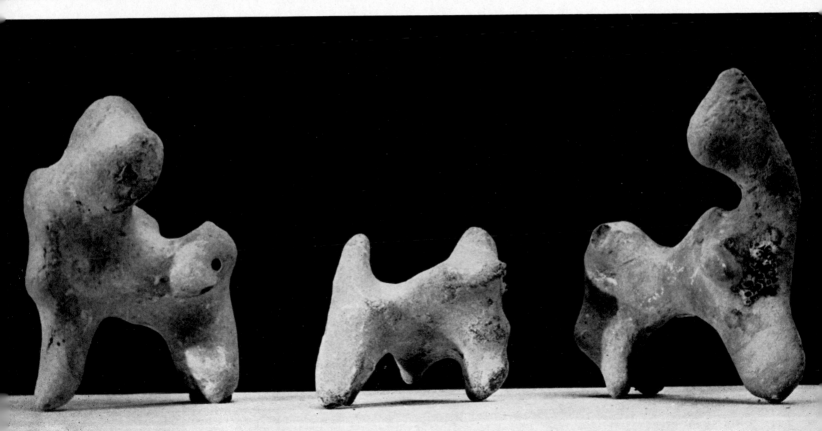

18 FOUR FLINTS *in the artist's studio. The stone on the extreme left may be compared with the head of the King in the* King and Queen *group (**101**). It can again be seen as a mother and child.*

19 THREE FLINTS *in the artist's studio. There are visual memories of these in the* Two-Piece Reclining Figures Nos. *1 and 2 (**117** and **122**).*

build, and yet be turned from an inert mass into a composition which has a full form existence, with masses of varied sizes and sections working together in spatial relationship.

A piece of stone can have a hole through it and not be weakened – if the hole is of studied size, shape and direction. On the principle of the arch, it can remain just as strong.

The first hole made through a piece of stone is a revelation.

The hole connects one side to the other, making it immediately more three-dimensional.

A hole can itself have as much shape-meaning as a solid mass.

Sculpture in air is possible, where the stone contains only the hole, which is the intended and considered form.

The mystery of the hole – the mysterious fascination of caves in hillsides and cliffs.

There is a right physical size for every idea.

Pieces of good stone have stood about my studio for long periods, because though I've had ideas which would fit their proportions and materials perfectly, their size was wrong.

There is a size to scale not to do with its actual physical size, its measurement in feet and inches – but connected with vision.

A carving might be several times over life size and yet be petty and small in feeling – and a small carving only a few inches in height can give the feeling of huge size and monumental grandeur, because the vision behind it is big. Example, Michelangelo's drawings or a Masaccio madonna – and the Albert Memorial.

Yet actual physical size has an emotional meaning. We relate everything to our own size, and our emotional response to size is controlled by the fact that men on the average are between five and six feet high.

An exact model to 1/10 scale of Stonehenge, where the stones would be less than us, would lose all its impressiveness.

Sculpture is more affected by actual size considerations than painting. A painting is isolated by a frame from its surroundings (unless it serves just a decorative purpose) and so retains more easily its own imaginary scale.

If practical considerations allowed me, cost of material, of transport etc., I should like to work on large carvings more often than I do. The average in-between size does not disconnect an idea enough from prosaic everyday life. The very small or the very big takes on an added size emotion.

Recently I have been working in the country, where, carving in the open air, I

find sculpture more natural than in a London studio, but it needs bigger dimensions. A large piece of stone or wood placed almost anywhere at random in a field, orchard or garden immediately looks right and inspiring (**14**).

My drawings are done mainly as a help towards making sculpture – as a means of generating ideas for sculpture, tapping oneself for the initial idea; and as a way of sorting out ideas and developing them.

Also, sculpture compared with drawing is a slow means of expression, and I find drawing a useful outlet for ideas which there is not time enough to realise as sculpture. And I use drawing as a method of study and observation of natural forms (drawings from life, drawings of bones, shells etc.).

And I sometimes draw just for its own enjoyment.

Experience, though, has taught me that the difference there is between drawing and sculpture should not be forgotten. A sculptural idea which may be satisfactory as a drawing always needs some alteration when translated into sculpture.

At one time whenever I made drawings for sculpture I tried to give them as much the illusion of real sculpture as I could – that is, I drew by the method of illusion, of light falling on a solid subject. But I now find that carrying a drawing so far that it becomes a substitute for the sculpture, either weakens the desire to do the sculpture, or is likely to make the sculpture only a dead realisation of the drawing.

I now leave a wider latitude in the interpretation of the drawings I make for sculpture, and draw often in line and flat tones without the light and shade illusion of three dimensions; but this does not mean that the vision behind the drawing is only two dimensional (**49**).

The violent quarrel between the abstractionists and the surrealists seems to me quite unnecessary. All good art has contained both abstract and surrealist elements, just as it has contained both classical and romantic elements – order and surprise, intellect and imagination, conscious and unconscious. Both sides of the artists's personality must play their part. And I think the first inception of a painting or a sculpture may begin from either end. As far as my own experience is concerned, I sometimes begin a drawing with no preconceived problem to solve, with only the desire to use pencil on paper, and make lines, tones and shapes with no conscious aim; but as my mind takes in what is so produced, a point arrives where some idea becomes conscious and crystallises, and then a control and ordering begin to take place.

Or sometimes I start with a set subject; or to solve, in a block of stone of known dimensions, a sculptural problem I've given myself, and then consciously attempt to

build an ordered relationship of forms, which shall express my idea. But if the work is to be more than just a sculptural exercise, unexplainable jumps in the process of thought occur; and the imagination plays its part.

It might seem from what I have said of shape and form that I regard them as ends in themselves. Far from it. I am very much aware that associational, psychological factors play a large part in sculpture. The meaning and significance of form itself probably depends on the countless associations of man's history. For example, rounded forms convey an idea of fruitfulness, maturity, probably because the earth, women's breasts, and most fruits are rounded, and these shapes are important because they have this background in our habits of perception. I think the humanist organic element will always be for me of fundamental importance in sculpture, giving sculpture its vitality. Each particular carving I make takes on in my mind a human or occasionally animal, character and personality, and this personality controls its design and formal qualities, and makes me satisfied or dissatisfied with the work as it develops.

My own aim and direction seems to be consistent with these beliefs, though it does not depend upon them. My sculpture is becoming less representational, less an outward visual copy, and so what some people would call more abstract; but only because I believe that in this way I can present the human psychological content of my work with the greatest directness and intensity. [1937/Bibl. 24].

68

Unit One[1]

Each sculptor through his past experience, through observation of natural laws, through criticism of his own work and other sculpture, through his character and psychological make-up, and according to his stage of development, finds that certain qualities in sculpture become of fundamental importance to him. For me these qualities are:

Truth to material. Every material has its own individual qualities. It is only when the sculptor works direct, when there is an active relationship with his material, that the material can take its part in the shaping of an idea. Stone, for example, is hard and concentrated and should not be falsified to look like soft flesh – it should not be forced beyond its constructive build to a point of weakness. It should keep its hard tense stoniness.[2]

Full three-dimensional realisation. Complete sculptural expression is form in its full spatial reality.

Only to make relief shapes on the surface of the block is to forego the full power of expression of sculpture. When the sculptor understands his material, has a knowledge of its possibilities and its constructive build, it is possible to keep within its limitations and yet turn an inert block into a composition which has a full form-existence, with masses of varied size and section conceived in their air-surrounded entirety, stressing and straining, thrusting and opposing each other in spatial relationship – being static, in the sense that the centre of gravity lies within the base (and does not seem

1. The group called *Unit One* was founded in 1933 by Paul Nash. The name combines, in the words of Herbert Read who edited the book with the same title from which this statement by Moore is taken, 'the idea of unity – Unit – with that of individuality – One.' The original members were John Armstrong, John Bigge, Edward Burra, Barbara Hepworth, Tristam Hillier, Henry Moore, Paul Nash, Ben Nicholson, Edward Wadsworth and the architects Wells Coates and Colin Lucas. The group held an exhibition in 1934 at the Mayor Gallery.
2. For the sculptor's more recent views on 'Truth to material' see p. 113.

to be falling over or moving off its base) – and yet having an alert dynamic tension between its parts.

Sculpture fully in the round has no two points of view alike. The desire for form completely realised is connected with asymmetry. For a symmetrical mass being the same from both sides cannot have more than half the number of different points of view possessed by a non-symmetrical mass.

Asymmetry is connected also with the desire for the organic (which I have) rather than the geometric.

Organic forms though they may be symmetrical in their main disposition, in their reaction to environment, growth and gravity, lose their perfect symmetry.

Observation of Natural Objects. The observation of nature is part of an artist's life, it enlarges his form-knowledge, keeps him fresh and from working only by formula, and feeds inspiration.

The human figure is what interests me most deeply, but I have found principles of form and rhythm from the study of natural objects such as pebbles, rocks, bones, trees, plants, etc.

Pebbles and rocks show nature's way of working stone. Smooth, sea-worn pebbles show the wearing away, rubbed treatment of stone and principles of asymmetry.

Rocks show the hacked, hewn treatment of stone, and have a jagged nervous block rhythm.

Bones have marvellous structural strength and hard tenseness of form, subtle transition of one shape into the next and great variety in section (**20**).

Trees (tree trunks) show principles of growth and strength of joints, with easy passing of one section into the next. They give the ideal for wood sculpture, upward twisting movement.

Shells show nature's hard but hollow form (metal sculpture) and have a wonderful completeness of single shape (**21**).[1]

1. In one notable sculpture, *Reclining Figure (external form)* 1953, Moore creates the image of a mother as a shell without the interior form or child (see bibl. 42 pls. 28–28e). There is a striking similarity of thought in the following passage from Hogarth's *Analysis of Beauty*, 1753: 'Let every object under our consideration be imagined to have its inward contents scooped out so nicely as to have nothing of it left but a thin shell, exactly the shape of the object itself . . . The very word shell makes us seem to see both surfaces alike . . . because the imagination will naturally enter into the vacant space within the shell, and there at once, as from a centre, view the whole form within, and mark the opposite corresponding parts so strongly as to retain the idea of the whole, and make us masters of the meaning of every view of the object as we walk round it and view it from without.'

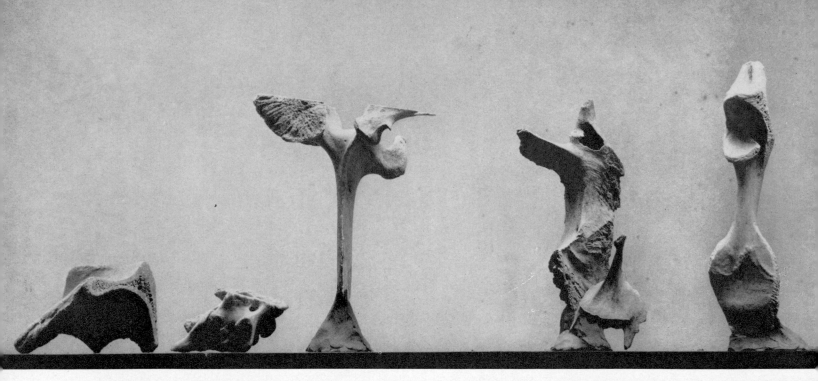

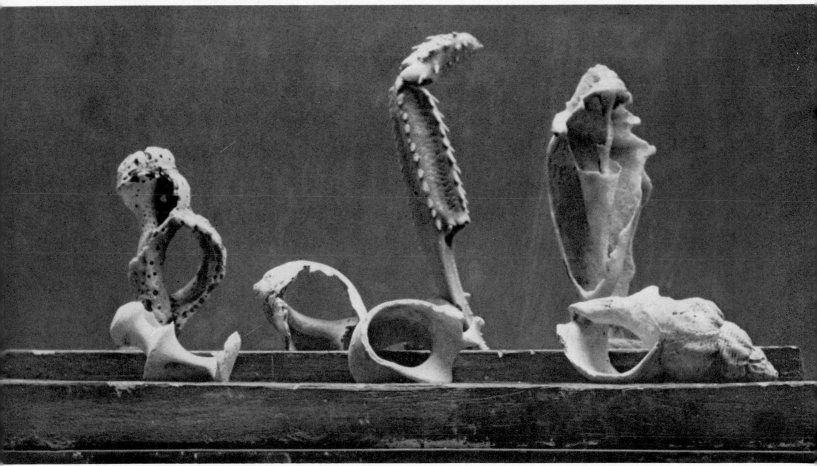

20 BONES. *Moore's interest in the shape of bones is reflected with particular clarity in two of his recent works, the* Locking-Piece (**48**), *and the* Standing Figure *(Knife-Edge) with which the second bone from the right may be compared* (**127**).

21 SHELLS *in the artist's studio.*

There is in nature a limitless variety of shapes and rhythms (and the telescope and microscope have enlarged the field) from which the sculptor can enlarge his form-knowledge experience.

But besides formal qualities there are qualities of vision and expression:

Vision and expression. My aim in work is to combine as intensely as possible the abstract principles of sculpture along with the realisation of my idea.

All art is an abstraction to some degree (in sculpture the material alone forces one away from pure representation and towards abstraction).

Abstract qualities of design are essential to the value of a work, but to me of equal importance is the psychological, human element. If both abstract and human elements are welded together in a work, it must have a fuller, deeper meaning.

Vitality and power of expression. For me a work must first have a vitality of its own. I do not mean a reflection of the vitality of life, of movement, physical action, frisking, dancing figures and so on, but that a work can have in it a pent-up energy, an intense life of its own, independent of the object it may represent. When a work has this powerful vitality we do not connect the word Beauty with it.

Beauty, in the later Greek or Renaissance sense, is not the aim of my sculpture.

Between beauty of expression and power of expression there is a difference of function. The first aims at pleasing the senses, the second has a spiritual vitality which for me is more moving and goes deeper than the senses.

Because a work does not aim at reproducing natural appearances it is not, therefore, an escape from life – but may be a penetration into reality, not a sedative or drug, not just the exercise of good taste, the provision of pleasant shapes and colours in a pleasing combination, not a decoration to life, but an expression of the significance of life, a stimulation to a greater effort in living. [1934/Bibl. 40].

Circle[1]

1. I dislike the idea that contemporary art is an escape from life. Because a work does not aim at reproducing the natural appearance it is not therefore an escape from life – it may be penetrating into reality; not a sedative or drug, not just the exercise of good taste, the provision of pleasant shapes and colours in a pleasing combination, not a decoration to life – but an expression of the significance of life, a stimulation to greater effort in living.

2. Architecture and sculpture are both dealing with the relationship of masses. In practice architecture is not pure expression but has a functional or utilitarian purpose, which limits it as an art of pure expression. And sculpture, more naturally than architecture, can use organic rhythms. Aesthetically architecture is the abstract relationship of masses. If sculpture is limited to this, then in the field of scale and size architecture has the advantage; but sculpture, not being tied to a functional and utilitarian purpose, can attempt much more freely the exploration of the world of pure form [1937/Bibl. 4].

1. The only issue of what was intended to be an annual volume on international constructive art, edited by Leslie Martin, Ben Nicholson and Naum Gabo. Preparations for it began in 1935 at the time of the appearance of the first issue of *Axis*, a quarterly review of abstract art. For a full documentation of the literature and exhibitions in this vital and productive period in the mid-thirties see *Art in Britain 1930–40*, the catalogue of an exhibition held in March–April 1965 at the Marlborough and New London Galleries; see also the article *Back in the thirties* by Myfanwy Piper, editor of *Axis*, in *Art and Literature*, No. 7, Winter 1965, pp. 136–162.

Notes from a sketchbook

XVIII Dynasty Egyptian – Head of a woman (princess?) in the Archaeological Museum, Florence.

I would give everything if I could get into my sculpture the same amount of humanity and seriousness; nobility and experience, acceptance of life, distinction and aristocracy. With absolutely no tricks, no affectation, no self-consciousness, looking straight ahead, no movement, but more alive than a real person.

The great, the continual, everlasting problem (for me) is to combine sculptural form (POWER) with human sensibility and meaning i.e. to try to keep Primitive Power with humanist content. Not to bother about stone sculpture versus modelling – bronze versus plaster construction, welding etc. – but finding the common essentials in all kinds of sculpture. [1958/Bibl. 32].

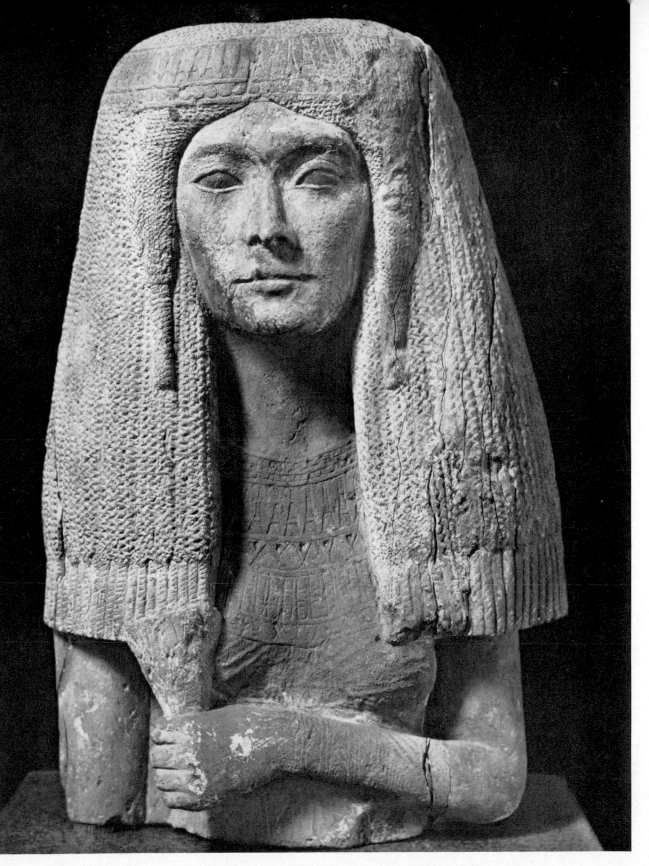

22 BUST OF A WOMAN. *Egyptian, 18th dynasty*. Museo Archeologico, Florence.

Art and life

Part of a discussion between V. S. Pritchett, Graham Sutherland,
Sir Kenneth Clark and Henry Moore

V. S. Pritchett: In the last discussion of this series there was one point which rather bothered me; Bell seemed to be longing for an artist to paint air-raid damage without expressing any human emotion – exactly as if he were Canaletto painting buildings which had been ruined centuries ago. When we spoke of literature, Read seemed at one point to have something very much like the same sort of view. Sutherland, you have done a good many pictures of war damage; do you approach your subject in this way?

Graham Sutherland: I can't say that I do. It's the force of the emotion in the presence of such a subject which determines and moulds the pictorial form that one chooses. The kind of emotion which one feels may vary. For instance, the forms of ruin produced by a high explosive force have a character of their own, but the effect which they have on one's emotions will vary according to one's mood. One day one will feel moved by the purely explosive character of one's subject and wish to get rid of this sensation in a picture. At another time, the sordidness and the anguish implied by some of these scenes of devastation will cause one to invent forms which are the pictorial essence of sordidness and anguish – dirty-looking forms, tormented forms, forms which take on an almost human aspect, forms, in fact, which are symbols of reality, and tragic reality at that. In either case, the point is, I think, that the forms which the artist creates, according to his inner capacity, will transcend natural appearances. To quote Maritain, such an art will re-compose its peculiar world with that poetical reality which resembles things in a far more profound and mysterious way than any direct evocation could possibly do.

Sir Kenneth Clark: Yes, of course, Sutherland, your pictures of war damage and Moore's shelter drawings are rather peculiar in modern art in that you had a really

moving tragic subject which is within the range of almost anyone's experience. It hasn't been common in painting for the last fifty years or so for an artist to treat such subjects, and he had to express his feelings about life less directly – in landscape, shall we say, or in still life. I suppose Delacroix was almost the last painter who could deal successfully with a great dramatic subject – except perhaps Rouault. One can't go into the reasons without telling the whole story of nineteenth-century painting; but there it is. And I suppose Picasso's great tragic symbolic picture of Guernica marks pretty clearly and appropriately the end of the nineteenth-century tradition.

Pritchett: You seem to be assuming, Clark, that art is concerned with ordinary human emotions about life. But as you said just now, Bell seemed to take an entirely opposite view.

Clark: Yes, I know I did and I confess I read Bell's remarks with a kind of incredulous respect – what one feels for someone else's religion. Well, I must come clean, I suppose, and confess that I think art has everything to do with life; it is, if one can venture a sort of definition, a concentration of human emotions and experiences communicated in a controlled and intelligible manner through an appropriate medium.

Pritchett: Well, that's started hares enough to give us plenty of exercise, I think. Moore, some of your work looks to the average man, I should say, fairly remote from human experience.

Henry Moore: What you mean, I take it, Pritchett, is that the average man, who's got very little time to look at sculpture and painting, looking at sculpture such as mine, would find such work puzzling and strange. I think this is natural, because for over twenty years I, like most artists, have been thinking all day long about sculpture and painting, and if after all that I can only produce something which the average man, who has very little time to think about it, would immediately recognise as something he would have done if he'd had the technical experience, then I think that my time would not have been very profitably spent. I think that is true of the past too, and that all good art demands an effort from the observer, and he should demand that it extends his experiences of life.

Clark: Yes, but, Moore, there is this difference in the past – that up to about 1830,

the patrons of art were in much closer touch with the artists and themselves had a tradition of taste and of understanding, so that they could follow an artist's new inventions and changes of direction much more easily than the average man nowadays, who visits an exhibition only two or three times a year, if that.

Moore: To come back to the other point: I agree that artists being human beings, human experience is the only experience we have got to work from. Even the most abstract artists of all who want to divorce their work from any representational element, when they want to show that their work is more than design or pleasant decoration have to use analogies to Greek skies or effects like deer passing through woods, and when they do this, they seem to me to admit that they can't get away from associations with life.

Pritchett: Then do you think that an art, as it succeeds in becoming abstract, loses its value?

Moore: No, I think abstract art is valuable. It teaches people the language of painting. In my own work I have produced carvings which perhaps might seem to most people purely abstract. This means that in those works I have been mainly concerned to try to solve problems of design and composition. But these carvings have not really satisfied me because I have not had the same sort of grip or hold over them that I have as soon as a thing takes on a kind of organic idea. And in almost all my carvings there has been an organic idea in my mind. I think of it as having a head, body, limbs, and as the piece of stone or wood I carve evolves from the first roughing-out stages it begins to take on a definite human personality and character. From then on one begins to be critical – satisfied or dissatisfied with its progress – in a deeper way than from only a sense of pleasant shape or formal design, and a more active relationship gets going, which calls upon the same sort of feelings one has about people in real life. And to bring the work to its final conclusion involves one's whole psychological make-up and whatever one can draw upon and make use of from the sum total of one's human and form experience.

Pritchett: So in all your work, even the most abstract, there is ultimately some human reference, both to the forms of the human body and to the emotions. Now Sutherland, do you think that can be applied to landscape.

78

Clark: Before Sutherland answers from the landscape-painter's point of view, I would like to give the historical point of view, I mean the point of view of the artist, because it is relevant I think. And that is that the art of landscape did develop comparatively recently in the history of painting precisely because it took a long time for the old painters to realise that landscape could be made to express all the qualities of moral grandeur and human destiny and so forth, which they thought a great picture ought to contain. I do believe that great landscapes must be painted with a pervading sense of human values; they can't be just records of a tract of country, but of the emotions which that particular scene allows the painter to express. That's why, to my mind, a painter must know his landscape intimately. He must belong to it, and it to him. And the idea that an English painter can take a holiday in Provence and paint a great landscape there seems to be a complete fallacy.

Sutherland: I thoroughly agree with Clark about the English painter in Provence. A painter must be part of his landscape to find the best in it. As the ground reflects sky, and sea reflects land, each appearing to be part of the other, so must the painter learn to recognise himself, as it were, both materially and spiritually in the landscape and the landscape in himself.

Clark: Yes, in a way it's a Wordsworthian relationship with nature, isn't it?

Moore: Yes, Wordsworth often personified objects in nature and gave them the human aspect, and personally I have done rather the reverse process in sculptures. I've often found that by taking formal ideas from landscape, and putting them into my sculpture I have, as it were, related a human figure to a mountain, and so got the same effect as a metaphor in painting.

Sutherland: Yes, I thoroughly agree about that. Personally I find that practically all the figurative elements are contained in landscapes. In a sense the landscape painter must almost look at the landscape as if it were himself – himself as a human being. As a landscape painter goes on with increased experience of his subject he will tend to find that the forms and qualities which start him off, excite his ideas and stimulate his emotions, are the more rare and hidden forms. And I'm interested in looking at landscapes in this way, so that the impact of the hidden forms develops in my mind. Later again I feel the necessity to break the whole thing up, break up the whole elements of landscape, separate all these elements. Then out of that reservoir, I find

that certain elements leave a decided and permanent mark on my enthusiasm and on my excitement, and form in themselves subjects for pictures. Thus follow forms which, because of the excitement connected with their discovery, assume in their pictorial essence what one might call a certain strangeness.

Clark: Yes, Sutherland, I'm sure that is one reason why some people might find your pictures rather hard to understand, but I believe there's another reason why all good artists, or nearly all good artists, seem to distort, or at any rate to re-arrange nature. And that is, in addition to his feelings about life and what he sees, every artist has inside him a few controlling rhythms, so to say, and those controlling rhythms are really him, and it's to those he has to make his vision of the external world conform, if he is to make it truly expressive. I would say that even the greatest artists have quite few forms, or rhythms or chords of colour, whichever it may be, which they feel to be completely expressive. Take two of the greatest draughtsmen who have ever lived – Leonardo and Michelangelo; well, Leonardo used the same forms – the same poses and gestures – the figure pointing back over its shoulder and so forth in his very first work that he did in his last. And as to Michelangelo, there's an amusing instance – he drew a figure of Tityus lying on a rock, and the form pleased him, so he turned the paper over and he traced the figure through and made it into a Christ rising from the tomb. Thus showing that even for Michelangelo a really coherent and expressive form wasn't a thing to be wasted.

Moore: I agree that everyone has a sort of individual form vision. In all the greatest artists the seeds of this form vision has been present even in their early work, and to some extent their work has been a gradual unfolding of this rhythm throughout. In their later work it becomes more concentrated, that's all. It's something the artist can't control – it's his make-up. All the same I think that he ought not to go on repeating it, he ought to be fighting against it. He ought not to sell himself his own idea over and over again. Or it should become so instinctive in him that he's not worried about it. In Michelangelo it was so instinctive that he was free to think about the other things that interested him. The less conscious you are of your own individual form rhythm, the more likely it is, I think, to get richer and fuller and develop.

Sutherland: I should say that this inner life which we've been talking about must be constantly refreshed by visual experience. A painter cannot create out of nothing, as it were, so he must be continually gathering material from his experience of things

seen. If he fails to nourish these conceptual ideas by familiarising himself with the ways of nature he will dry up and fail to produce. But I feel that it is always the idea of nature, transcending nature and forming reconstructed and recreated images, via the heart and mind of the artist which is the thing that is worth while.

Clark: I'm not much impressed with the claim that an artist may have an inner life which is incomprehensible to everybody. We are members one of another. But it is true that certain of the greatest artists have made great leaps ahead of their contemporaries, and for a time only a few people have been able to follow them.

Pritchett: Wouldn't you say that in the last few years the artists have made greater leaps ahead of their contemporaries than ever before – or at least that some artists have been painting further away from ordinary visual experience than ever was known in the history of the past?

Clark: Yes, I think that by and large that is true, and there seem to me to be two reasons for it. One is that just as language can be degraded by popular use and thoughtless use, so the realism of the nineteenth century degraded the realistic style of painting till it became like the lowest form of journalese, and then some violent form of purification became necessary, and that form of purification was the abstract movement. And the second reason is that as the painter became more and more cut off from his patrons and began to paint for himself, and for a few friends, a few fellow artists, so he became more interested in specialised problems of picture-making, design and composition, and in the realising of his own inner vision and he didn't try to carry with him the section of informed opinion that had previously constituted his body of patrons.

Sutherland: I thoroughly agree with that. Then I think there's also the effect of photography. I think that's had a very definite effect on painters, because people have been made much more familiar with appearances. Painters are always feeling the need for experiment, and the need for working away from known facts, and therefore the photograph has done away with three-quarters of what they were originally asked and what they originally set out to do.

Pritchett: Do you mean that the main purpose of the artist up to the invention of photography was in fact imitation?

Moore: That would be, I think, to take too narrow a view. There have been other times at which it has not been the first aim of the artists to reproduce the visible world. In fact, if you took the whole history of art, you would find that artists have only made the representation of the visible world their chief aim for a relatively short time, round about the Mediterranean countries. I think one of the main difficulties people have over so-called modern art is that they don't know enough about the whole history of the world's art.

Pritchett: Yes, I agree. But isn't is possible that all the so-called 'primitive' art in the world doesn't imitate nature simply because the artists were not capable of doing so?

Moore: I think it couldn't have been their chief aim at all these times, because once it did become their chief aim, as with the Greeks, within a hundred years they had achieved an almost perfect representation of human form. And it's not that they didn't have technical skill enough, because the degree of technical skill in what used to be called 'primitive' arts – that is to say, non-representational arts – is very high indeed.

Pritchett: If you say the chief aim was not representational in this sense, then what do you think it was?

Clark: Well, let's say for the sake of argument that all art in its beginning is concerned with religion or at any rate with the magical nature of imaginative experience. The Greeks, who thought of their gods as looking like human beings, developed an art in which there was naturally a very close representation of nature, and of human beings, but in other civilisations, where the religion was more mysterious, the art was more symbolic. Art had to employ more abstract symbols.

Pritchett: And what's a symbol in this sense?

Clark: Let's say the pictorial equivalent of an idea.

Pritchett: Well, there's another question that I'd like to ask, and that concerns the relation of the artist and society. Do you think that there is a sense in which an artist reflects the society which has produced him? He may be expressing himself, of course, but isn't he also society expressing itself? If this is so, it ought to follow, I think, that

the best art will arise at a time when relationship between the artist and society is most vital and mutually refreshing.

Clark: Yes, the artist cannot escape from his time. He cannot fail to reflect the society that produced him. Even if he thinks that he has chosen to live, as the saying goes 'in an ivory tower', that's probably only because his digestion is too weak to allow him to assimilate contemporary life or perhaps because the society of his time is so disintegrated as to be incapable of assimilation. Recent art really has shown very clearly the conflict and the lack of unity of purpose in recent society. But there are also in art more subtle reflections of social and intellectual currents as – to take rather an erudite instance – when Correggio, by shifting the vanishing point of his perspective outside the picture frame, seemed to anticipate the Copernican revolution. [1941/Bibl. 16].

The sculptor in modern society

I have been asked to address you as a sculptor and it might therefore be appropriate if I began by trying to give you some idea of my own attitude to the art I practise. Why have I chosen to be a sculptor, or why has the art of sculpture chosen me as an exponent of its special aims? If I can answer that question satisfactorily I may be in a better position to answer some of the specific questions which are before this conference.

Some become sculptors because they like using their hands, or because they love particular materials, wood or stone, clay or metal and like working in those materials – that is they like the craft of sculpture – I do. But beyond this one is a sculptor because one has a special kind of sensibility for shapes and forms, in their solid physical actuality. I feel that I can best express myself, that I can best give outward form to certain inward feelings or ambitions by the manipulation of solid materials – wood, stone, or metal. The problems that arise in the manipulation of such materials, problems of mass and volume, of light in relation to form and of volume in relation to space, the problem of continually learning to grasp and understand form more completely in its full spatial reality, all these are problems that interest me as an artist and which I believe I can solve by cutting down, building up or welding together solid three-dimensional materials.

But what is my purpose in such activity? It might, of course, be merely a desire to amuse myself, to kill time or create a diversion. But then I should not find it necessary, as I do, to exhibit my sculpture publicly, to hope for its sale and for its permanent disposition either in a private house, a public building or an open site in a city. My desire for such a destination for my work shows that I am trying, not merely to express my own feelings or emotions for my own satisfaction, but also to communicate those feelings or emotions to my fellow men. Sculpture, even more than painting (which generally speaking, is restricted to interiors) is a public art, and for that reason I am at once involved in those problems which we have met here to discuss – the relation of the artist to society – more particularly, the relation of the artist to the particular form of society which we have at this moment of history.

There have been periods – periods which we would like to regard as ideal proto-

84

types of society – in which that relationship was simple. Society had a unified struc-ture, whether communal or hierarchic, and the artist was a member of that society with a definite place and a definite function. There was a universal faith, and an accepted interplay of authority and function which left the artist with a defined task, and a secure position. Unfortunately our problems are not simplified in that way. We have a society which is fragmented, authority which resides in no certain place, and our function as artists is what we make it by our individual efforts. We live in a transitional age, between one economic structure of society which is in dissolution and another economic order of society which has not yet taken definite shape. As artists we do not know who is our master; we are individuals seeking patronage, sometimes from another individual, sometimes from an organisation of individuals – a public corporation, a museum, an educational authority – sometimes from the State itself. This very diversity of patronage requires, on the part of the modern artist, an adaptability or agility that was not required of the artist in a unified society.

But that adaptability is always in a vertical direction, always within a particular craft. One of the features of our industrialised society is specialisation – the division of labour. This tendency has affected the arts, so that a sculptor is expected to stick to his sculpture, a painter to his painting. This was not always so. In other ages – the Middle Ages and the Renaissance, to mention only European examples – the artist's talent was more general, and he would turn his hand now to metalwork or jewellery, now to sculpture, now to painting or engraving. He might not be equally good in all these media, and it is possible, that we have discovered good reasons for confining our talents within narrower bounds. There are certainly painters who would never be capable of creating convincing works of art in three-dimensional forms, just as there are sculptors who could not convey the illusion of three-dimensional space on a two-dimensional surface. We know now that there are specific kinds of sensibility, belong-ing to distinct psychological types, and for that reason alone a certain degree of specialisation in the arts is desirable.

The specialisation, due to psychological factors in the individual artist, may conflict with the particular economic structure of society in which the artist finds himself. Paintings and sculpture, for example, might be regarded as unnecessary trimmings in a society committed by economic necessity to an extreme utilitarian form of architecture. The artist might then have to divert his energies to other forms of production – to industrial design, for example. No doubt the result would be the spiritual impoverishment of the society reduced to such extremes, but I only mention this possibility to show the dependence of art on social and economic factors. The

artist should realise how much he is involved in the changing social structure, and how necessary it is to adapt himself to that changing structure.

From this some might argue that the artist should have a conscious and positive political attitude. Obviously some forms of society are more favourable to art than others, and it would be argued the artist should on that account take up a position on the political front. I would be more certain of his duty in this respect if we could be scientifically certain in our political analysis, but it must be obvious to the most superficial observer, that the relation between art and society has always been a very subtle one, and never of the kind that could be consciously planned. One can generalise about the significant relationship between art and society at particular points in history, but beyond describing such relationships in vague terms such as 'organic' and 'integrated', one cannot get near to the secret. We know that the Industrial Revolution has had a detrimental effect on the arts, but we cannot tell what further revolution or counter-revolution would be required to restore the health of the arts. We may have our beliefs, and we may even be actively political on the strength of those beliefs; but meanwhile we have to work, and to work within the contemporary social structure.

That social structure varies from country to country, but I think that broadly speaking we who are participating in this conference are faced with mixed or transitional economies. In my own country, at any rate, the artist has to satisfy two or three very different types of patron. In the first place there is the private patron, the connoisseur or amateur of the arts, who buys a painting or a piece of sculpture to indulge his own taste, to give himself a private and exclusive pleasure. In addition there are now various types of public patron, the museums, or art galleries that buy in the name of the people: the people of a particular town, or the people of the county as a whole. Quite different from such patrons are those architects, town-planners, organisations of various sorts who buy either from a sense of public duty, or to satisfy some sense of corporate pride.

This diversity of patronage must be matched by a certain flexibility in the artist. If I am asked to make a piece of sculpture for (a) a private house; (b) a museum; (c) a church; (d) a school; (e) a public garden or park, and (f) the offices of some large industrial undertaking, I am faced by six distinct problems. No doubt the Renaissance sculptor had similar problems, but not of such a complexity; whereas the medieval sculptor had to satisfy only one type of patronage – that of the Church. Flexibility was always demanded by the function and destination of the piece of sculpture, but that is a difficulty which the artist welcomes as an inspiration. The

difficulty that might cause the modern artist some trouble is due to the shift, at a moment's notice, from the freedom of creation which he enjoys as an individual working for the open market of private patrons to the restrictions imposed on him when he accepts a public commission. It is usually assumed that if sufficient commissions were forthcoming from public authorities, all would be well with the arts. It is an assumption that takes no account of the fact that the tradition of modern art is an individualistic one, a craft tradition passing from artist to artist. We have only to look eastwards, beyond the Iron Curtain, to see that State patronage on an authoritarian basis requires quite a different tradition – a tradition in which the State that pays the artist calls the tune, in other words, determines the style. I am not making any judgment of the relative merits of the two traditions, but I think it should be made quite clear that the transition from private patronage to public patronage would mean a radical reorganisation of the ideals and practice of art. We have to choose between a tradition which allows the artist to develop his own world of formal inventions, to express his own vision and sense of reality; and one which requires the artist to conform to an orthodoxy, to express a doctrinaire interpretation of reality. It may be that in return for his loss of freedom the artist will be offered economic security; it may be that with such security he will no longer feel the need to express a personal philosophy, and that a common philosophy will still allow a sufficient degree of flexibility in interpretation to satisfy the artist's aesthetic sensibility. I think most, artists, however, would prefer to feel their way towards a solution of this problem, and not have a solution imposed on them by dictation. The evolution of art cannot be forced, nor can it be retarded by an obstinate adherence to outworn conventions.

We already have considerable experience in the State patronage of art, even in countries which are still predominantly individualistic in their economy. I have myself executed various pieces of sculpture for public authorities – schools, colleges, churches, etc. – and although I have had to adapt my conception to the function of the particular piece of sculpture, I have been able to do this without any surrender of what I would regard as my personal style. Such pieces of sculpture may meet with violent criticism from the public, and I might be influenced, perhaps unconsciously, by such criticism. That is my own look-out, and I do not suggest that the artist should be indifferent to such criticism. But the public is also influenced by the work of art, and there is no doubt that the public authority which has the vision and the courage to commission forward-looking works of art, the work of art with what might be called prophetic vision, is doing more for art than the public authority that plays for safety

and gives the public what the public does not object to. But can we rely on such courage and initiative in public bodies in a democratic society? Isn't there a primary duty in such a society to make sure that the people have the interest and eagerness that demand the best art just as surely as they demand the best education or the best housing? It is a problem beyond the scope of this address, but not beyond the scope of Unesco – the renewal of the sources of artistic inspiration among the people at large.

I turn now to technical matters more within my special competence as a sculptor. When sculpture passes into the public domain, the sculptor is then involved, not merely in a simple artist-patron relationship, but also in a co-operation with other artists and planners. The piece of sculpture is no longer a thing in itself, complete in its isolation, it is a part of a larger unit, a public building, a school or a church, and the sculptor becomes one artist in a team collaborating in the design as a whole. Ideally that collaboration should begin from the moment the building is first conceived, and neither the planner of the town nor the architect of the particular building, should formulate their plans without consulting the sculptor (or the painter if he too is involved). I mean that the placing of a piece of sculpture, in a public square, on or in a building, may radically alter the design as a whole. Too often in modern building the work of art is an afterthought, a piece of decoration added to fill a space that is felt to be too empty. Ideally the work of art should be a focus round which the harmony of the whole building revolves, inseparable from the design, structurally coherent and aesthetically essential. The fact that the town planner or the architect can begin without a thought of the artists he is going to employ to embellish his building, shows how far away we are from that integral conception of the arts which has been characteristic of all the great epochs of art.

Assuming that such co-operation is sought and given from the beginning of an architectural conception, then there are many considerations which the sculptor must bring into play. He will want to consider both external proportions and internal spatial volumes in relation to the size and style of sculpture that might be required, not merely the decorative function of sculpture in relation to formal quantities, but also the possibility of utilitarian functions. Utilitarian is perhaps not the right word, but I am thinking of the didactic and symbolic functions of sculpture in Greek architecture, inseparable from the architectural conception itself. The sculptor will also want to consider his own materials in relation to those to be employed by the architect, so that he can secure the effective harmony or contrast of textures and colours, of fantasy and utility, of freedom and necessity as one might say.

These are perhaps obvious rights for a sculptor to claim in the conception and execution of a composite work of art, but nothing is such a symptom of our disunity, of our cultural fragmentation, as this divorce of the arts. The specialisation characteristic of the modern artist seems to have as its counterpart the atomisation of the arts. If a unity could be achieved, say in the building of a new town, and planners, architects, sculptors, painters and all other types of artist could work together from the beginning, that unity, one feels, would nevertheless be artificial and lifeless because it would have been consciously imposed on a group of individuals, and not spontaneously generated by a way of life. That is perhaps the illusion underlying all our plans for the diffusion of culture. One can feed culture to the masses, but that does not mean that they will absorb it. In the acquisition of culture there must always be an element of discovery, of self-help; otherwise culture remains a foreign element, something outside the desires and necessities of everyday life. For these reasons I do not think we should despise the private collector and the dealer who serves him; their attitude to the work of art, though it may include in the one case an element of possessiveness or even selfishness and in the other case an element of profit-making, of parasitism, nevertheless such people circulate works of art in natural channels, and in the early stages of an artist's career they are the only people who are willing to take a risk, to back a young artist with their personal judgment and faith. The State patronage of art is rarely given to young and unknown artists, and I cannot conceive any scheme, outside the complete communisation of the art profession such as exists in Russia, which will support the artist in his early career. The present system in Western Europe is a very arbitrary system, and entails much suffering and injustice. The artist has often to support himself for years by extra artistic work, usually by teaching, but this, it seems to me is preferable to a complete subordination of the artist to some central authority, which might dictate his style and otherwise interfere with his creative freedom. It is not merely a question of freedom. With the vast extension of means of communication, the growth of internationalism, the intense flare of publicity which falls on the artist once he has reached any degree of renown, he is in danger of losing a still more precious possession – his privacy. The creative process is in some sense a secret process. The conception and experimental elaboration of a work of art is a very personal activity, and to suppose that it can be organised and collectivised like any form of industrial or agricultural production, is to misunderstand the very nature of art. The artist must work in contact with society, but that contact must be an intimate one. I believe that the best artists have always had their roots in a definite social group or community, or in a particular region. We

know what small and intimate communities produced the great sculpture of Athens, or Chartres, or Florence. The sculptor belonged to his city or his guild. In our desire for international unity and for universal co-operation we must not forget the artist's freedom and his social function, between his need for the sympathy of a people and his dependence on internal springs of inspiration.

I believe that much can be done, by Unesco and by organisations like the Arts Council in my own country, to provide the external conditions which favour the emergence of art. I have said – and it is the fundamental truth to which we must always return – that culture (as the work implies) is an organic process. There is no such thing as a synthetic culture, or if there is, it is a false and impermanent culture. Nevertheless, on the basis of our knowledge of the history of art, on the basis of our understanding of the psychology of the artist, we know that there are certain social conditions that favour the growth and flourishing of art, others that destroy or inhibit that growth. An organisation like Unesco, by investigating these laws of cultural development, might do much to encourage the organic vitality of the arts, but I would end by repeating that by far the best service it can render to the arts is to guarantee the freedom and independence of the artist.[1] [1952/Bibl. 30 and 39].

1. An address given at an international conference of artists organised by Unesco and held in Venice, 22–28 September, 1952.

The hidden struggle

There is one quality I find in all the artists I admire most – men like Masaccio, Michelangelo, Rembrandt, Cézanne. I mean a disturbing element, a distortion, giving evidence of a struggle of some sort. It is absent, of course, in all late Greek, Hellenistic art and in painters like Botticelli in his pre-Savonarola period, or in Raphael; although I find traces of it in the last. Look at his details – the face of Plato or that of Aristotle in the *School of Athens* at the Vatican, for instance. There it is again (**23**).

The classical style has a pleasing quality, a happy fixed finality is its aim – a resolved world. Rembrandt, on the other hand, shows in every painting marks of an unending struggle, as though he were being impelled all the time to solve something. Van Gogh is another matter. His art, great as it is, grows from a weakness, we have to admit it. It is panicky when compared to Rembrandt. Rembrandt had an undisputable success as a portraitist of the Amsterdam burghers. But it did not satisfy him; he wanted something deeper. He wanted to achieve the impossible.

Here, the disturbing element comes in. It is instructive to know that Rembrandt copies Mantegna, whose art is the extreme opposite of his own. Why did he do so? Because he was conscious that his own art lacked the classical element. He was aware of the opposite, and that makes him greater. Cézanne, too, wanted to do the impossible. His art was always disturbing. One of his last works was almost a Rembrandt. The picture is now in the National Gallery.[1] When we ask ourselves whether Cézanne really underwent a change, the answer must be: No. His late *Bathers* have still the disturbing quality which we find already in the large romantic baroque compositions he began with. One cannot change one's nature. Artists try to debate all the time what they do instead of seeing that there is something in the opposite. No one really knows anything unless he knows also the opposite.

I personally believe that all life is a conflict; that's something to be accepted, something you have to know. And you have to die, too, which is the opposite of living.

1. *La vieille au chapelet.* c. 1896

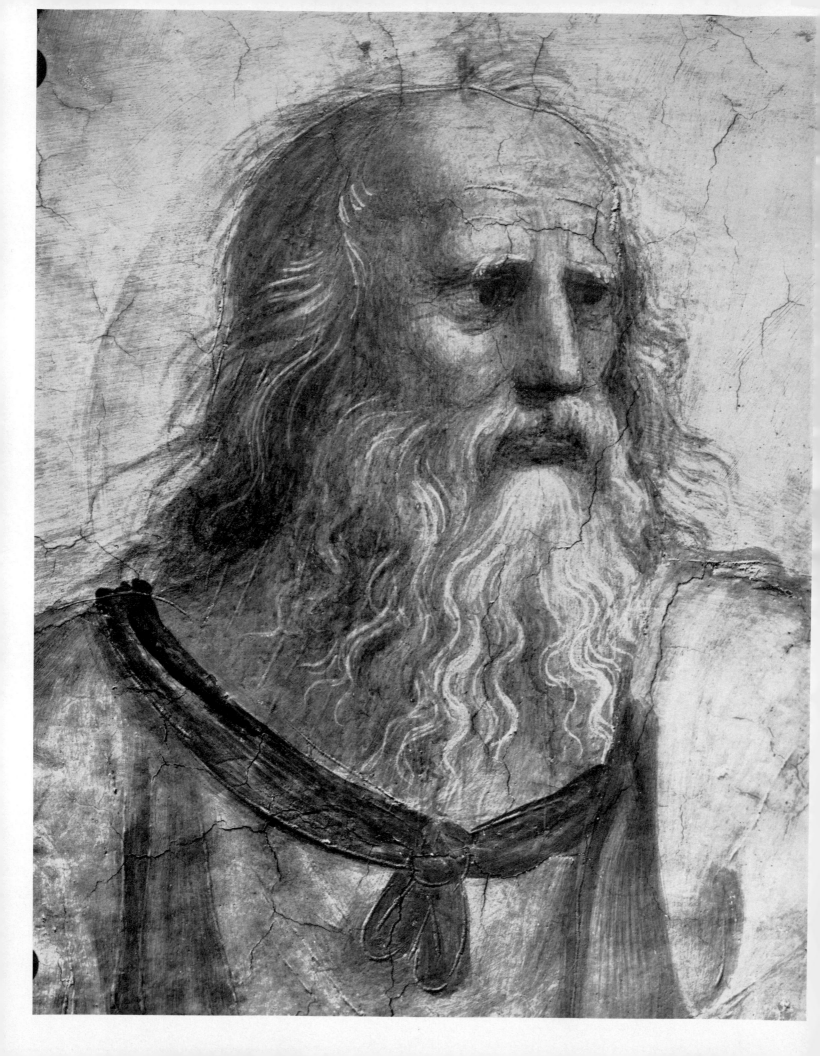

One must try to find a synthesis, to come to terms with opposite qualities. Art and life are made up of conflicts.

I think really that in great art, i.e., in the art I find great, this conflict is hidden, it is unsolved. Great art is not *perfect*. Take the *Rondanini Pietà*, one of the greatest works of Michelangelo. It is not a perfect work of art. There is a huge arm remaining from the earlier statue which was later changed into the *Pietà*. It has nothing to do with the composition. Nevertheless, it was left there (**64**).

Perfectionist art does not move me. Chinese painting is unsatisfactory to me. I can appreciate it and find it very pleasing and decorative, even beautiful, but something is missing. At the Chinese exhibition in Venice in 1954 I realised more strongly than ever before the conscious aesthetic and effectivist point of view which determined these works and which empties them of conflict. Try to compare, in your mind, some of the late Chinese works with Rembrandt. Rembrandt never started from this. His aim was not the perfect brush stroke arrived at by continual hand practice. For me this is just where the difference lies between art and craft.

All that is bursting with energy is disturbing – not perfect. It is the quality of life. The other is the quality of the ideal. It could never satisfy me. The crystal which is an ideal in life can hardly change this general rule.

It is the same quality of disturbance, which makes one distrust things too easily achieved. I always have a distrust of something I can do easily. X once showed me a big picture and remarked with pride 'I did it in half an hour.' If I had done something as easily as that, I would have felt unhappy.

The average person does not want to be disturbed by art. What he asks from art is the entertainment value of the cinema. When the modern artist turned away from his entertainment function, he found himself isolated. The Greeks, up to the fifth century B.C., did not want only to please. The Parthenon sculptures are not perfectionist sculptures. If you put a Parthenon figure against one of the sixth century B.C. you'll find that they are of the same spirit. Compare it with the work of a hundred years later, and one realises what a wealth of content the Parthenon still had. Not the sweetness and emptiness into which it degenerated later on.

All primitive art is disturbed, or an experience of power, not perfectionist. You may come to certain periods when the primitive element seems to have gone altogether as, say, in the outward calm of Piero della Francesca, but in him, in spite of his sophistication and conscious mastery of art, there is also a disturbing element. It is present in all true art, as it is in life. Classical detachment doesn't try to solve enough.

This disturbing quality of life goes hand in hand with the disturbing quality of our

93

23 *Raphael*. THE SCHOOL OF ATHENS. *Detail showing the head of Plato (a supposed portrait of Leonardo da Vinci). 1510–11, Fresco.* Rome; Vatican (Stanza della Segnatura).

time. The temporal emphasises the perpetual. I put it into words – because people criticise. They do not understand the basic character of their age. They want to escape. Many of them expect of art perfect craftsmanship artefacts. They have become through education, used to other standards. Never once did I want to make what I thought of as a 'beautiful' woman. This does not mean that I don't want beauty in what I do. Beauty is a deeper concept than perfection or niceness, or attractiveness, sweetness, prettiness. To me, 'beautiful' is much more than that. I find a bull more beautiful than a frisking lamb ('How beautiful!'), or a big fleshy beech-tree trunk more beautiful than an orchid.

I do not really want to play the role of the obvious disturber. The bogy-man business I leave to the Grand Guignol, to others. The crime and horror-comic line is theirs. I don't want to produce shocks. After surrealism nobody should be upset that a head of one of my sculptures is different from the rest. Could we not say the same of Chartres, or of many primitive works? In Chartres Cathedral, the bodies are like columns and the heads are realistic (**24**). No one reproaches them for disunity of style.

I willingly accept what I try to bring together. In the heads of my *King and Queen* or in the head and body of my *Warrior*, some mixture of degrees of realism is implicit. But we got used to this mixture in Chartres, and we shall get used to it again. I do not suggest that I have intentionally done it. I did not say: 'Now, I'll make the head different' – it is just that in the head part I could focus, in essence, the intention of the entire figure. A bull-like though docile, a strong though battered, being; suffering – the cleft down the middle of the skull – a resignation but still a defiance. By contrasting the head to the natural structure of the rest, the whole idea of the figure is pointed out – it is these contrasts which do it (**106** and **107**).

Many of my contemporaries, even some great ones, want to produce a perfect world in life. They see it as an ideal at which life has to aim. To me, it is a life which I do not want. Consequently, I do not consider our age to be worse than others. I would not want to transplant myself to another period. I could not even imagine it. For life, every period is a terrible period. Lots of people argue and would probably say that the artist to-day is in a deplorable position. We are sorry for the poor fellow! There is no unified structure in society for him to fit into. Because they think that life and thought were unified in Gothic times, therefore, every artist of the Gothic era necessarily produced great works of art. They did not and they could not. Only a few are great. Works of art are not done so easily. I don't believe that the really important contributions were done easily by anybody.

Besides, what is valid socially and spiritually for the visual arts must be equally

24 OLD TESTAMENT FIGURES *on the south portal of the Portail Royal, Chartres Cathedral. About 1150. Stone, h. 20½ ft.*

valid for music and poetry. The human spirit expresses itself now through one art, now through another – for this twenty years poetry will be good and somewhere else for a hundred years painting will flourish. There is Beethoven in the late eighteenth and early nineteenth century, or Shelley, but around them no painters. One cannot argue that society is spiritually unable to produce great painting but able to produce great poetry and music. Society is bad for all or for none.

I don't believe in crying out at the artist's lot. I don't believe in decrying conditions to-day. ('My goodness, if only we had lived in the past, we could have done much better!')

No art has ever existed, and no artist has ever created, out of real despair. To be an artist is the opposite of being in a state of despair. To be an artist is to believe in life. Would you call this basic feeling a religious feeling? In that sense an artist does not need any church and dogma.

We all think that art and society now are torn apart. But I believe that in other periods the relationship was an individual relationship; it was not based on a State decree. If you can admit that a novelist can produce a great novel without being commissioned, say Dickens, Tolstoy, Flaubert, Stendhal – if one admits that theirs are works of art, why should one accept the case for the visual arts to be different?

Cézanne, by all the arguments should have had everything against him. He had enough money to be lazy, or to go on modestly working in isolation, but no commissions, no public use. We must say however, it is certainly better that he was not commissioned. If he had been, we might not care for Cézanne. To-day, in Sweden, the arts are patronised. They are the pet of society. But how much happens there artistically?

Then again, they say that great works of art need a religious belief. This was the unifying bond in former times and it is gone. To-day you can base your art only on life itself. All right. When did Rembrandt create his greatest works? When he was old and cut off from society. And Goya's boldest fantasies were produced in isolation, in protest, when he was deaf and sick. Either the society argument is valid, then a Rembrandt, a Goya, etc., cannot happen. Or it is bunk. The artist is a human being. He has to live; that is understood. We have to live in this world. This fact does not change my argument.

Society, the public, cannot have any say in art. Because they cannot work it out. It is a bit of a mystery what happens there. . . . It disturbs, it is interesting. In poetry there is something which is not easily explainable. If it were, it would be like the public monuments in squares – one passes and does not look.

Sculpture in the open air

Sculpture is an art of the open air. Daylight, *sunlight*, is necessary to it, and for me its best setting and complement is nature. I would rather have a piece of my sculpture put in a landscape, almost any landscape, than in, or on, the most beautiful building I know. [1951/Bibl. 18].

In 1928 I agreed to carve a relief for the Underground Building at St. James's, although I had never felt any desire to make relief sculpture. Even when I was a student I was totally preoccupied by sculpture in its full spatial richness, and if I spent a lot of my time at the British Museum in those days, it was because so much of the primitive sculpture there was distinguished by complete cylindrical realisation. I was extremely reluctant to accept an architectural commission, and relief sculpture symbolised for me the humiliating subservience of the sculptor to the architect, for in ninety-nine cases out of a hundred, the architect only thought of sculpture as a surface decoration, and ordered a relief as a matter of course. But the architect of the Underground Building was persuasive, and I was young and when one is young one can be persuaded that an uncongenial task is a problem that one doesn't want to face up to. So I carved this personification of the *North Wind*,[1] cutting as deeply as the conditions would allow – to suggest sculpture in the round.

It was a long time before I accepted any other important architectural commissions; the architect who persuaded me to carve the *North Wind* relief was responsible for the London University Senate House in Malet Street, and he approached me again in 1934 and told me that there were places on the Senate House Building – 50 to 60 feet up – that needed sculpture. But again it was only reliefs that were wanted. We discussed it quite a lot and I even went so far as to make some models . . . Eight seated figures were wanted, on eight separate stones but I couldn't sustain any excitement about it.

1. Illustrated in bibl. 41. pl.11a and b.

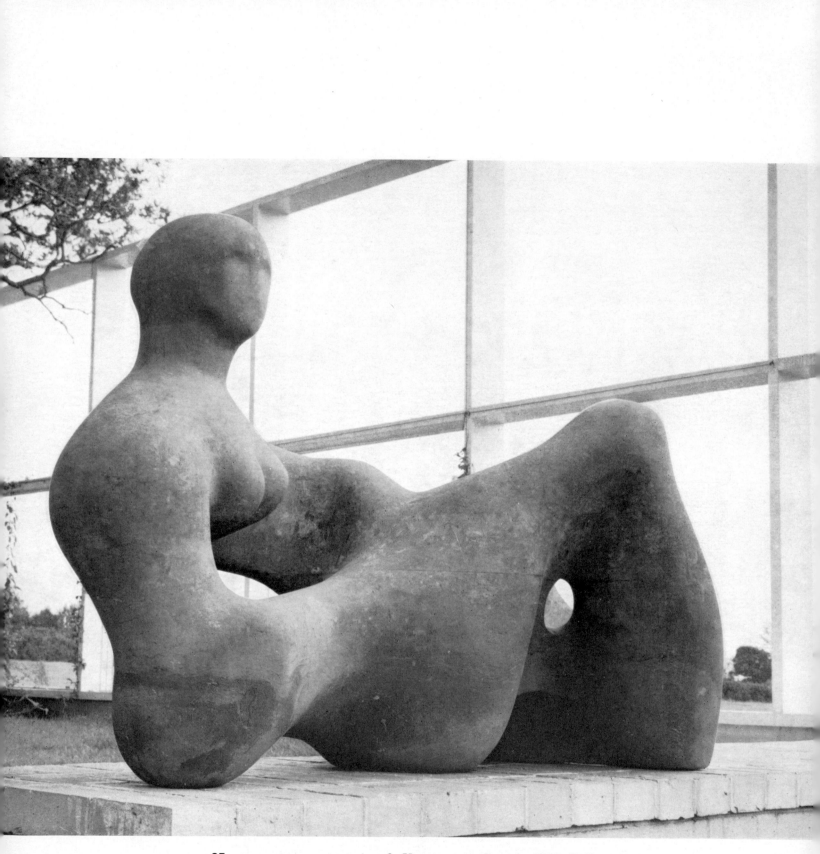

25 RECUMBENT FIGURE, *1938. Hornton stone, l. 55 in.* Tate Gallery, London. *Made for the garden of Serge Chermayeff at Halland, Sussex. The first figure in stone to be substantially opened out.*

I was trying at this time to achieve form in the round making figures which occupied real space and I preferred to forego the commission rather than work for a long time on a kind of sculpture that went against the grain – and that would be too high up to be seen anyway. The architect said he would go ahead and put up the stones in case I altered my mind. The eight stones cut to the proportions of my drawings are there high up on the Senate House but they remain blank to this day.

I had no desire to do anything more for architects until some of the architects of my own generation began to think about sculpture in relation to the new architecture. I went on my own way concerned only with the self-sufficiency of sculpture. At the time of which I am talking – the late twenties and early thirties – the architects I liked best were absorbed by functionalism. They were leaving all unnecessary (even some necessary) details off their buildings and they had no use at all for sculpture. This was a good thing then, both for the sculptor and the architect, for the architect was concentrating on the essentials of his architecture, and it freed the modern sculptor from being just a decorator for the architect.

The best architects of my own generation began to think seriously about sculpture in relation to their buildings in the late thirties. And when they came around to it, some were persuaded not to have sculpture *on* a building but *outside* it, in a spatial relation to it. And the beauty of this idea of a spatial relationship is that the sculpture must have its own strong separate identity.

The architect Chermayeff was thinking along these lines when he invited me, in 1936, to look at the site and lay-out of a house he was building for himself in Sussex. He wanted me to say whether I could visualise one of my figures standing at the intersection of terrace and garden. It was a long, low-lying building and there was an open view of the long sinuous lines of the Downs. There seemed no point in opposing all these horizontals, and I thought a tall, vertical figure would have been more of a rebuff than a contrast, and might have introduced needless drama. So I carved a reclining figure for him (**25**), intending it to be a kind of focal point of all the horizontals, and it was then that I became aware of the necessity of giving outdoor sculpture a far-seeing gaze. My figure looked out across a great sweep of the Downs, and her gaze gathered in the horizon. The sculpture had no specific relationship to the architecture. It had its own identity and did not *need* to be on Chermayeff's terrace, but it so to speak *enjoyed* being there, and I think it introduced a humanising element; it became a mediator between modern house and ageless land.

When Chermayeff sold his house, and went to live in the United States the Contemporary Art Society bought the *Recumbent Figure* and presented it to the

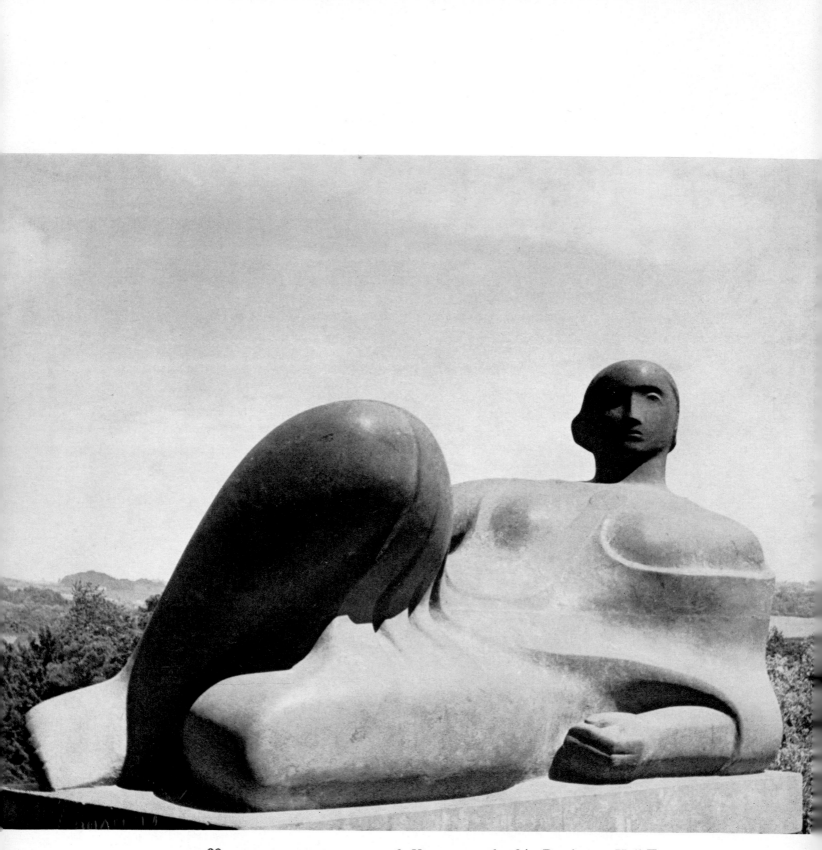

26 MEMORIAL FIGURE, *1945–46. Hornton stone, l. 56 in.* Dartington Hall Trustee, Totnes. *A memorial to Christopher Martin, the first administrator of the arts at Dartington Hall.*

Tate Gallery, and now it is usually indoors, but has occasional airings.

I liked its position in the first open-air exhibition at Battersea Park, where it was in distant communication with my *Three Standing Figures* (**28**). But it had a pretty tough experience when it was a war-time refugee in New York. It had been lent to an international exhibition at the New York World Fair, and as it was still there when war broke out, the Museum of Modern Art kindly took it over and exhibited it, throughout the war, in its sculpture garden. When it came back it was in a very weather-worn condition owing to the extremes of heat and cold in New York, and its proximity to the sea. But at least I discovered that Hornton – a warm friendly stone that I like using – is not suitable for exposure in intemperate climates.

When the idea of free-standing sculpture set in a spatial relationship to a building became accepted practice it looked as if the sculptor had got his way at last, and had won all the freedom he could wish for. But it isn't as simple as that. The site itself, that is to say, the space left vacant on the building plot, may well be too skimpy, or the money available for a sculpture may be quite inadequate for a work of the right size, or the architect may have found an ideal position on the plan that turns out to be inappropriate in actuality.

This *Reclining Figure* (**37**) was commissioned by the Arts Council for the Festival of Britain in 1951. But I knew that the South Bank would only be its temporary home, so I didn't worry about where it was placed. If I had studied a Festival site too carefully, the figure might never have been at home anywhere else. As it was, I made the figure, then found the best position I could. I was simply concerned with making a sculpture in the round . . .

I think the figure I carved in 1945 and 1946 (**26**) in memory of Christopher Martin has found a perfect setting in the grounds of Dartington Hall; there are other parts of those lovely gardens that may well have been equally suitable, but it was this setting I had in mind when working on the maquettes. The figure is a memorial to a friend who loved the quiet mellowness of this Devonshire landscape. It is situated at the top of a rise, and when one stands near it and takes in the shape of it in relation to the vista one becomes aware that the raised knee repeats or echoes the gentle roll of the landscape. I wanted it to convey a sense of permanent tranquillity, a sense of *being* from which the stir and fret of human ways had been withdrawn, and all the time I was working on it I was very much aware that I was making a memorial to go into an English scene that is itself a memorial to many generations of men who have engaged in a subtle collaboration with the land. Obviously, it would be out of place in a wilder, more rugged setting.

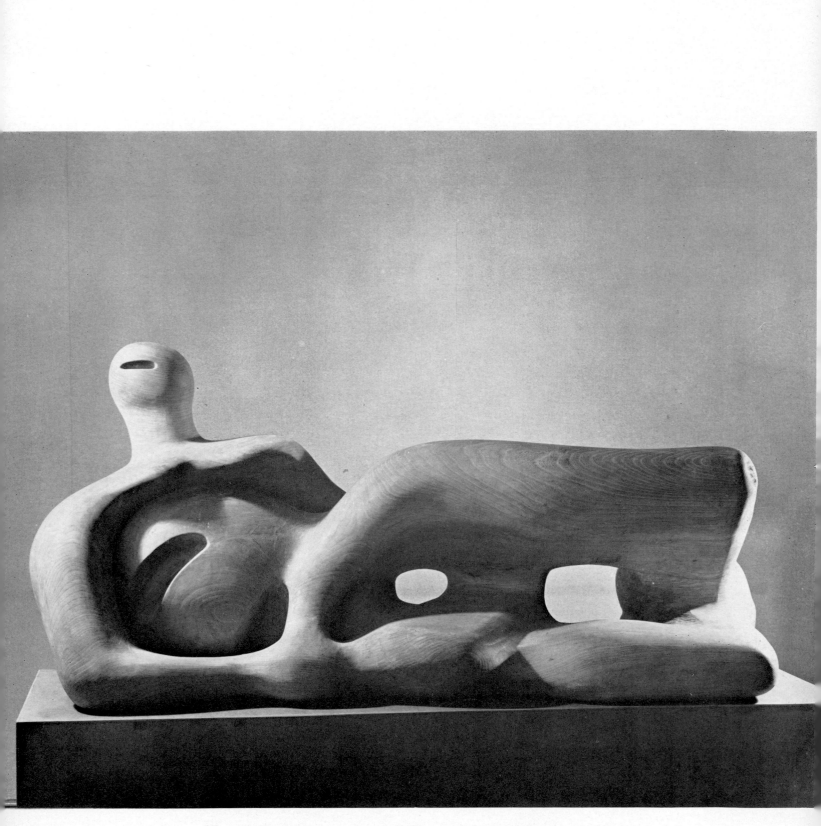

27 RECLINING FIGURE, *1945–46. Elm wood, l. 75 in*. Cranbrook Academy of Art, Bloomfield Hills, Michigan.

It was done at the same time as this large elm figure (**27**) and I was working on both figures throughout a year. They are poles apart in feeling. But carving is a slow business, and if one works for too long a stretch upon a carving which satisfies only one side of one's nature, one becomes restive, one tends to become absorbed by projects which have not yet been started, and one's growing anxiety to be done with the thing one is working on will show in some of the forms. But if there is something with a quite different content on the go at the same time there is an interplay of one's interests. This reclining figure carved in elm, expresses more disturbing, more violent feelings. And it is these oppositions and contrasts in one's nature that make a whole personality. And the value of such contrasts goes beyond the confines of a single personality . . .

The group, *Three Standing Figures* made in 1947–49, was not done especially for the position it now occupies in Battersea Park (**28**). The project was on the way before the Contemporary Art Society thought of commissioning it. The Museum of Modern Art in New York had said that they wanted from me a large work, and I had their request in mind when I decided to carve this group in Darley Dale stone, which stone I chose because it would have weathered well and kept clear in the sea air of New York. In the smoke-laden atmosphere of London, especially being near Battersea Power Station, I think the stone will slowly go darker, it may perhaps look very well when nearly black. At present though, in its in-between stage it is looking rather dirty. But it is no use being over-concerned about its surface appearance for the next few years.

When the Contemporary Art Society decided that they wanted to offer it to the London County Council Parks Committee, the Museum of Modern Art agreed to wait for a large work, and later they had a cast of the Stevenage *Family Group*. The three figures were well sited when they were shown in the first open air sculpture exhibition at Battersea Park, but they couldn't remain there because the tree to the right of one of them was rotten, and after it was felled the site lost a good deal of its attractiveness. But I was very happy about the original situation. The slight rise overlooking an open stretch of park and the background of trees emphasised their outward and upward stare into space (**29**). They are the expression in sculpture of the group feeling that I was concerned with in the shelter drawings and although the problem of relating separate sculptural units was not new to me, my previous experience of the problem had involved more abstract forms; the bringing together of these three figures involved the creation of a unified human mood. The pervading theme of the shelter drawings was the group sense of communion in apprehension.

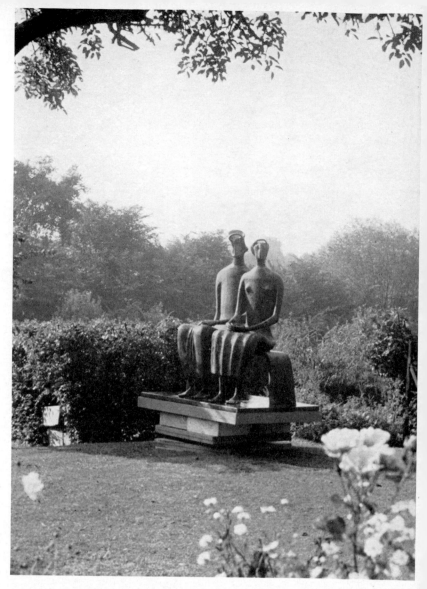

30–32 KING AND QUEEN, *1952–53. Bronze, h. 64½ in. While these three views illustrate this piece in a park, against a wall and in a garden, the finest setting, a moor in Scotland, is shown in* **101** *and* **103**.

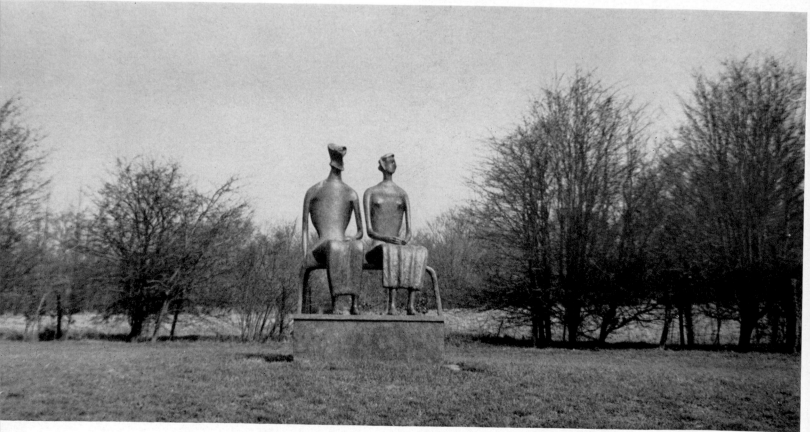

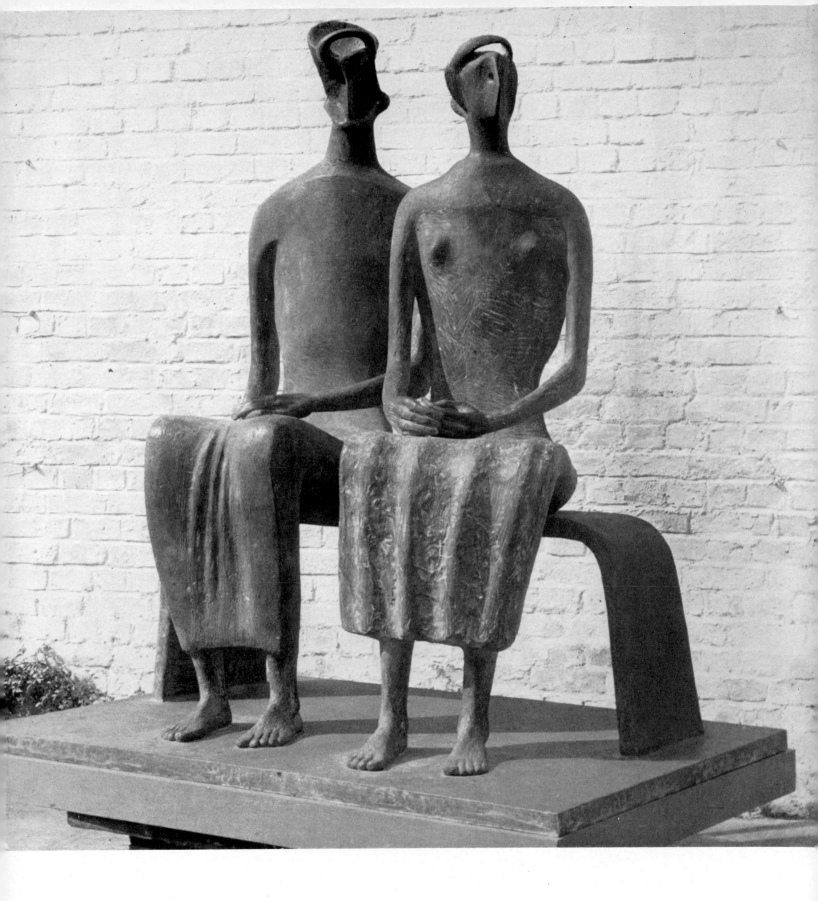

But I only wanted a hint of that mood to remain in the three figures. I wanted to overlay it with the sense of release, and create figures conscious of being in the open air; they have a lifted gaze, for scanning distances . . .

Although the *King and Queen* has been listed as a commission from the Burgomaster of Antwerp, the maquette had already been produced before Antwerp decided to have a piece of my sculpture for the open-air museum in Middelheim Park. It was simply a sculpture that I wanted to do. The point I want to make here is that a free-standing sculpture can be suitable for an infinite number of settings. I'd like to show you this group in different settings. Against a wall (**32**). In a garden (**30**). In a park (**31**).

The thing is that sculpture gains by finding a setting that suits its mood, and when that happens, there is a gain for both sculpture and setting. My own garden is open, and almost merges with the Hertfordshire landscape, and I have noticed that even people who have no feeling for sculpture become aware of a kind of dislocation when a sculpture they have been seeing pretty regularly in the garden goes away.

Some sculpture finds its best setting on a stretch of lawn or beside a pool. Others might be more effective, more poignant, set against the rhythm and raggedness of trees. Some of these might look best against oaks and others against elms. Yet others need the secret glade, a patch of grass enclosed by high bushes to give a sense of privacy. It is certain that one wouldn't want to see, say, a realistic nude of an adolescent girl exposed on a bleak hillside, and except in a warm sunny climate such a figure would be best indoors.

But there are a great many places that no sculptor has thought of – or has ever seen – that must be superb settings for sculpture, and this is where collectors and museum directors and parks committees and owners of country estates can make discoveries of great importance for the future of sculpture. This point is, I think, well illustrated by the unusual setting found for my tall standing figure by a Scottish collector.

This figure – *Standing Figure* – was made in 1950, and was first exhibited at Battersea, and the siting committee placed it beside the lake. I was delighted to see a piece of my sculpture against a quiet expanse of water. It was an effect produced by very sharp contrast – a gaunt figure rising in agitated verticals from the verge of a calm, flat sheet of water that seemed the very essence of horizontalism.

When this figure came back from Battersea a second cast of it had already arrived from the bronze foundry, and having them both at the studio I was able to try out a double figure arrangement. For some little time before working on this figure, I

was thinking of making four separate figures standing in a row on the same base . . . But one never finds the time to carry out all one's plans, and when the two casts of this single figure were together I saw a chance to carry out at least part of the first unrealised conception.

Now open sculpture of this kind can offer more complex form relations than the single solid tree-trunk kind of sculpture because the spaces between the exterior forms that can be seen from any one viewpoint give access to interior aspects of other forms (**34**). But the doubling up of the two figures increased the complexity of the formal relations and intensified the kind of rhythm that the single one had. The two figures can't help having a certain unity since they are in fact the same figure but in placing them together I made sure that each figure presented a different view from the other whichever way one looked at them (**33**), and this makes it almost impossible I think for a person not knowing they are the same figure, to pick it out.

I think the double figure is more telling than the single figure when it is indoors or in an outdoor situation that has well-defined limits. Some of the complexity is lost at a distance, that is. Generally speaking, sculpture needs a certain amount of bulk to make it tell in the open because the vast expanse of sky has a diminishing effect, yet in the case of the most open setting to which any work of mine has ever been exposed this rule doesn't apply. In theory, the double figure with its greater bulk should be more effective in an open setting than the single figure, but the extreme openness of the Scottish setting for the single figure has upset whatever preconceptions I had. In the bleak and lonely setting of a grouse moor the figure itself becomes an image of loneliness, and on its outcrop of rock, its lean, skeletonic forms stand out sharp and clear against the sky, looking as if stripped to the bone by the winds of several centuries (**35**).

This collector's estate, with its farm, its grouse moor and its sheep-grazing land covers some 3,000 acres, and he says that he would like to have other things of mine there. When he invited me to stay with him, I went all over his land, and there are not only the wild hills and moors, but woods and lawns and a lake with an island in the middle. I saw at least twenty or thirty sites for sculpture which are separated from one another by hillside or trees, so that one would never see more than one sculpture at a time. There is such a variety that I feel that every large sculpture I have done could find a suitable setting there. [1955/Bibl. 55].

I have always liked sculpture in the open air and I like making sculpture which will

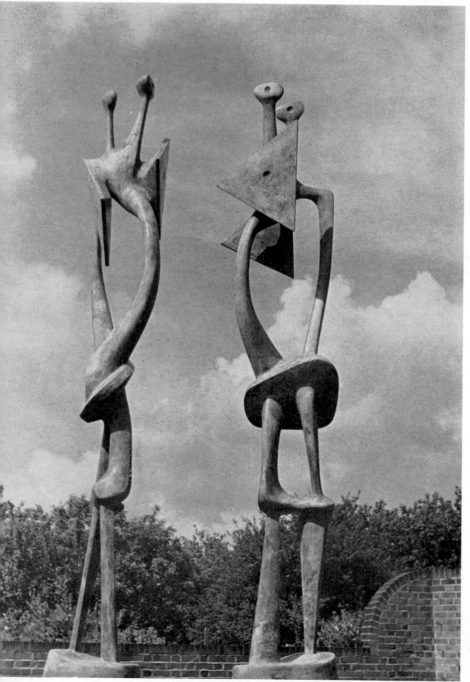

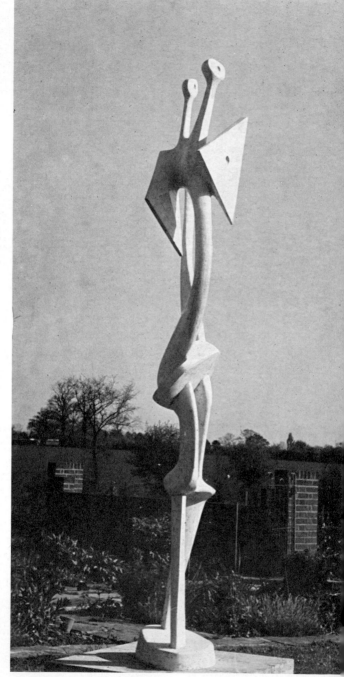

33 DOUBLE STANDING FIGURE, *1950.*
Bronze, h. 87 in.

34 STANDING FIGURE, *1950. Plaster for
bronze, h. 87 in. A comparison may be made between
this figure and a Cycladic figurine (see* **56**). *It is also
closely related to the form in a lithograph of May
1929 by Picasso entitled* Figure (*reproduced in
Geiser, B.* Picasso, peintre-graveur. *2nd edition
1955, no. 246 and in the Arts Council's catalogue*
Picasso, fifty years of graphic art, *1956, pl. 15*).

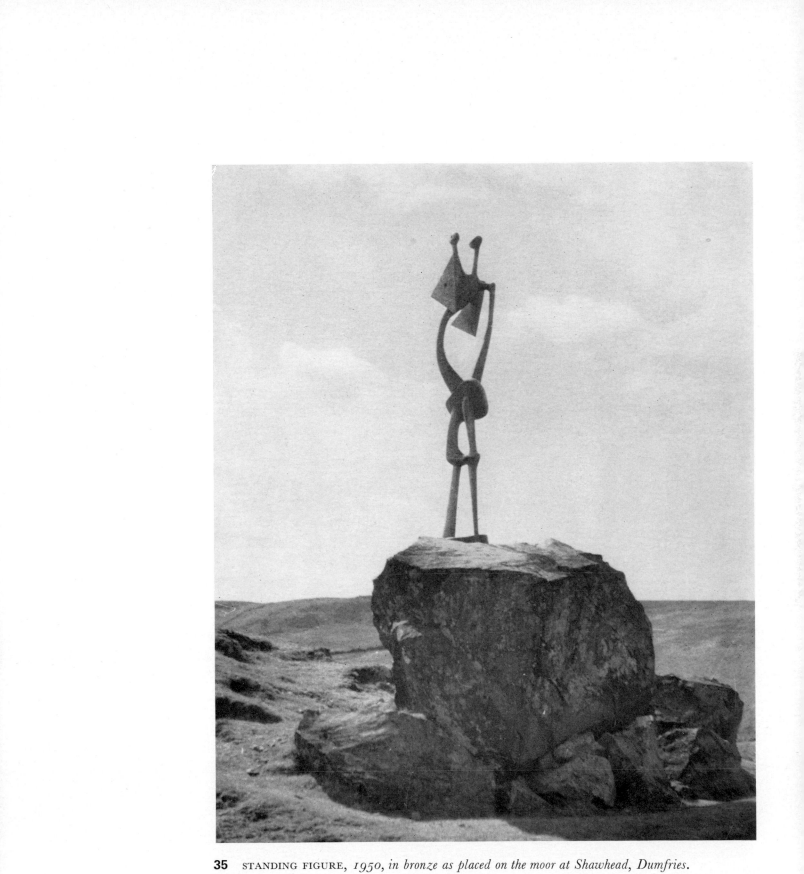

35 STANDING FIGURE, *1950, in bronze as placed on the moor at Shawhead, Dumfries.*
W. J. Keswick.

stand outside in nature, and now I'm able for all sorts of practical reasons to satisfy my desire, whereas in earlier days some of my sculpture had to be small in size. You can't make a small piece of sculpture stand outside in nature. It just gets lost. It depends on its position in the landscape or in a field or in a garden, whether you want to make a thing much over life-size or not quite life-size. But on the whole for outdoor sculpture it should be over life-size, because the open air reduces a thing in its scale. If you stood a real man on a pedestal of some of the public statues, one would find how much bigger than real life are even the things which look life-size. They have to be.

Really, I have been concerned with outdoor sculpture nearly all my life. I like to *work* outside, perhaps because to begin with the only place I had to work in my summer holidays away from the school was the garden. I had no studio, so I worked out-of-doors. It may also be that my liking for landscape and for nature has made me want to work out-of-doors too, because I find a tremendous pleasure in actually working in the open air. To work shut inside a studio in good weather is like being in a prison for me. But also I like seeing sculpture in relation to nature, and have done ever since I can remember doing sculpture. Now I have had the chance to make the kind of studio where one can switch from indoor to outdoor easily, and even in bad weather now I can work out-of-doors and be under cover.

I think it has been a good thing this fashion for open air sculpture exhibitions, as long as people know that you shouldn't depend too much on a nice garden or park for making you accept sculpture that you wouldn't think much of it if weren't prettily set. . . .

If you work in a specially lit studio it is a temptation to push your sculpture into a position where the light flatters it. Always in any studio there is a place where things look better, where their less good views can be turned to the wall, and where the lighting suits them. Now in ordinary daylight – particularly English daylight, English weather, which can be very diffused and very even – only a sculpture which really has completely realised form will tell at all. Incised relief, or surface scratchings won't show in dull English weather. Only your big architectural contrasts of masses – real sculptural power, real sculptural organisation – will tell at all on a dull day. Therefore it one gets used to working out-of-doors, to be satisfied with it one will be challenged into making sculpture that has some reality to it – like the reality of nature around it. [1960/Bibl. 9].

112

Truth to material

When I began to make sculptures thirty years ago, it was very necessary to fight for the doctrine of truth to material (the need for direct carving, for respecting the particular character of each material, and so on). So at that time many of us tended to make a fetish of it. I still think it is important, but it should not be a criterion of the value of a work – otherwise a snowman made by a child would have to be praised at the expense of a Rodin or a Bernini. Rigid adherence to the doctrine results in domination of the sculpture by the material. The sculptor ought to be the master of his material. Only, not a cruel master. [1951/Bibl. 18].

In your early days you put 'truth to material', respect for the material he's working in, as the first necessity for a sculptor. Do you still feel the same?

No. There I've changed. I still think it's tremendously important but I used to exaggerate the importance. That's partly due to the state sculpture was in in this country thirty or forty years ago – it had become almost entirely representational and decorative. So it was necessary to get back to first principles and emphasise them afresh.

But what happens over a period of time is this. One starts out with certain ideas of one's own, and those ideas breed others – a whole fresh crop. It's impossible for a sculptor to keep lots of pieces of stone lying around his studio, or to go about constantly searching for the right piece to embody each idea that's working in his mind.

He may start by, so to speak, trying to liberate from a particular piece of stone the form he feels it contains. But in the end, though he still respects his material and doesn't ask it to do what it can't, he has to master it and not be at its mercy.

That's partly why I've turned more to bronze in the last ten years: it enables me to do things I couldn't do in stone. I was wanting to do upright figures. No stone figure, you know, can stand on its own ankles. You can stand on your ankles because of the marvellous arrangement of your bones and muscles, but if you were in stone you'd just break. That's why the Greeks supported their standing figures with

H

tree-trunks, the Egyptians placed theirs against temples, and so on. But bronze has tremendous tensile strength. You can make your figures long and thin, wider at the top than at the bottom,[1] giving them uplift, a soaring feeling. And bronze lasts out-of-doors much better than stone. [1957/Bibl. 13].

1. The *Standing Figure*, 1950 (**34**) illustrates this point.

The human form

My first few months at College had rid me of the romantic idea that art schools were of no value and I'd begun to draw from life as hard as I could. A sculptor needs to be able to understand and see three-dimensional form correctly, and you can only do that with a great deal of effort and experience and struggle. And the human figure is both the most exacting subject one can set oneself and the subject one knows best. The construction of the human figure, the tremendous variety of balance, of size, or rhythm, all those things, make the human being much more difficult to get right in a drawing than anything else.

It's not only a matter of training – you can't understand it without being emotionally involved, and so it isn't just academic training: it really is a deep, strong, fundamental struggle to understand oneself as much as to understand what one's drawing.

And so I had a double goal or double occupation; drawing and modelling from life in term-time and daytime (**36**) and the rest of the time trying to develop in pure sculptural terms – which for me, at that time, was a very different thing from the Renaissance tradition. [1961/Bibl. 47].

In my opinion, long and intense study of the human figure is the necessary foundation for a sculptor. The human figure is most complex and subtle and difficult to grasp in form and construction, and so it makes the most exacting form for study and comprehension. A moderate ability to 'draw' will pass muster in a landscape or tree, but even the untrained eye is more critical of the human figure – because it is ourselves. [1951/Bibl. 18].

For me sculpture is based on and remains close to the human figure. That works both ways. We make the kind of sculpture we make because we are the shape we are, because we have the proportions we have. All those things make us respond to form and shape in certain ways. If we had the shape of cows, and went about on four legs, the whole basis of sculpture would be entirely different. If it were only a matter of making a pleasurable relationship between forms, sculpture would lose, for me, its fundamental importance. It would become too easy. [1962/Bibl. 14].

36 SEATED WOMAN, *1924. Drawing from life. Pencil,* $10\frac{1}{2} \times 12$ *in.*
Peter Palumbo.

Some people have said why do I make the heads so unimportant. Actually, for me the head is the most important part of a piece of sculpture. It gives to the rest a scale, it gives to the rest a certain human poise and meaning, and it's because I think that the head is so important that often I reduce it in size to make the rest more monumental. It's a thing that anyhow was done. The heads of Michelangelo's figures will sometimes go twelve times instead of the usual six and a half, which is the average. It is a recognised thing. [1964/Bibl. 3].

The sculptor, the artist in general, in going around, in living, in just using his eyes, must inevitably take in his environment, above all he must react to the human figure. This does not imply, of course, that the artist is restricted only to overtly figurative works; in some sculpture, I am intrigued by the problem of a formal nature almost exclusively while in others I am intent on endowing what I do with a human meaning. You must concede that a sculpture can possess more than one meaning. The artist will sometimes start with a scribble, a piece of clay perhaps, and in the process of working out his initial idea – the impulse that led him to start – fuller ideas will come to him, so that the forms carved out from a piece of wood may become susceptible of interpretation say as a mother protecting her child, or as an embryo. The artist has no need to take a literary theme to substantiate his delight in humanity; he can make his point, reveal his love for his fellows just by suggesting, as I tried to do in my *Reclining Figure* in elmwood of 1945/1946, the operations, the palpitations of a human heart (**27**).

What I mean is this. You don't need to represent the features of a face to suggest the human qualities that are special to a particular person. My aim has not been to capture the range of expressions that can play over the features but to render the exact degree of relationship between, for example, the head and the shoulders; for the outline of the total figure, the three-dimensional character of the body, can render the spirit of the subject treated. If you see a friend in the distance, you don't recognise him by the colour of his eyes (these you are unable to see) but by the total effect made by his figure – the general disposition of the forms. Look, for instance, at a red chalk drawing by Watteau – one of those little tender sketches in which he has captured from the back view the poise of a neck and a head.[1] We can tell the character of the sitter, her face even from the way she holds herself. [1959/Bibl. 49].

1. See **39** which, although a detail from a painting and not a drawing, illustrates this point.

On space and form

One distorts the forms in order to create space . . .

If space is a willed, a wished-for element in the sculpture, then some distortion of the form – to ally itself to the space – is necessary.

At one time the holes in my sculpture were made for their own sakes. Because I was trying to become conscious of spaces in the sculpture – I made the hole have a shape in its own right, the solid body was encroached upon, eaten into, and sometimes the form was only the shell holding the hole. Recently I have attempted to make the forms and the spaces (not holes) inseparable, neither being more important than the other. In the last bronze *Reclining Figure* (1951) I think I have in some measure succeeded in this aim (**37**). What I mean is perhaps most obvious if this figure is looked at lengthwise from the head end through to the foot end and the arms, body, legs, elbows, etc. are seen as forms inhabiting a tunnel in recession (**38**). Seen in plan the figure has 'pools' of space.

FORM FROM THE INSIDE OUTWARDS

Tension and inner force of forms

Force, Power, is made by forms straining or pressing from inside. Knees, elbows, forehead, knuckles, all seek to press outwards. Hardness projecting outwards, gives tension, force, and vitality – clenched fist, symbol of Power – of Force.

Although carved sculpture is approached from the outside, if it ends by seeming to be sliced or scooped into its shape out of a larger mass, it will not have its maximum sense of bigness. [1953/Bibl. 22].

Have you ever done any wire sculpture?

No, I've not done wire sculpture in the usual way. But when you start any sculpture

that's built-up in plaster or modelled in clay, you make an armature first to support the clay or plaster, and this armature is a kind of sculpture made up of the centre lines, the spatial skeleton as it were of the form you are going to make afterwards. To that extent wire sculpture is not a new invention at all.

Do you think it has contributed anything new to sculpture?

Yes, I mean in this sense that there was and still is an interest among young sculptors in space more than in solid form, and an armature has a more obvious sense of space about it, more than a single solid form has. But one gets to know eventually that the understanding of space is only the understanding of form . . . If you hold your hand as I am doing now, the shape that those fingers would enclose if I were holding an apple would be different from the shape if I were holding a pear. If you can tell what that is, then you know what space is. That is space and form. You can't understand space without being able to understand form and to understand form you must be able to understand space. If I can really grasp in my mind the shape of your head, I must know what distance there is from your forehead to the back of your head, and I must know what shape the air is between your eyebrows and your nostrils, or down to the cheeks. The idea that space is something new in sculpture is only spoken of by people who can't know what space and form are.

How did you first arrive at your own early uses of space? I am thinking of your use of holes.

That was the attempt to understand three-dimensional form, and to try and grasp all kinds of form, whether it's hollow form, solid form, form projecting from a surface or . . . every possible facet of three-dimensional reality. When I first began doing stone sculpture, about 1920, the most obvious thing about stone was its solidity. I began by trying to make sculpture which should be as stony as the stone itself, but afterwards I realised that unless you had some tussle, some collaboration and yet battle with your materials, you were being nobody. The artist must impose himself and his ideas on to the material, in a way that uses the material sympathetically but does not use it passively. Otherwise you are only behaving like the waves. There must be a human imprint and a human idea.

I wanted to make the forms in the stone more completely realised. Instead of embedding an arm into a body – which is the first way that one begins direct carving, or rather only drawing on the surface, only making incised marks on the surface – I

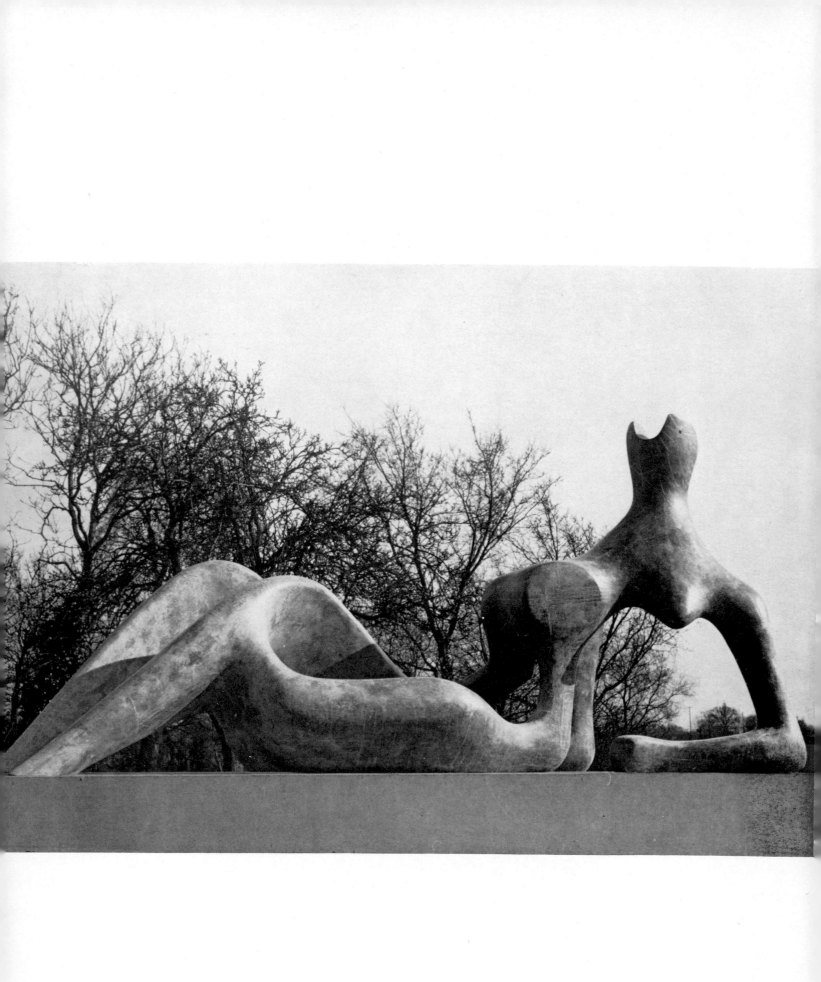

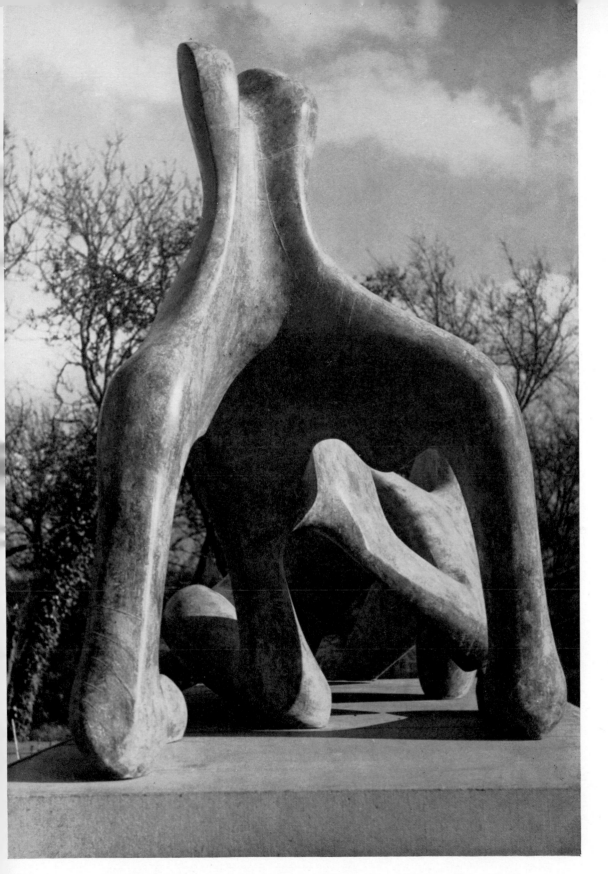

37 *and* **38** RECLINING FIGURE, *1951. Bronze, l. 90 in.* Arts Council of
Great Britain; Musée de l'Art Moderne, Paris.

wanted to make forms free themselves from the matrix. I tried to divide a single piece of stone up into three or four forms which had angles to each other, which thrusted in different directions, in the same way that reality does. When I look at you, I see the space that is made by your head resting on your hand and the space in between, your forearm is a single mass, your head is another – your head is being supported by that forearm at present, and that's resting on the knee that juts out. All this is giving space, all this is giving action and reality to form. It's not just drawing on the surface. To understand space I have to begin to think of actual penetrations into the stone. [1960/Bibl. 9].

Scale

Every sculptor has a size to which he works. Michelangelo's was the sublime. You know his *David* – it's fourteen feet high. He carved that when he was twenty-one – an unbelievable feat for a young man, but he had already established his own monumental scale.

Watteau, to take an opposite, had a tiny scale. He could say everything he wanted, create his own special world, in a picture eighteen inches square. He didn't aim at grandeur; one can be on easy familiar terms with his creations. You could take a Watteau woman out to dinner (**39**); you couldn't take a Michelangelo woman out to dinner, you'd be terrified.

My own scale? It's just over life-size. I think that's because I want my works to stand out-of-doors and be seen in a natural setting, and figures seen out-of-doors always look slightly smaller than they are.

The figure for Unesco I'm working on now is the biggest I've ever done. (**111**) That's about twice life-size – and it has brought me an entirely new set of problems. One of them is to keep the distinction between strength and mass. It's easy in doing a work on a huge scale to imagine it's strong, full of vitality – which is what I want – when it's merely big and heavy.

Isn't it a relief to turn from working on a full size figure to working on little clay models?

Not a bit. Everything I do is intended to be big, and while I'm working on the models, for me they are life-size. When I take one in my hand like this, I am seeing and feeling it as life-size. It's actually easier to visualise the small models in this way than, say, a half-size figure which would cover the top of a desk or table.

When I've got the model in my hand, I can be on all sides of it at once and see it from every point of view – as a sculptor has to do – instead of having to keep walking round it. So in my mind there's never any change of scale at all. [1957/Bibl. 13].

Scale is an extraordinarily subtle matter, and the figures of an artist whose vision is

39 *Watteau.* L'EMBARQUEMENT POUR L'ÎLE DE CYTHÈRE (*detail*), *c. 1719.*
Oil, 50¾ × 76 in. Gemäldegalerie, Berlin-Dahlem.

attuned to certain dimensions create an illusion of those dimensions regardless of their actual size. For example Boucher's nudes even when they are much larger than life-size, are always images of a woman about 5 ft. 4 ins. in height, whereas the smallest thumbnail sketches by Michelangelo project monumental figures at least 7 feet tall. By the same token there are many sculptures that look less than life-size even when they are over 7 feet high. [1955/Bibl. 55].

Does the idea as you first conceive it have a size to go with it?

Yes, the idea usually has a size to go with it. But also, one often has a size in one's mind before the idea. Now for some reason or other – perhaps it's since I built the new studio where I've got more space – I tend to make bigger sculptures than I used to. It may also be the fact that I did the large sculpture for the Unesco building in Paris which was easily five or six times as big as anything I'd ever done before. That stretched my ideas of size. I find now that even the smallest drawing that I make, or the smallest idea that I model in plaster in my hand, in my mind is often on a scale over life-size.

I wonder if you feel that your physical circumstances hampered the ideal size of your early sculpture?

There's no doubt that in some of the early sculptures I would have liked to work on a bigger size than I did, and that circumstances prevented me. I had a studio in Hampstead which one had to approach up iron steps, and any stone which was over a couple of hundredweight – and that's very little for a piece of stone – became a tremendous physical problem to get in, and to get out to send to exhibitions. All this in the background tends to make you reduce your size a bit.

Anyhow, that thing of scale, of size, is a mixture of the two things, of physical size and mental scale . . . For example the little sketches of horses (**40**) that Leonardo made in his sketch book were sometimes no bigger than a thumbnail, but you don't have that idea when you look at them. You think of a horse big enough to make a statue. And the same with Michelangelo sketches. There's a mental scale independent of the actual physical size.

I personally would like to think that the smallest sculpture that one makes has a bigness in it which would, if it had been necessary, have allowed the work to be

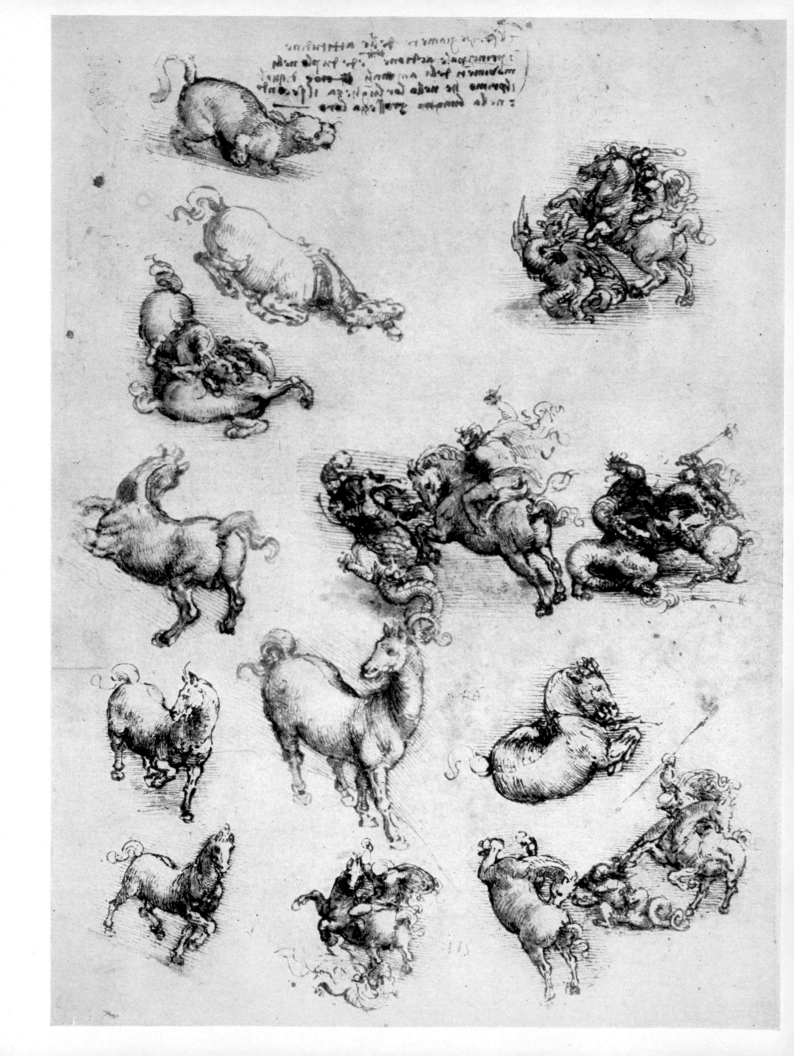

enlarged without losing anything. In fact I would like to think that it would have gained, and in that sense I have an admiration, an ambition, a goal for something which looks big even in a photograph. I would like to think that one's works have about them a monumentality even if they're small. And I think that can happen.

There are some things like, for example, the Albert Memorial, that are really just enlarged small ideas. They're wrong in their scale, they haven't got their true physical size. [1960/Bibl. 9].

If I were to go over the experiences that have stood out for me above all others, I think that nearly all of them would have what I'd call a quality of monumentality. It's not a question of size – a Cézanne can be only ten inches by eight and yet have absolute monumentality – it's a question of the mind behind the work. I found it in the Cézanne *Bathers* (**72**) . . . and in the Masaccio *Tribute Money* (**41**). When I was in Florence I used to go and see the *Tribute Money* for ten minutes or a quarter of an hour every day before I went on to other things. And Michelangelo's *Last Judgment* has it too, of course, and Rembrandt's self-portraits.

It comes up in Mexican sculptures, too, but they also have a cruel hard stoniness that's the opposite of the other qualities I like in European art. Because, you see, the things I like most are also marked by a deep human understanding. I like art to give a more than every-day feeling. If it's only a reflection of some commonplace mood, enjoyable and pleasurable as that may be, I don't think it helps us to stand up to what we all know is a difficult life. But when Cézanne starts painting his *Card-Players* they take on a nobility that raises everyday life to a height that gives you a new faith in it and a new excitement [1961/Bibl. 47].

You see, there is a difference between scale and size. A small sculpture only three or four inches big can have about it a monumental scale, so that if you photographed it against a blank wall in which you had nothing to refer it to but only itself – or you photographed it against the sky against infinite distance – a small thing only a few inches big might seem, if it has a monumental scale, to be any size. Now this is a quality that I personally think all really great sculpture has; it's a quality which, for me, all the great painters have – Rubens, Masaccio, Michelangelo – all the great painters, artists, and sculptors have this monumental sense. Perhaps it's because they don't allow detail to become important in itself, that is, they always keep the big

40 *Leonardo da Vinci.* STUDIES OF ST. GEORGE AND THE DRAGON, HORSES AND A CAT. *Between 1500 and 1513. Pen and ink over black chalk, 11¾ × 8¼ in.* Her Majesty the Queen (Royal Library, Windsor).

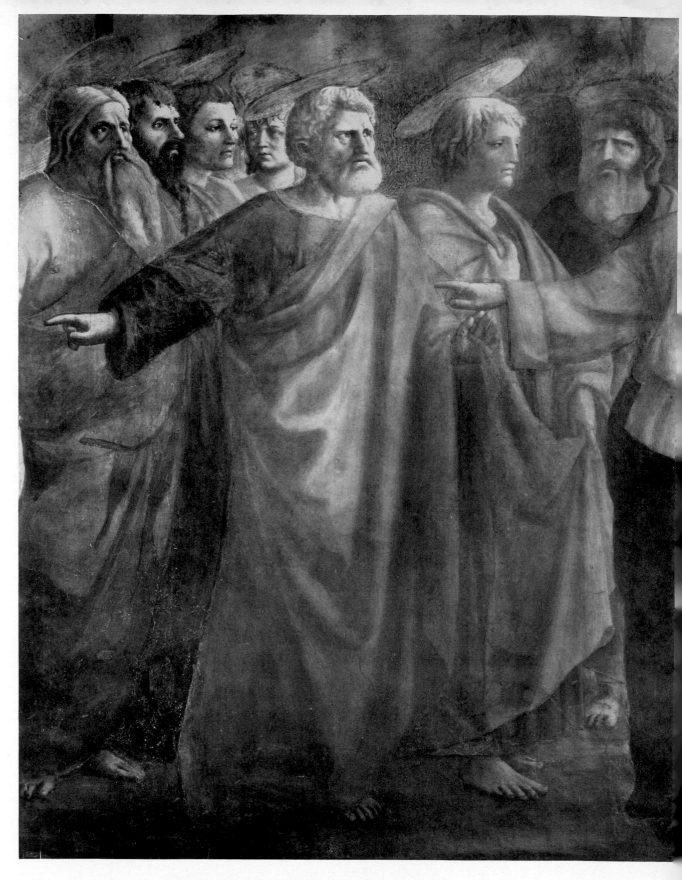

41 *Masaccio*. THE TRIBUTE MONEY (*detail*). *1427. Fresco*. Brancacci Chapel,
Santa Maria del Carmine, Florence. *The central figure is St. Peter.*

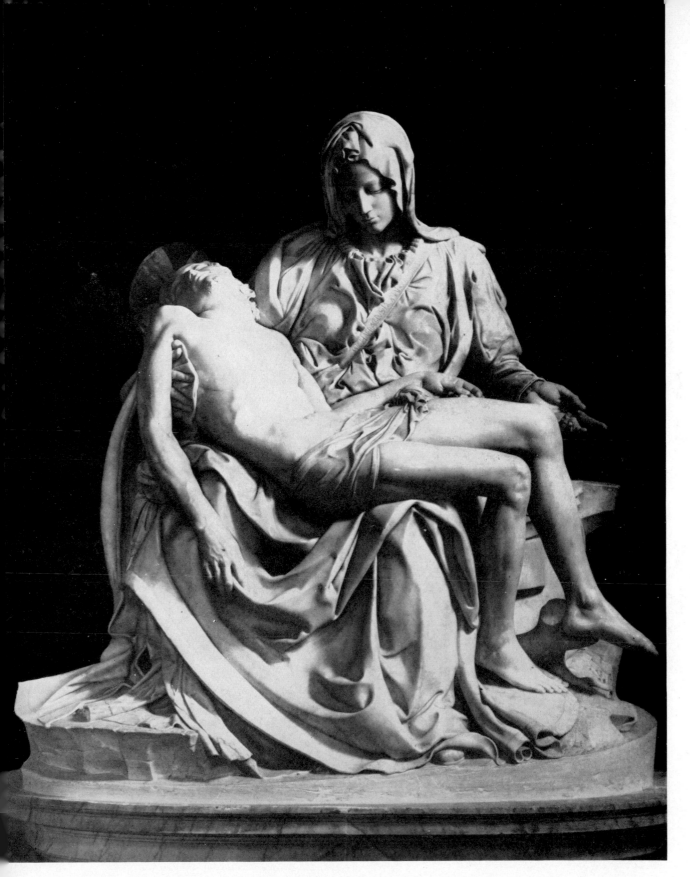

42 *Michelangelo.* PIETÀ, *1500. Marble, h. 69 in.* St. Peter's, Rome.

I

things in their proper relationship and the detail is always subservient. I don't know what does it, but something . . . that is, an artist can have a monumental sense, and it's a very rare thing to have; what I'm saying is that it doesn't come from actual physical size. When the work has this monumentality about it, then you can enlarge it almost to any size you like, and it will be all right; it will be correct. But in doing it, if a thing becomes bigger than life-size, then as you stand and look at it, the angle that you might look at the head will be different from what you'd look at if it were small. Therefore it might need some alteration to give you the same feeling that you'd get from it if it were a different size. As you make a thing bigger or smaller, you alter to keep true to the mental vision you've had of it. But I don't know; I can't explain what it is that gives monumental scale to something. I think it's an innate vision, a mental thing rather than a physical thing. It's in the mind rather than in the material.

In trying to analyse what this big scale in a work comes from, perhaps it is having an instinct so that the sculptor never forgets the big relevance of things, and no matter what amount of detail he puts into it, it is always subservient to the big general design of his form. For example, the Michelangelo *Pietà* in Saint Peter's in Rome (**42**) is full of detail – the drapery, hands, faces. Everything in the sculpture is finished to the nth degree and yet the whole sculpture is monumental, mainly because I think that Michelangelo in doing the detail never forgot the whole big general design that he was making; so that to say, for example, that simplicity gives monumentality in itself isn't absolutely true. Simplicity alone, just leaving things out, will not produce monumentality; it may only produce emptiness. True simplicity is done not for simplicity's sake, but because you don't forget the essentials. It's done to keep the essentials and not because you like simplicity; it's only because there's something more important. Therefore it becomes simple because you're saying a big thing that has a big statement. [1964/Bibl. 6].

Tactile values

Whenever I see this figure (**43**) I am reminded of a boyhood experience that contributed towards the conception of its form. I was a Yorkshire miner's son, the youngest of seven and my mother was no longer so very young. She suffered from bad rheumatism in the back and would often say to me in winter when I came back from school, 'Henry, boy, come and rub my back.' Then I would massage her back with liniment. When I came to this figure which represents a fully mature woman, I found that I was unconsciously giving to its back (**44**) the long-forgotten shape of the one that I had so often rubbed as a boy

Tactile experience is very important as an aesthetic dimension in sculpture. Our knowledge of shape and form remains, in general, a mixture of visual and of tactile experiences. A child learns to judge distance by touching things, and our sense of sight is always closely associated with our sense of touch. That is why a blind man learns to rely more exclusively on the use of his hands. A child learns about roundness from handling a ball far more than from looking at it. Even if we touch things with less immediate curiosity, as we grow older, our sense of sight remains closely allied to our sense of touch

Blind persons have been known to model sculptures which are usually exciting. Still, there are limitations to the proportions of a blind artist's sculpture. Size would pose a great problem, and it would be almost impossible to conceive a very large figure, with a proper integration of the relationships of its masses as parts, without ever being able to have recourse to one's sight. Some people, misunderstanding the nature of tactile values, and perhaps wishing to be fashionable, will often say, 'I love touching sculptures'. That can be nonsense. One simply prefers to touch smooth forms rather than rough ones, whether these forms be natural or created by art. Nobody can seriously claim to enjoy touching a rough-cast sculpture, with its unpleasantly prickly surface that may be nonetheless good sculpture. No one likes touching cold and wet objects for example. A sculpture may thus be excellent according to quite a number of different criteria and still unpleasant to touch. But the tactile element remains of primary importance in the actual creation of mass sculpture.

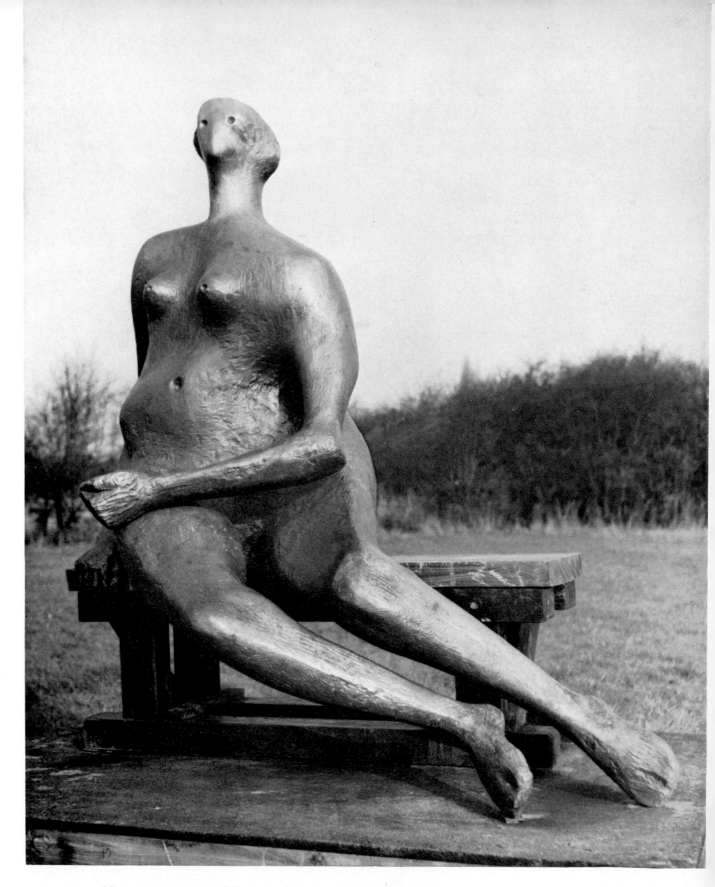

43 SEATED WOMAN (*front view*), *1957. Bronze, h. 57 in.*

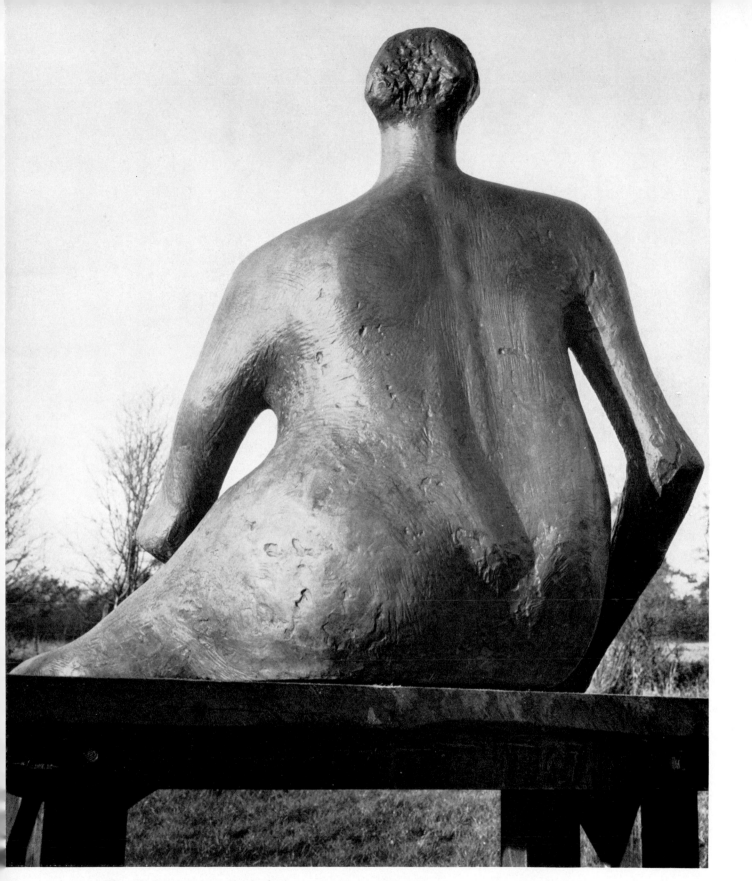

44 SEATED WOMAN (*back view*), *1957. Bronze, h. 57 in.*

Berenson has already discovered at great length the tactile qualities of a certain kind of painting, especially of the more sculptural art of Piero della Francesca or of Mantegna. But painting can suggest a whole range of tactile qualities, not only of sculptural awareness of roundness or relief that is suggested by Mantegna and Piero della Francesca, but also the awareness of texture that is suggested in a Courbet still-life, where the features of a pheasant and the fur of a hare can almost make your fingers tingle.

But these last tactile qualities of painting can also degenerate into a kind of cheap illusion, like that of a performing magician. They exist, in a way, in sculpture too, for instance when a marble or bronze suggests the silky texture and the softness of human flesh. Actually, this is fairly easy to achieve, and many an outstanding sculptor is popularly admired for the finish that his assistants have given to his works.

I have often been struck by the essentially tactile nature of certain distortions of the human form in your sculpture. It has seemed to me that these are sometimes inspired by tactile illusions of feeling, as opposed to the optical illusions that inspire most distortions in art.

You are right. I believe that there can be distortions, tactile rather than visual in origin, which can make a sculpture much more exciting, though they may give an impression of awkwardness and disjointedness to an art-lover who is more accustomed to the distortions of painting. Sculpture with such tactile exaggerations can be so much more exciting than the smooth and merely pictorial ease that characterises most bad nineteenth-century sculpture.

I have often felt that only Carpeaux, Rodin and Medardo Rosso, in the whole second half of the nineteenth century, really understood the purposes and the principles of sculpture.

Rodin of course knew what sculpture is: he once said that sculpture is the science of the bump and the hollow. [1960/Bibl. 45].

Carving

I like carving as a physical occupation, better than modelling. I vividly remember the pleasure I felt when I first used a hammer and chisel. I was sixteen at the time and I made a little war memorial, a roll of honour for the grammar school I was at.

When I was a student direct carving as an occupation and as a sculptor's natural way of producing things, was simply unheard-of in academic circles, though Brancusi and Epstein and Modigliani had used it. I liked the different mental approach involved – the fact that you begin with the block and have to find the sculpture that's inside it. You have to overcome the resistance of the material by sheer determination and hard work. I liked that very much, and in fact I still prepare my plasters for bronzes with a mixture of modelling and carving. (**15** and **16**).

But I don't want to put too much stress on the actual act of carving, or on the craftsmanship involved. Craftsmanship in sculpture is just common sense – anyone can learn it. It's certainly easier than in painting, I'd say. The mental grasp is difficult, and the three-dimensional conception, but the workmanship, which people like Eric Gill thought so important, can degenerate into a most awful mental laziness, like knitting or polishing the silver. [1961/Bibl. 47].

I think it's a very good disciplinary training for the young sculptor because in a stone sculpture you can't take things so easily, you don't get away with something that doesn't exist, and you can't alter and rub out, and build up, and stick on and take off . . . At one time I used to think that carved sculpture . . . was the best sculpture. . . . But now I don't think it matters how a thing is produced, whether it's built up, modelled, welded, carved, constructed or whatever. What counts really is the vision it expresses . . . that is, it's the quality of the mind revealed behind it, rather than the way it's done. . . . I think it was perhaps my discovery of and excitement over primitive sculpture that made me more sympathetic to carving than modelling, for most primitive sculpture is carved sculpture. In those days too, I loved stone. A piece

of stone, any piece of stone in a landscape (**14**), a big rock (**119**), I just love, more even than I love wood. Yet I like wood and I like clay too. Clay is wonderful stuff to punch and feel that the imprint of your fist is left in it. [1960/Bibl. 9].

Bronze casting

To cast a large work into bronze is quite a major operation, but bronze casting on a small scale can, of course, be done by the sculptor himself. At one period of my career I thought I ought to know how bronze casting was done, and I did it myself at the bottom of the garden, along with my two assistants. We built a foundry in miniature of our own, and throughout one year I cast some eight or ten things into bronze. The experience was very valuable, but I now get all my casting done by long established bronze foundries with generations of experience in the work. . . .

There are two main methods of bronze casting – the 'sand' process and the 'lost wax' process which I used. In this method, the founder (by the same moulding procedure that he would use to make a copy in plaster) makes a wax replica of the sculptor's original work. This wax replica is covered with a mixture of water, plaster and powder made from ground-up pottery – called grog – and this mixture sets hard, leaving the wax buried inside it. This mould is then baked in a kiln, when, through a hole left in the mould, the wax melts and runs out (is 'lost'), so you now have a space inside the mould exactly the shape of the original model, and into this hole you pour the molten bronze, and because of the baking in the kiln, the mould is conditioned to resist the enormous heat of the molten bronze.

Of course there are details you have to watch. For example, in an intricate model there must be 'leads' and 'runners' inside the mould so that the molten bronze runs into all parts and doesn't make any air locks, and you must know the exact temperature at which to pour in the molten metal, and have a furnace to bring it up to this great heat.

Except for the difficulty of melting bronze, I had done all this same metal casting in making my lead sculptures of 1938, '39 and '40, and I had then found that I could jump the early stage of casting by making my original sculpture directly in wax. Now, working direct in wax has many possibilities, since wax has a toughness about it that will allow you to do very thin forms – for example take that rocking chair sculpture of mine (**45**) in which the back of the chair is in struts like a ladder, you couldn't make that construction in clay, nor in plaster, without awful trouble, whereas that was modelled directly in wax, easily and straightforwardly. Then all

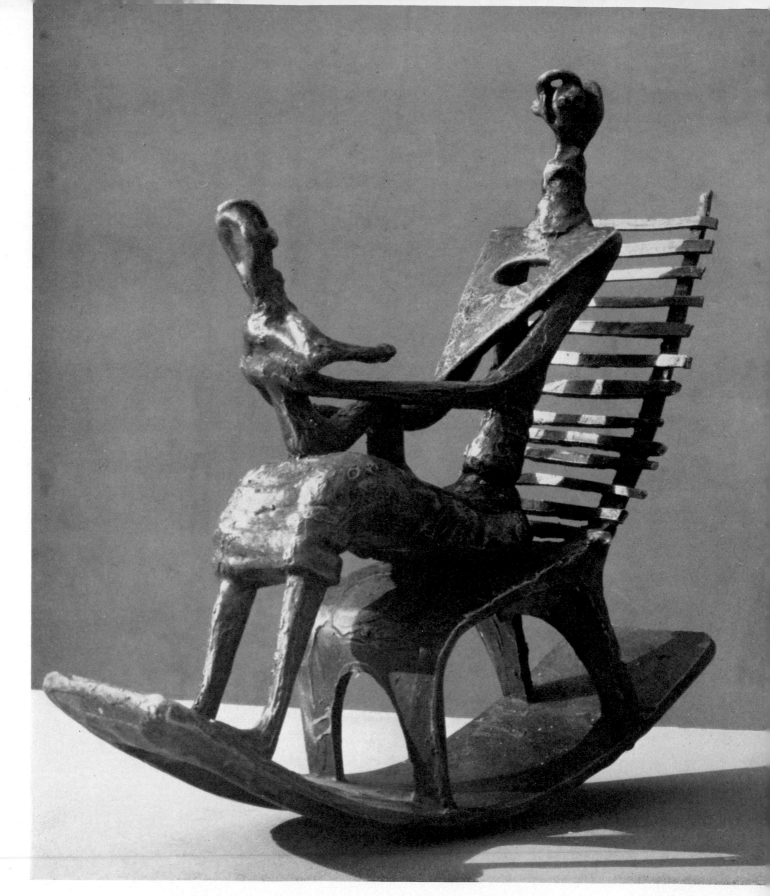

45 MOTHER AND CHILD ON LADDERBACK ROCKING CHAIR, *1952.*
Bronze, h. 8¼ in.

one had to do was to cover that with plaster and ground-up pottery and melt the wax out and cast it in bronze. By working direct in wax, one was able to make shapes and forms much thinner and more open than ever you could have done direct in plaster. Doing my own metal casting led me to doing those, and some other basket forms. . . . And one could do a sort of birdcage idea – one form inside another – which would be impossible to make in clay or plaster.

And this working direct in wax has become, with very many young sculptors, an understood and general method now. They model directly in wax and then just have that wax turned into bronze. It gives them a chance to do more spatial forms.

Have you made any more wax sculptures recently?

Not very many at present. I make most of my sculptures direct in plaster – if they are going to be in bronze. That plaster original is sent to the foundry. The foundry then makes a mould and from that single mould it can make as many waxes as I intend the edition of bronzes to be.

How many do you have made?

Well, it varies according to the size of the sculpture and what demand there might be for it. One has to decide when a piece is done what edition you are going to make, just as a lithographer or an etcher will decide that he is not going to produce more than such and such a number. For example, of each of the Degas bronzes there are twenty casts. In some cases of Rodin's there are thirty or forty casts of a work. I personally don't like having more than four or five casts made of a large sculpture, but of a very small piece one doesn't mind if the edition goes to ten.

What does it cost to cast a large, life-size sculpture?

It's a very expensive business. And this precludes young sculptors in the beginning of their careers from having their sculptures cast into bronze. A life-size sculpture, my *King and Queen* for example (**101**), costs over a thousand pounds to cast into bronze. When one is young, beginning, it tends to keep you from doing a large sculpture, certainly from having your large sculptures cast into bronze, unless a copy happens to be ordered.

You mentioned the process of patinating your bronzes when they come back from the foundry.

What is this process and how do you do it?

I like working on all my bronzes after they come back from the foundry. A new cast to begin with is just like a new-minted penny, with a kind of slight tarnished effect on it. Sometimes this is all right and suitable for a sculpture, but not always. Bronze is very sensitive to chemicals, and bronze naturally in the open air (particularly near the sea) will turn with time and the action of the atmosphere to a beautiful green. But sometimes one can't wait for nature to have its go at the bronze, and you can speed it up by treating the bronze with different acids which will produce different effects. Some will turn the bronze black, others will turn it green, others will turn it red.

In doing your sculpture you have imagined a certain quality in the bronze. No sculptor works direct in bronze; you can't take a solid piece of bronze and cut it to the shape you want, so all sculptors who intend having their work in bronze are working with a mental idea of what it is going to look like, while they make it in some other material.

I usually have an idea, as I make a plaster, whether I intend it to be a dark or a light bronze, and what colour it is going to be. When it comes back from the foundry I do the patination and this sometimes comes off happily, though sometimes you can't repeat what you have done other times. The mixture of bronze may be different, the temperature to which you heat the bronze before you put the acid on to it may be different. It is a very exciting but tricky and uncertain thing, this patination of bronze.

It is entirely a matter of swabbing it with chemicals, is it?

And also afterwards you can then work on the bronze, work on the surface and let the bronze come through again, after you've made certain patinas. You rub it and wear it down as your hand might by a lot of handling. From this point of view bronze is a most responsive and unbelievably varied material, and it will go on being a favourite material for sculptors. You can, in bronze, reproduce any other material you care to. [1960/Bibl. 9].

New ideas

I use the little studio . . . when I'm thinking of a new idea, when I'm trying to get my mind working on a new sculpture. In the far end there's a small room where I put all the odds and ends that I have collected, bits of pebbles, bits of bone, found objects, and so on, all of which help to give one an atmosphere to start working (**46**).

Do you consciously try to get your mind working on a new piece? How do ideas come to you?

Well in various ways. One doesn't know really how any ideas come. But you can induce them by starting in the far little studio with looking at a box of pebbles. Sometimes I may scribble some doodles, as I said, in a notebook; within my mind they may be a reclining figure (**47**), or perhaps a particular subject. Then with those pebbles, or the sketches in the notebook, I sit down and something begins. Then perhaps at a certain stage the idea crystallises and then you know what to do, what to alter. You dislike what you've just made, and change it. At the end of a week you're sitting in that nice little easy chair with the bench in front, and there'll be probably some fifteen or so maquettes about five or six inches long, if it's a reclining figure, or that height if it's an upright. Then either I know that a few of those are ideas that I like, or that I don't like any of them. If some are ones that I like, then I'll do a variation on that idea, or I'll change it if I'm critical. Done in that way the thing evolves. In my mind always though, in making these little ideas, is the eventual sculpture which may be ten or twelve times the size of the maquette that I hold in my hand. [1960/Bibl. 9].

When I first began doing sculpture about 1922 or so, I often worked direct in a piece of stone or wood, which might have been not a geometric shape but just an odd random block of stone that one found cheaply in some stonemason's yard, or a log of wood which was a natural shape, and then I'd make a sculpture, trying to get as big a sculpture out of that bit of material as I could, and therefore one would wait until the material suggested an idea.

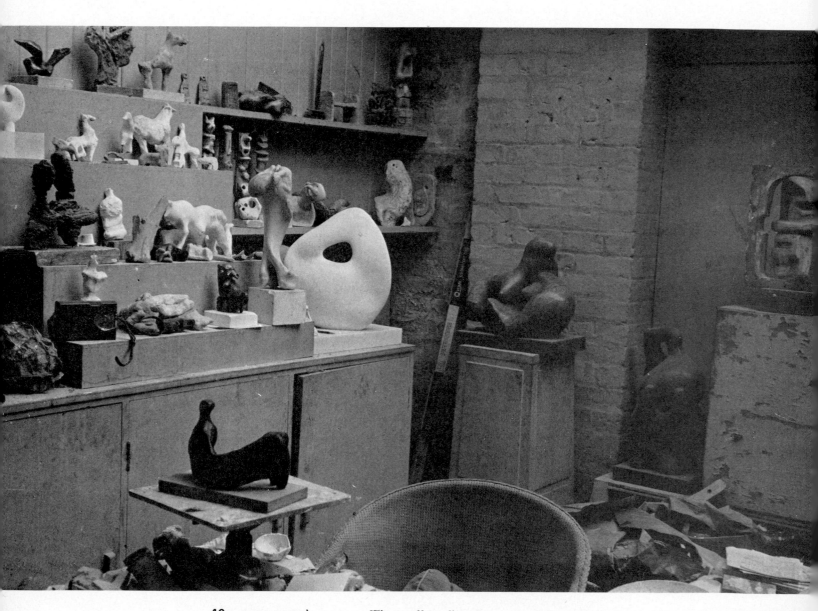

46 THE ARTIST'S STUDIO. *The small studio where most of the maquettes are made. Some of the natural objects, from which ideas for sculpture have grown can be seen in the background.*

In Transferring studies into
stone — harden & tighten, stiffen
tauughten them up

Reclining Figure

47 STUDIES AND TRANSFORMATIONS OF BONES, *c. 1932. Pencil drawing,*
9¼ × 8 in. The artist. *A jawbone becomes a reclining figure.*

Nowadays I don't work so much in that way, as I have an idea, or an idea comes to me, and then I find the material to make it in, and to do that, the ideas that I am concerned with, I'll produce several maquettes – sketches in plaster – not much bigger than one's hand, certainly small enough to hold in one's hand, so that you can turn them around as you shape them and work on them without having to get up and walk around them, and you have a complete grasp of their shape from all around the whole time. If the form, the idea, that you're doing is much bigger than that, then to see what it's like on the other side, you have to get up, walk around it, and this restricts your imagining and grasping what it's like as you can when it's small. But all the time that I am doing this small model, in my mind it isn't the small model that I'm doing, it's the big sculpture that I intend to do. It's as though one were drawing in a little sketchbook a tiny little sketch for a monument, or a tiny little drawing might be on the back of an envelope, but in your mind would be the equestrian statue that is over life-size. In the same way, these little plaster maquettes that I make, to me, are all big sculptures. Therefore, when I choose the one that I think has the best possibility and retains my interest, then it's only carrying out one's original idea in reality. For example, the maquette for this two-piece *Locking-Piece* (**48**) came about from two pebbles which I was playing with and which seemed to fit each other and lock together, and this gave me the idea of making a two-piece sculpture – not that the forms weren't separate, but that they knitted together. I did several little plaster maquettes, and eventually one nearest to what the shape of this big one is now pleased me the most and then I began making the big one. But in making the big one, the small one changes because you have to alter forms when they are bigger from what they are when they're small, because your relationship to them is a different one. [1964/Bibl. 6].

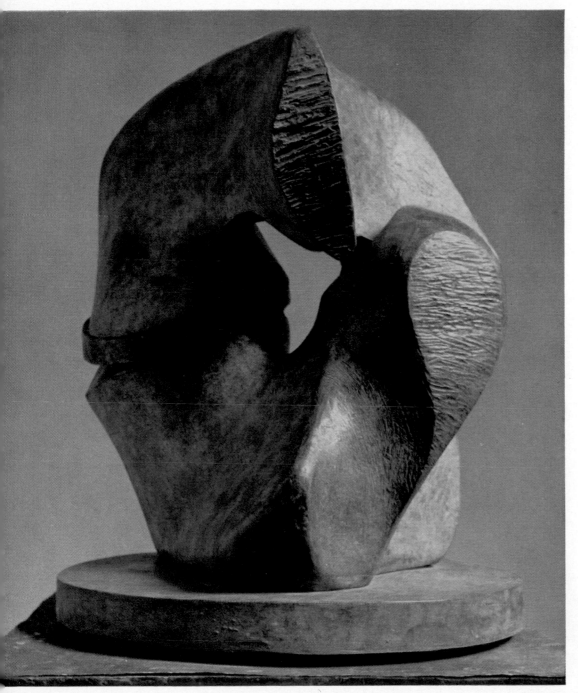

48 WORKING MODEL
FOR LOCKING
PIECE, *1962. Bronze,
h. 42 in.* Lehmbruck
Museum, Duisburg.

K

Drawing

Every few months I stop carving for two or three weeks and do life drawing. At one time I used to mix the two, perhaps carving during the day and drawing from a model during the evening. But I found this unsatisfactory – the two activities interfered with each other, for the mental approach to each is different, one being objective and the other subjective. Stone as a medium is so different from flesh and blood that one cannot carve directly from life without almost the certainty of ill-treating the material. Drawing and carving are so different that a shape or size or conception which ought to be satisfying in a drawing will be totally wrong realised as stone. Nevertheless there is a connection between my drawings and my sculpture. Drawing keeps one fit, like physical exercises – perhaps acts like water to a plant – and it lessens the danger of repeating oneself and getting into a formula. It enlarges one's form repertoire, one's form experience. But in my sculpture I do not draw directly upon the memory or observations of a particular object, but rather use whatever comes up from my general fund of knowledge of natural forms. [1944/Bibl. 41].

I still do drawings in notebooks, usually in an evening as I sit by the fire after a day's work in the studio. But they are not drawings which I envisage being framed afterwards or exhibited, they are either sketchbook tryouts of possible ideas for sculpture (**49**), or just scribbles in which one hopes that some new idea might come . . . perhaps because I am now doing sculptures which are bigger in actual dimensions and so each one takes longer to do, and is perhaps more continuously absorbing than the smaller pieces were. And perhaps because sculpture for me is now really the main thing, and gives me nearly all that I want to do. When one is young there are lots of possibilities that one hasn't tried out; drawing is a means of finding your way about things, and a way of experiencing, more quickly than sculpture allows, certain tryouts and attempts. Now I have work planned out, or in progress, for several months ahead – and I have at present, I think, three large sculptures going on together in different stages – and each large sculpture can take three to four months.

146

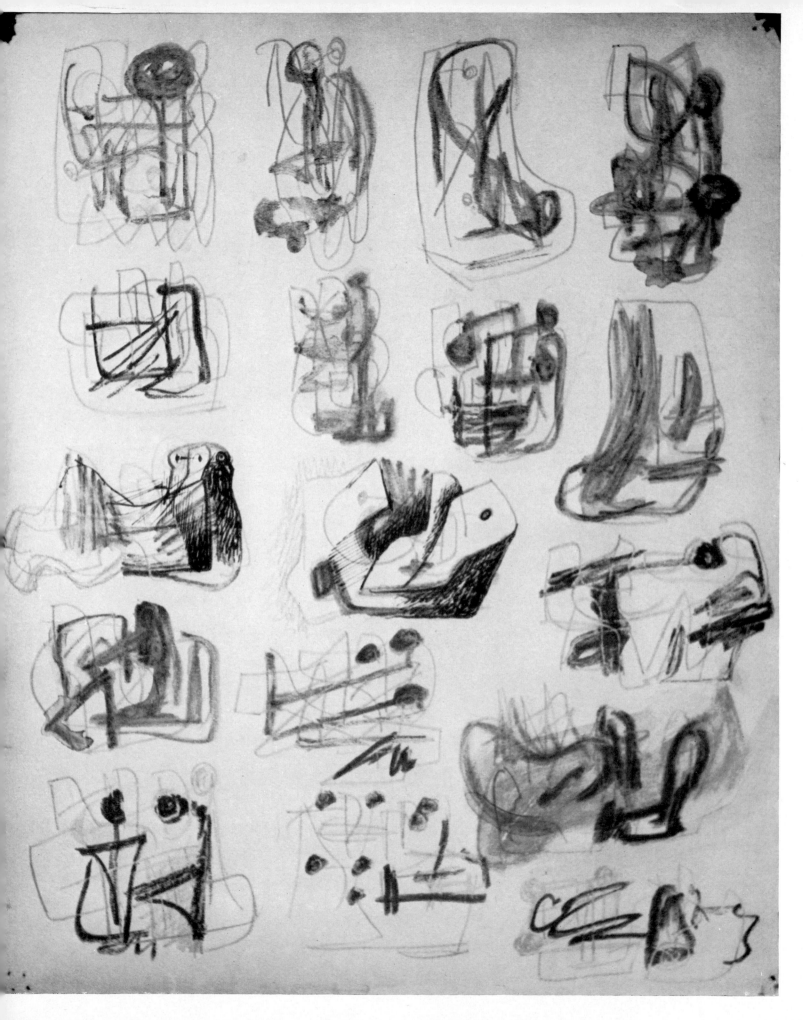

I don't now attempt through drawing to get out so many ideas for new sculptures. . . .

Leonardo has a great passage in which he lists the reasons why painting is superior to sculpture. . . . Do you have any reason for thinking that sculpture is superior to drawing, or do you simply prefer it for yourself?

I think Leonardo also said that sculpture wasn't a gentleman's occupation, that you got dirty doing it.[1] This seemed to him a very important argument. Whereas on the other side Michelangelo said that sculpture could express everything. And I think I know now what Michelangelo meant by saying that. I think he meant that it can express so much that what it can't express you don't need to worry about, because ten lifetimes wouldn't be enough to do what it *can* do.

This explanation, this attempt, this interest in three-dimensional form – in expressing oneself through solid form – this for me is the sculptor's aim. I think I am a sculptor and not a painter because I want something absolutely realised from all points of view, as I want to make it, something which exists, like myself, or like a table, or like a horse. That is the real satisfaction in making sculpture. You have really made something, you're not kidding yourself that something exists. A drawing or a painting can be read or interpreted by one person in one way or another. He may think that a certain depth is more than another person thinks it is. Some people may think that a certain form in drawing is meant to project *so* much. Other people may see it and think that it doesn't. In sculpture the form actually does whatever you have intended it to do. And so you can be satisfied that you have made what you intended to make. It may be that a sculptor has that kind of nature: he wants to make a piece of reality – wants to make an actual thing. I'm not meaning that it can't have implications which differ from one person to another, and I don't

1. He refers to a passage in Leonardo's remarks on the difference between painting and sculpture where he describes the art of the sculptor as 'a very mechanical exercise causing much perspiration which mingling with the grit turns into mud. His [the sculptor's] face is pasted and smeared all over with marble powder, making him look like a baker, . . . and his dwelling is dirty and filled with dust and chips of stone. How different the painter's lot . . . He is well dressed and handles a light brush dipped in delightful colour. He is arrayed in the garments he fancies, and his home is clean and filled with delightful pictures, and he often enjoys the accompaniment of music or the company of men of letters who read to him from various beautiful works to which he can listen without the interference of hammering and other noises.' Quoted from *Paragone. A comparison of the arts by Leonardo da Vinci.* With an introduction and English translation by I. A. Richter. London (Oxford University Press) 1949, pp. 94–5.

mean that it must have copied reality.

Perhaps all I should say is that sculpture is what I want to do most, and that the less time one has left in life the less does one want to distract or disperse one's energies into things other than sculpture. [1960/Bibl. 9].

There is a general idea that sculptors' drawings should be diagrammatic studies, without any sense of a background behind the object or of any atmosphere around it. That is, the object is stuck on the flat surface of the paper with no attempt to set it in space – and often not even to connect it with the ground, with gravity. And yet the sculptor is as much concerned with space as the painter.

He must make the object he draws capable of having a far side to it, that is, make it an object in space, not an object in relief (only half an object stuck on the paper, and stopping at the edges). It is necessary to give it the possibility of an existence beyond the surface of the paper.

Any wash, smudge, shading, anything breaking the tyranny of the flat plane of the paper, opens up a suggestion, a possibility of SPACE. [1953/Bibl. 22].

You were telling me a little while ago that you didn't work in the old way any more, beginning by drawing. Your way used to be to fill pages, sketch-book pages, with drawings, a variety of drawings. And you would go through these, selecting things that seemed interesting ideas. Then you would make a sketch model from a drawing and go on from there. This was your method for many years, wasn't it?

Yes.

When did you start to do that?

I think that was when one wasn't sure of ideas and directions. And it is also true that, being so young, one had lots of influences mixed up in one's mind, so that drawing was a means of generating ideas and also of sorting them out. Now I find that when what seems to me a good idea comes, I recognise it a lot quicker than perhaps I used to do.

May I get this idea straight about drawing, as a means of generating ideas? How much auto-

matism was there? Was it when the pencil was on the paper that things began to happen? Or were you actually carrying out things you visualised clearly in your head before you drew them?

One used to use both methods. Sometimes you would sit down with no idea at all, and at some point you'd see something in the doodling, scribbling – whatever you call it; and from then on you could evolve the idea. That would be a way of doing it, say, late in the evening. Early in the morning I used to find one would start off with a definite idea, that, for instance, it was a seated figure I wanted to do. That in itself would lead to a lot of variations of the seated figure; you would give yourself a theme and then let the variations come, and choose from those which one seemed the best.

When you say you started with this, was it simply the idea that you wanted to do some sort of seated figure or did you actually have a seated figure in your head as something you could see?

One tries – at least one tried when younger – to fit in one's mental ambition for sculpture with the immediate idea one had. I thought I knew what good sculpture was. But also, too, I was interested in particular subjects – especially reclining figure, and mother and child. But one has to amalgamate one's ideas of good sculpture, just as Michelangelo had an ideal of good sculpture when he said that a good piece of sculpture could be rolled down a hill without breaking. It proved that he had in his mind a vision of what was good sculpture.

This idea of a piece of sculpture that could roll down a hill without breaking was closely tied up with the thought of contrapposto,[1] which implied making the figure compact.

Sometimes you can begin from the two opposite ways. You can begin with the idea that you are searching for a good sculptural idea or you begin with the human idea, the mother and child, and you try to make it become a good sculpture; that is, you amalgamate life and art, and how you do it, whether you start from the art side or the life side, in a way doesn't matter, as long as the amalgamation comes.

But when you have in mind, shall we say, a Moore 'Seated Figure' would you actually, before beginning to draw, visualise what you were going to put down?

1. A pose in which one part of the body is twisted in the opposite direction from that of the other. Michelangelo in particular was famed for his skill in this mannerism.

I tried to avoid visualising the finished product until a later stage.

So in the morning drawing as well as the evening drawing you really were using drawing as a means of generating ideas?

Yes. I still like drawing just as much as ever, but there seems to be less time to do the sculpture one wants to do. Drawing has always been to me the lesser activity.

Your main work in the last few years has been a series of multiple-piece reclining figures. Has any of these started from a drawing?

No.

And what was the last important work you did that did start from a drawing?

I think probably the *Family Group* ones. The family group ideas were all generated by drawings: and that was perhaps because the whole family group idea was so close to one as a person; we were just going to have our first child, Mary, and it was an obsession. [1963/Bibl. 53].

Periods of art and individual artists

Primitive art

The term 'Primitive Art' is generally used to include the products of a great variety of races and periods in history, many different social and religious systems. In its widest sense it seems to cover most of those cultures which are outside European and the great Oriental civilisations. This is the sense in which I shall use it here, though I do not much like the application of the word 'primitive' to art, since, through its associations, it suggests to many people an idea of crudeness and incompetence, ignorant gropings rather than finished achievements. Primitive art means far more than that; it makes a straightforward statement, its primary concern is with the elemental, and its simplicity comes from direct and strong feeling, which is a very different thing from that fashionable simplicity-for-its-own-sake which is emptiness. Like beauty, true simplicity is an unselfconscious virtue; it comes by the way and can never be an end in itself.

The most striking quality common to all primitive art is its intense vitality. It is something made by people with a direct and immediate response to life. Sculpture and painting for them was not an activity of calculation or academism, but a channel for expressing powerful beliefs, hopes, and fears. It is art before it got smothered in trimmings and surface decorations, before inspiration had flagged into technical tricks and intellectual conceits. But apart from its own enduring value, a knowledge of it conditions a fuller and truer appreciation of the later developments of the so-called great periods, and shows art to be a universal continuous activity with no separation between past and present.

All art has its roots in the 'primitive', or else it becomes decadent, which explains why the 'great' periods, Pericles' Greece and the Renaissance for example, flower and follow quickly on primitive periods, and then slowly fade out. The fundamental sculptural principles of the Archaic Greeks were near enough to Phidias' day to carry through into his carvings a true quality, although his conscious aim was so naturalistic; and the tradition of early Italian art was sufficiently in the blood of Masaccio for him to strive for realism and yet retain a primitive grandeur and simplicity. The steadily growing appreciation of primitive art among artists and the public today is therefore a very hopeful and important sign.

50 A COURT OFFICIAL AND HIS WIFE. *Egyptian, 18th dynasty, c. 1325 B.C. Limestone, 52 in.* British Museum.

Excepting some collections of primitive art in France, Italy and Spain, my own knowledge of it has come entirely from continual visits to the British Museum during the past twenty years. Now that the Museum has been closed, one realises all the more clearly what one has temporarily lost – the richness and comprehensiveness of its collection of past art, particularly of primitive sculpture, and perhaps by taking a memory-journey through a few of the Museum's galleries I can explain what I believe to be the great significance of primitive periods.

At first my visits were mainly and naturally to the Egyptian galleries, for the monumental impressiveness of Egyptian sculpture (**50**)[1], was nearest to the familiar Greek and Renaissance ideals one had been born to. After a time, however, the appeal of these galleries lessened; excepting the earlier dynasties. I felt that much of Egyptian sculpture was too stylised and hieratic, with a tendency in its later periods to academic obviousness and a rather stupid love of the colossal.

The galleries running alongside the Egyptian contained the Assyrian reliefs – journalistic commentaries and records of royal lion hunts and battles, but beyond was the Archaic Greek room with its lifesize female figures, seated in easy, still naturalness, grand and full like Handel's music; and then near them, downstairs in the badly lit basement, were the magnificent Etruscan sarcophagus figures, which, when the Museum reopens, should certainly be better shown.

At the end of the upstairs Egyptian galleries were the Sumerian sculptures, some with a contained bull-like grandeur and held-in energy, very different from the liveliness of much of the early Greek and Etruscan art in the terracotta and vase rooms. In the prehistoric and Stone Age room an iron staircase led to gallery wall-cases where there were originals and casts of Palaeolithic sculptures made 20,000 years ago – a lovely tender carving of a girl's head, no bigger than one's thumbnail, and beside it female figures of very human but not copyist realism with a full richness of form, in great contrast with the more symbolic two-dimensional and inventive designs of Neolithic art.

And eventually to the Ethnographical room, which contained an inexhaustible wealth and variety of sculptural achievement (Negro, Oceanic Islands, and North and South America), but overcrowded and jumbled together like junk in a marine stores, so that after hundreds of visits I would still find carvings not discovered there before. Negro art formed one of the largest sections of the room. Except for the Benin

1. Moore clearly had an Egyptian official couple of this kind in mind when he made his *King and Queen* (**101**).

51 MASK *representing the god Xipe Totec (the flayed one) whose priests dressed themselves in the skins of freshly slain sacrificial victims as a symbol of the year's regeneration. Mexican (Aztec) 14th century. Basalt, h. 8¾ in.* British Museum.

52 MASK, *1929. Concrete, h. 8½ in.* Sir Philip Hendy. *The inspiration which Moore drew from Mexican sculpture was at its height at the end of the nineteen twenties. Compare the mask in* **51**. *See also the* Reclining Figure *of the same year in conjunction with the Mexican figure of* Chacmool. (**9** *and* **10**).

bronzes it was mostly woodcarving. One of the first principles of art so clearly seen in primitive work is truth to material; the artist shows an instinctive understanding of his material, its right use and possibilities. Wood has a stringy fibrous consistency and can be carved into thin forms without breaking, and the Negro sculptor was able to free arms from the body, to have a space between the legs, and to give his figures long necks when he wished. This completer realisation of the component parts of the figure gives to Negro carving a more three-dimensional quality than many primitive periods where stone is the main material used. For the Negro, as for other primitive peoples, sex and religion were the two main interacting springs of life. Much Negro carving, like modern Negro spirituals but without their sentimentality, has pathos, a static patience and resignation to unknown mysterious powers; it is religious and, in movement, upward and vertical like the tree it was made from, but in its heavy bent legs is rooted in the earth.

Of works from the Americas, Mexican art was exceptionally well represented in the Museum (**51**). Mexican sculpture, as soon as I found it, seemed to me true and right, perhaps because I at once hit on similarities in it with some eleventh-century carvings I had seen as a boy on Yorkshire churches. Its 'stoniness', by which I mean its truth to material, its tremendous power without loss of sensitiveness, its astonishing variety and fertility of form-invention and its approach to a full three-dimensional conception of form, make it unsurpassed in my opinion by any other period of stone sculpture.

The many islands of the Oceanic groups all produced their schools of sculpture with big differences in form-vision (**55**). New Guinea carvings, with drawn out spider-like extensions and bird-beak elongations, made a direct contrast with the featureless heads and plain surfaces of the Nukuoro carvings; or the solid stone figures of the Marquesas Islands against the emasculated ribbed figures of Easter Island (**54**). Comparing Oceanic art generally with Negro art, it has a livelier, thin flicker, but much of it is more two-dimensional and concerned with pattern making. Yet the carvings of New Ireland have, besides their vicious kind of vitality, a unique spatial sense, a bird-in-a-cage form (**53**).

But underlying these individual characteristics, these featural peculiarities in the primitive schools, a common world-language of form is apparent in them all; through the working of instinctive sculptural sensibility, the same shapes and form relation-ships are used to express similar ideas at widely different places and periods in history, so that the same form-vision may be seen in a Negro and a Viking carving, a Cycladic stone figure (**56**) and a Nukuoro wooden statuette. And on further familiarity

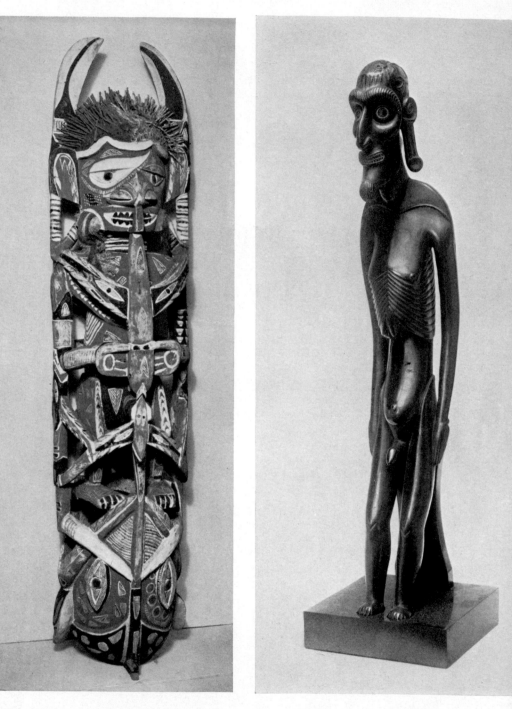

53 CARVING IN OPEN-WORK (*Malanggan*)
representing spirits and mythical beings.
Northern New Ireland, c. 1900. Wood with
painted decoration in red, black and white,
h. 42 in. British Museum. *An 'exterior-*
interior form' type of sculpture, the formal
idea of which appealed to Moore although he
did not find the spirit of the carving congenial.

54 ANCESTRAL FIGURE. *Easter*
Island. Toromiro wood, h. 19 in.
British Museum.

55 STOOL *of a chief in the form of a hula dancer. Hawaii, late 19th century. Wood,*
h. 26 in. British Museum. This figure, which also stands on its feet, has the sculptural
strength and formal power which Moore admires in primitive art.

56 MOTHER-GODDESS FIGURE
*from the Cyclades. Prehistoric Greek,
3rd millenium B.C. Marble, h. 16 in.*
Mrs. Irina Moore. *The sensitive and subtle
modelling, together with the unified simplicity
of design in these Cycladic figures, have
influenced not only Moore but many other
modern sculptors, notably Brancusi whose*
Beginning of the World (**17**), *may
well owe something to his familiarity with a
Cycladic figure in the Louvre. Sir Herbert
Read* (The art of sculpture, 1956, p. 42)
*remarks on the formal and aesthetic closeness
of Moore's* Standing Figure 1950 (**34**)
*to a Cycladic figure. An even closer resemblance
may be observed in Giacometti's* Nude *and*
Woman Walking, *both of 1934.*

with the British Museum's whole collection it eventually became clear that the realistic ideal of physical beauty in art which sprang from fifth-century Greece was only a digression from the main world tradition of sculpture, whilst, for instance, our own equally European Romanesque and Early Gothic are in the main line.

Primitive art is a mine of information for the historian and the anthropologist, but to understand and appreciate it, it is more important to look at it than to learn the history of primitive peoples, their religions and social customs. Some such knowledge may be useful and help us to look more sympathetically, and the interesting tit-bits of information on the labels attached to the carvings in the Museum can serve a useful purpose by giving the mind a needful rest from the concentration of intense looking. But all that is really needed is response to the carvings themselves, which have a constant life of their own, independent of whenever and however they came to be made, and remain as full of sculptural meaning today to those open and sensitive enough to receive it as on the day they were finished.

But until the British Museum opens again books and photographs must be a substitute, so far as they can, for the works we are unable to see in the round; and the above reflections have been prompted by an excellent, solid little book called *Primitive Art*, by L. Adam, which has just appeared, with 36 photogravure reproductions and numerous line drawings in the text. It is within everyone's reach in the sixpenny Pelican series, and if it receives the attention it deserves, it should bring a great many extra visitors to the British Museum when its galleries reopen. Dr Adam does not regard primitive art in the condescending way in which it used to be regarded, i.e., as if the real aim of the artist had been naturalistic representation, and though he hadn't yet learned how to do the job convincingly, he could be praised every now and then for making some pretty good shots at it. Even so, in spite of Dr Adam's general sensibility to his subject, the very high praise he gives to the portrait heads from Ife may perhaps be regarded as an indication that this prejudice still lingers, and it is no doubt as a further concession to it that the reproduction of one of these heads has been chosen for the cover of the book. [1941/Bibl. 25].

Mesopotamian art

In the last thirty years or so many factors have worked together to call for a review and a revaluation of past periods of art. Easier means of communication and travel, more scientific and systematic conduction of excavations, the development in photographic reproduction, better arrangement and showing of collections in museums, the breakdown of the complete domination of later decadent Greek art as the only standard of excellence – the interplay of such factors as these, together with the work of the important artists of the last thirty or forty years, in their researches and experiments, has enlarged the field of knowledge, interest and appreciation of the world's past art.

M. Christian Zervos has now produced two of his series of volumes devoted to the great periods of art. His first volume, *L'art en Grèce*, appeared a few months ago; the second volume *L'art de la Mésopotamie*, has just appeared. Both set a new standard for books on art, in the selection and quality of the works reproduced and in the size and number (close upon 300) of superb photographs of sculpture.

The present volume covers the period of Mesopotamian art from the earliest times up to the time when the Sumerian race was absorbed by the Semites, that is up to the beginning of the Babylonian dynasties. Most scholars and critics writing about Mesopotamian art have either neglected the sculpture of the earlier and greater Sumerian period or else have lumped it together with the later Babylonian and Assyrian work, which (except perhaps for a few isolated pieces) is much inferior. The Sumerian period, as M. Zervos says, cannot be interpreted through the decadent art of the Babylonians and Assyrians with their materialist and militarist society, their love of the sumptuous and the colossal, their luxurious palaces and temples.

The Sumerians were an agricultural and pastoral people, and they had their poets and perhaps scholars – astronomers and learned men. Their art dates from the birth of civilisation, so that most of the work reproduced in *L'art de la Mésopotamie* was made between 5000 and 4000 years ago. But it is not necessary to know their history in order to appreciate and respond to these works of art. We need to look at them as sculpture, for once a good piece of sculpture has been produced, even if it was made like the palaeolithic 'Venuses' 20,000 years ago, it is real and a part of

life, here and now, to those sensitive and open enough to feel and perceive it.

For me, Sumerian sculpture ranks with Early Greek, Etruscan, Ancient Mexican, Fourth and Twelfth Dynasty Egyptian, and Romanesque and early Gothic sculpture, as the great sculpture of the world. It shows a richness of feeling for life and its wonder and mystery, welded to direct plastic statement born of a real creative urge. It has a bigness and simplicity with no decorative trimmings (which are the sign of decadence, of flagging inspiration). But for me its greatest achievement is found in the free-standing pieces – sculpture in the round, which is fullest sculptural expression – and these have tremendous power and yet sensitiveness. The sculpture of most early periods, even when carved from a block and not from a slab, is not fully realised form, it is relief carving on the surface of the block; but these Sumerian figures have full three-dimensional existence.

And in Sumerian art (as perhaps in all the greatest sculpture and painting) along with the abstract value of form and design, inseparable from it, is a deep human element. See the alabaster figure of a woman which is in the British Museum and reproduced here (**57**), with her tiny hands clasped in front of her. It is as though the head and the hands were the two equal focal points of the figure – one cannot look at the head without being conscious also of the held hands. But in almost all Sumerian works the hands have a sensitiveness and significance; even in the very earliest terracotta figures, where each hand seems no more than four scratches, there is a wealth of meaning there.

Except for the impressions from Sumerian seals which are all placed at the end, and which are remarkable for their vitality and flicker of life, the reproductions in this book are arranged chronologically, and so one can observe the changes that occur as the period proceeds. From the beginning to the end there is astonishing virility and power. Perhaps the Gudea period (about 2400 B.C.) can be called the peak of Sumerian art. Soon after then it seems to fall quickly, and from bare sculptural statement moves towards decorative and linear stylisation. In many of the earliest works (around 3000 B.C.) there is a richness, a tenderness and fullness. The Gudea period (which a *Governor of Lagash* beautifully represents) is baldly powerful with a tense, held-in tightness of conserved energy (**58**).

And throughout the whole period, the Sumerian artist shows understanding of the possibilities and limitations of whatever material he uses. Clay, being soft, is modelled and is worked quickly, and allows a freedom of treatment, so that the terracottas have spontaneity and ease. Stone by its resistance gives to the carvings more hardness, power and precise exactness. And there is a difference between the free-standing

57 A FEMALE WORSHIPPER *from Lagash, southern Iraq. Sumerian, early dynastic period, c. 2900 B.C. Brown limestone, h. 8½ in.* British Museum.

58 STATUE (UPPER HALF) OF A GOVERNOR OF LAGASH (*Telloh*) in *southern Iraq. Neo-Sumerian, c. 2125–2025 B.C. Black diorite, h. 28 in. British Museum. Probably a statue of Gudea. It seems likely that the head and the torso did not originally belong together.*

sculpture and the reliefs. Their sculpture in the round is still and static, no physical movement or action is attempted, for one of the essential facts about a block of stone is its weight and immovability. But in their reliefs we find actual movement and action portrayed – for work in relief is akin to drawing, and it is an easy attribute of line to flow and move.

The photographs in *L'art de la Mésopotamie* are by M. Horacio Coppola, and they cannot be over-praised. As a substitute or as an introduction to the actual sculptures good photographs are very useful. In illustrated books on sculpture the photographs should be the best possible and well produced, or the book loses half its value. Most people, I think, respond more easily and quickly to a flat image than to a solid object (this may partly explain why sculpture seems to be a more difficult art to appreciate than painting). I have often noticed that people, after seeing a good photograph of a piece of sculpture which until then they had more or less ignored, find their interest in the original greatly increased.

The real appreciation of sculpture comes from seeing and comprehending it in its full three-dimensional volume, but if a photograph leads people to see the original, then it has been of value.

Some of the photographs in M. Zervos' book are many times larger than the original works. To see a piece one knows to be only 2 or 3 inches high looking several times its real size comes as a great surprise – but I think it is legitimate to use any means which help to reveal the qualities of the work. A further justification for these enlarged photographs is that they may draw attention to very fine small pieces which, exhibited in a crowded collection, can easily be overlooked. Another point raised by these small figures seen suddenly enlarged four or five times, is the importance of size in sculpture. These small figures, seen so much bigger, take on an extra importance and impressiveness, and are a proof that size itself has an emotional value. But size alone should not in sculpture become of main importance. There is a limit at which the control of the unity of the parts to the whole becomes physically too difficult – and when the love of size becomes a love of the colossal it results in insensitiveness and vulgarity. About one-third of the reproductions in M. Zervos' book are of works in the British Museum and help us to realise what a wonderful selection of the world's sculptures we have there. It is only recently that the Mesopotamian works have been collected in one room and shown so that they can now be well seen. A central position has been given to the very fine upper portion of the figure already mentioned, a *Governor of Lagash*, acquired by the Museum two or three years ago. But the effect of this figure has been ruined by the way it has been

abominably mounted on a wooden stand[1] which is a kind of reconstruction of the remainder of the figure. [1935/Bibl. 23].

1. Today, over thirty years later, the same stand supports this figure.

Tribal sculpture [1]

Do you think that it is possible to distinguish among these exhibits the elements that are the contribution of original inspiration as opposed to the mechanical reproduction of traditional forms? How is one to tell whether to ascribe to a particular primitive sculpture the status of an original work of art or that of a competent copy comparable, say, to one of Meegeren's copies of Vermeer?

Looking at these sculptures, for example those from the Chamba, Ashani and Okuni tribes of Northern Nigeria, I think that even where a traditional form is followed fairly closely, there are many subtle touches which a poor artist would have missed. All these pieces have been selected for their quality, and practically every one of them has the 'flicker' of originality. Of course, it is difficult often to say whether the artist merely recognised these touches and copied them or whether he thought of them himself – but the Chamba figure (**60**) seems to me to have been conceived by an individual, and I should think that it has a special rhythm and set of proportions, and a unique expression in the head, for example, not to be found in any other Chamba figure.

How far do you feel that these sculptures show domination of the artist by his material?

I should say, on the contrary, that the material is dominated by the artist in almost every case. The soapstone figures from Sierra Leone have a quality of stoniness about them because the artists have avoided the more deeply carved and slender forms which are easily possible in wood, but they show a mastery of the possibilities of stone;

1. During the Festival of Britain in 1951, the Colonial Office sponsored one of the most important exhibitions of tribal art ever held in this country or elsewhere under the title *Traditional Art from the Colonies*. The Honorary Editor of *Man*, Mr. William Fagg, of the British Museum, feeling that 'the views of an eminent sculptor – famous both for his profound appreciation of the essential qualities of primitive form and for that respect for the nature of materials which can perhaps be regarded as a higher aspect of technological skill – might well bring out points mostly of field study by anthropologists' persuaded Henry Moore to answer a series of questions put to him during a visit to the exhibition.

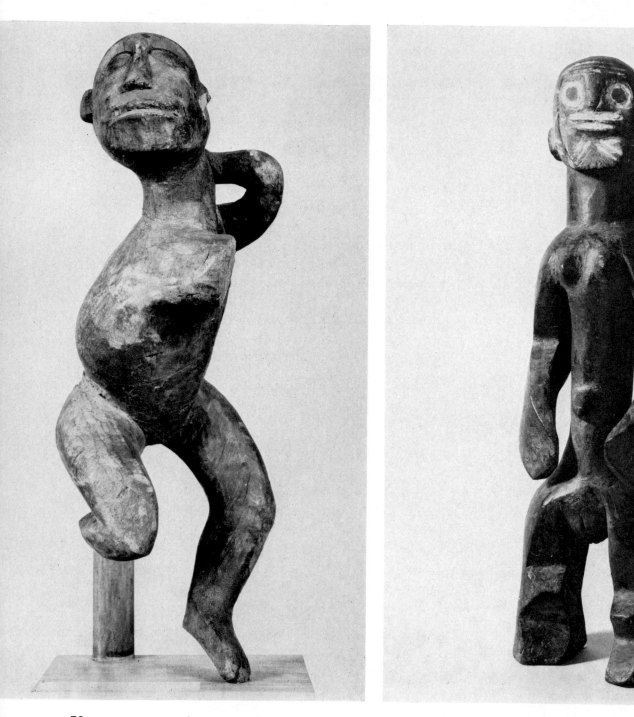

59 STATUETTE OF 'BOLLI ATAP'
a benevolent demon. Sarawak, Borneo.
Wood, h. 14¾ in. British Museum.

60 FUNERARY ANCESTOR FIGURE. *From the*
Chamba tribe (Nigeria). Wood, h. 18¾ in.
British Museum.

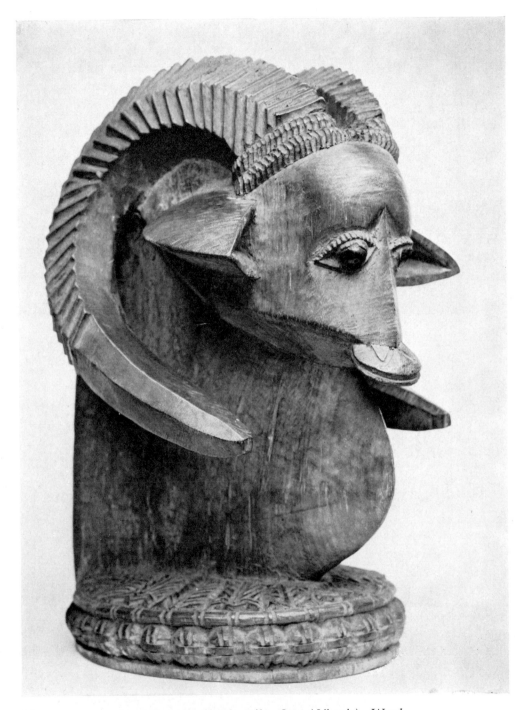

61 HEAD OF A RAM. *From the Yoruba tribe, Owo (Nigeria). Wood, h. 19½ in.* Mrs. Barclay.

they are not just incised lumps of stone – but have forms fully realised in the round. In most of the wood carvings the sculptor has imagined something which has no relation to the original form of the tree trunk. In the Bali elephant mask from the Cameroons the artist has imagined a shape – everything a child would remember about an elephant – which could not possibly have been suggested to him by the block of wood from which he started.

The imagination of the artist has been equally free in the Okuni antelope mask with long slender horns, or in the complicated Akumaga mask from the Jukun, or the great ram head from Owo in which the neck and breastbone have been carved down to a deep, narrow, wedge-shaped form of astonishing power (**61**).

Do you think that the static, four-square qualities of most of these works are to be regarded as restrictions inhibiting the artist's genius or rather as a useful discipline which assists its expression? In fact, is 'primitive' art to be regarded as limited, when compared to 'civilised' art?

The only piece of primitive sculpture I can call to mind which represents actual physical movement is the Borneo dancing figure (**59**) from the British Museum, in this exhibition, which I well remember from my earlier visits to the Museum. But I do not think that representation of movement is at all necessary to the finest sculpture, or that its absence is a crippling restriction upon the artist; there is so much else left for him to do. (In fact, most of the finest carved sculpture of the past, of all periods and styles, is static.)

As to the 'four-square' posture of most primitive figures, I think that this is a limitation on the artist. But even then there is a tendency to avoid exact symmetry: the Chamba figure has a definite twist in it, and the life-size figure of a woman from Bekom in the Cameroons has its folded hands placed to the left of the centre line of the body.

Is it possible from a study of the sculptures themselves to discern where the carver has transcended the religious or magical basis of the sculpture and produced what is, to all intents and purposes, art for art's sake?

I feel certain that this never happens in primitive art. A man must have something more than an intellectual interest in art before he can produce a work of art. All of these works seem to me to be based on much more than just aesthetic impulses. I do not think in fact that any real or deeply moving art can be purely for art's sake.

To what extent can you correlate high finish, smoothness of surface, with a particular kind of form? Or, to what extent is the high polish of some styles essential to their nature as works of art?

Some pieces, such as the warthog mask from the Nafana of the Gold Coast must certainly have been conceived with a highly polished surface, and would look unfinished without it. But all these masks and figures show some finishing on at least the salient surfaces – even the masks of the Kalabari Ijo. Though the adze marks are still visible on many medium-sized pieces, they are usually softened by partial finishing. On big sculptures like the Urhobo village fetish rough adze marks are left, but they are in scale with the carving as a whole.

High polish brings out the special quality of some materials – but finish and high polish in sculpture is often a matter of the size of the work. If the work is small and the sculptor wants to show subtle shapes or small refinements of detail he must have 'finish' – but on a large piece definition of shape can be got without it.

Which sculpture would you select as showing the best use of the special qualities of wood?

The Chamba figure seems to me one of the best from this point of view. The carver has managed to make it 'spatial' by the way in which he has made the arms free and yet enveloping the central form of the body. A rather similar effect can be seen in the large Owo ram head, with its great forward-curving horns framing the head and breastbone. But very many of the sculptures show a good use of the special qualities of their particular wood.

How can we counteract the impact of European aesthetic concepts on the tribal artists? How would you set out to convince a school of tribal artists of the value of their traditional style, as compared with the European concepts of photographic realism which threaten it? Is there any hope for the preservation of these primitive values?

I do not believe that it is any use to try to keep primitive art going or to shield the African artist from outside influences. All that we can do is to see that all the good tribal sculpture is preserved from destruction so that it can be put on show in wonderful exhibitions like this – here and in the colonies – to teach young artists what real vitality is. Nowadays artists have a greater opportunity than ever before of studying all the great traditions in the history of art, and working their way through them until they find their own style; at first, they may imitate Picasso, or primitive art, or the

painters of the Renaissance, but eventually, if they have it in them, they will find their own way. So with the young African artists. What they have to learn from tribal art is not how to copy the traditional forms, but the confidence that comes from knowing that somewhere inside them there should be the vitality which enabled their fathers to produce these extraordinary and exciting forms. [1951/Bibl. 28].

Michelangelo

Your generation of avant-garde *artists tended to react against Renaissance art. I know that you yourself as a student were especially interested in things like Pre-Columbian and African art. Where did you see Michelangelo in relation to this?*

I still knew that as an individual he was an absolute superman. Even before I became a student I'd taken a peculiar obsessive interest in him, though I didn't know what his work was like until I won a travelling scholarship and went to Italy. And then I saw he had such ability that beside him any sculptor must feel as a miler would knowing someone had once run a three-minute mile.

Take the *Moses* (**62**). The way he builds up a mass of detail yet keeps the same vision and dignity throughout it – it really is staggering that anyone should do that out of such an intractable material as marble. There's an ability to realise his conception completely in the material and to find no restrictions or difficulties in doing it. You look at any of the parts and it's absolutely perfect: there's no hesitation – it's by someone who can do just what he wants to do. But later his technical achievement became less important to him, when he knew that the technical thing was something he could do without worrying.

I do dislike in some of his sculptures, like the figures of *Night* (**63**) and *Day*, the kind of leathery thickness of the skin. You feel that the bodies are covered with a skin that is half an inch thick rather than a skin such as you see in the *Ilissus* of the Parthenon. The skin there is exactly skin thick, whereas in some of Michelangelo's middle-period sculptures there's a thick leatheriness that looks to me a little bit repellent. Nevertheless in a work like the *Night* there's a grandeur of gesture and scale that for me is what great sculpture is. The reason I can't look at Bernini, or even Donatello, beside him is his tremendous monumentality, his over-life-size vision. What sculpture should have for me is this monumentality rather than details that are sensitive.

Do you ever find yourself put off by that high polish on his marble?

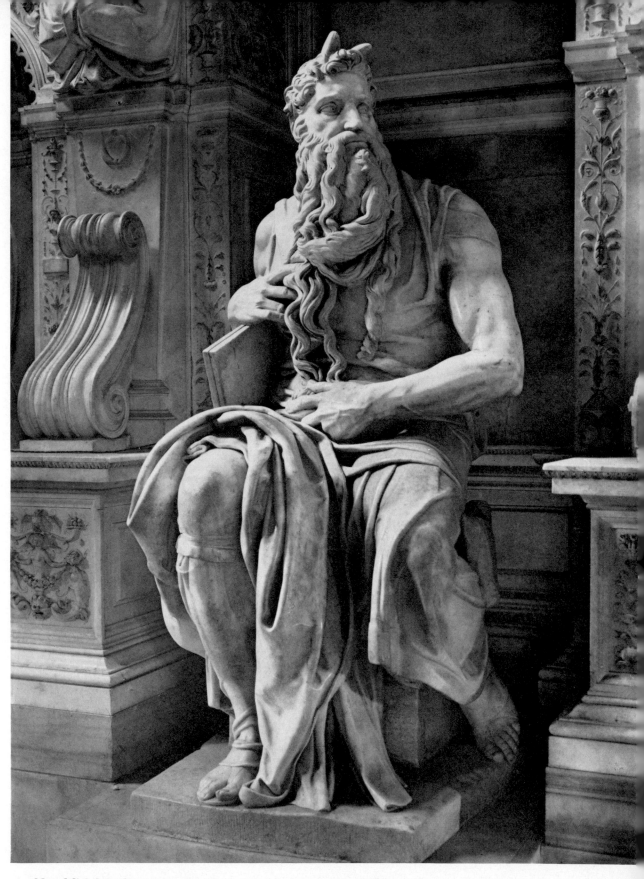

62 *Michelangelo.* MOSES. *1513–16. Marble, h. 100½ in.* S. Pietro in Vincoli, Rome.
In the mausoleum of Pope Julius II.

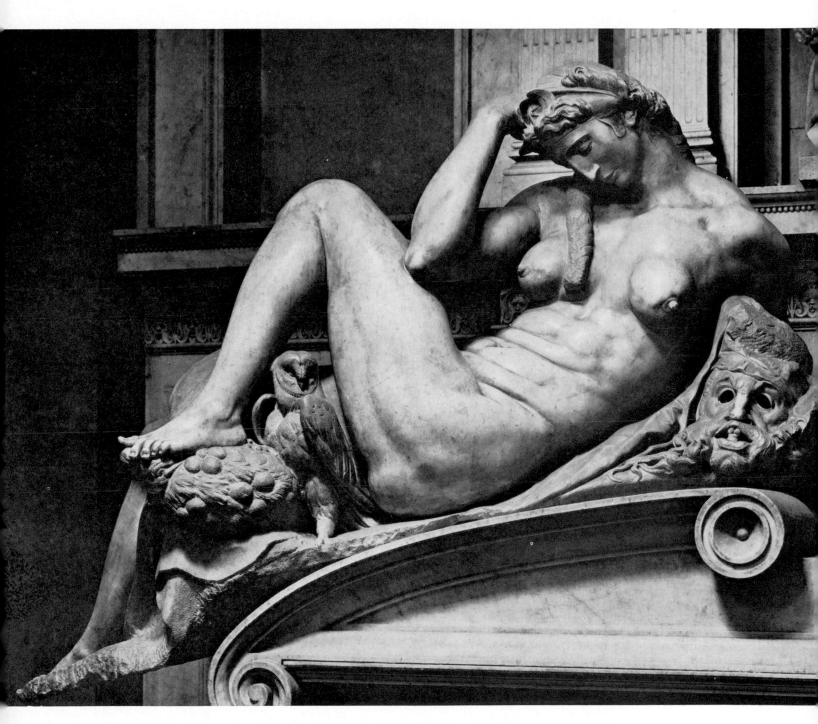

63 *Michelangelo.* NIGHT. *1525–31. Marble, l. 76¼ in. On the tomb of Giuliano de Medici.* Medici Chapel, San Lorenzo, Florence.

M

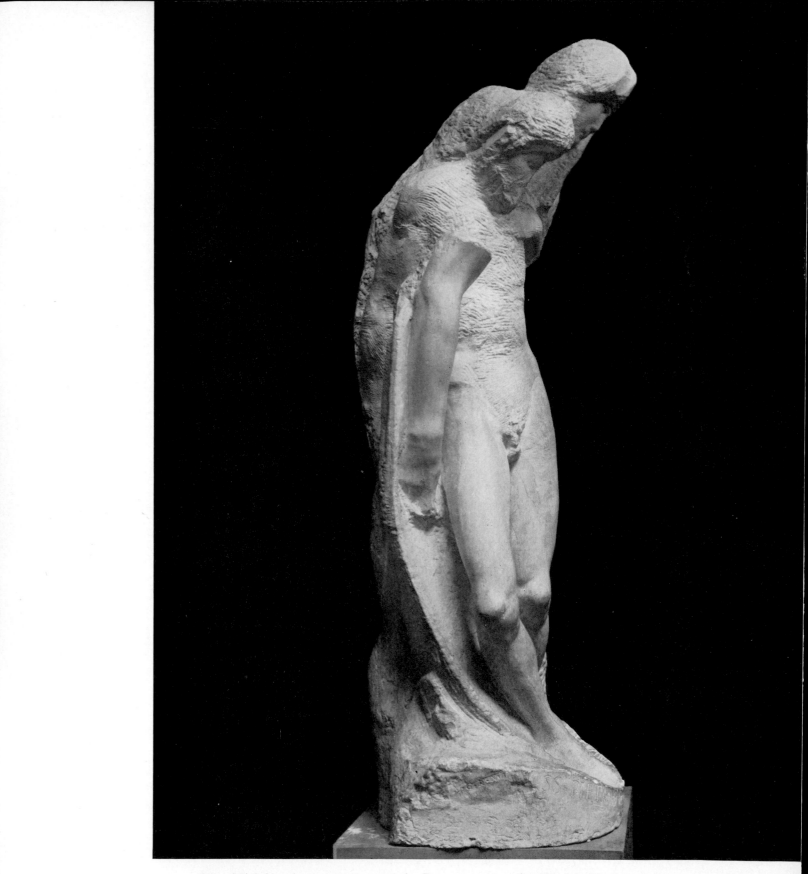

64 *Michelangelo.* RONDANINI PIETÀ. *Between 1552 and 1564. Marble, h. 75⅝ in.*
Castello Sforzesco, Milan.

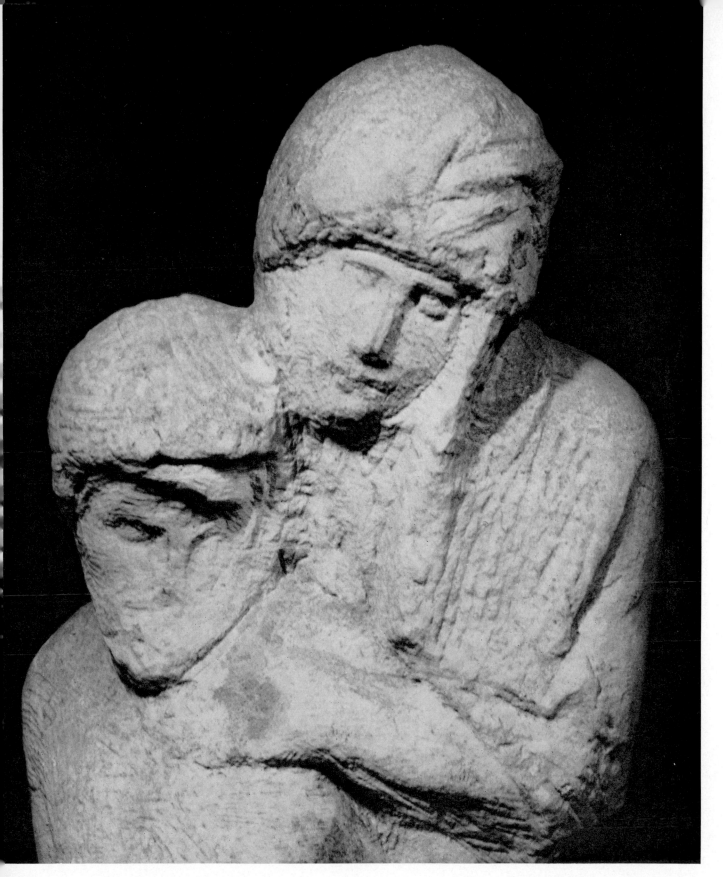

65 *Detail of the heads of the* RONDANINI PIETÀ.

Sometimes. But in the *Night* or the *Moses* you'd lose something without that high polish. In some of his works he used contrast between a highly finished part and a part that is not so finished, and this is something one likes.

I would say that all young sculptors would be better if they were made to finish their early works to the very utmost. It's like a singer learning to sing higher than he can readily go, so that he can then sing within his own range. In the same way, if you can finish a sculpture, later you can afford to leave some parts unfinished. And for me Michelangelo's greatest work is one that was in his studio partly finished, partly unfinished, when he died – *The Rondanini Pietà* (**64**). I don't know of any other single work of art by anyone that is more poignant, more moving. It isn't the most powerful of Michelangelo's works – it's a mixture, in fact, of two styles.

It must have been started at least ten years before his death and at some stage was probably nearly finished throughout, in the style that the legs are in still. Then Michelangelo must have decided that he was dissatisfied with it or wanted to change it. And the changing became so drastic that I think he knocked the head off the sculpture. Because, if you look at that arm, which hangs there detached from the body of Christ, you see that it ends less than halfway up the biceps, yet this brings it nearly level to the shoulder of the existing figure. So the figure must originally have been a good deal taller. And if we also see the proportion of the length of the body of Christ compared with the length of the legs, there's no doubt that the whole top of the original sculpture has been cut away.

Now this to me is a great question. Why should I and other sculptors I know, my contemporaries – I think that Giacometti feels this, I know Marino Marini feels it – find this work one of the most moving and greatest works we know of when it's a work that has such disunity in it? There's a fragment – the arm – of the sculpture in a previous stage still left there; here are the legs finished as they were perhaps ten years previously, but the top re-carved so that the hand of the Madonna on the chest of Christ is only a paper-thin ribbon.

But that's so moving, so touching: the position of the heads, the whole tenderness of the top part of the sculpture (**65**), is in my opinion more what it is by being in contrast with the rather finished, tough, leathery, typical Michelangelo legs. The top part is Gothic and the lower part is sort of Renaissance. So it's a work of art that for me means more because it doesn't fit in with all the theories of critics and aestheticians who say that one of the great things about a work of art must be its unity of style.

It has been called by some historians a wreck – which seems obtuse.

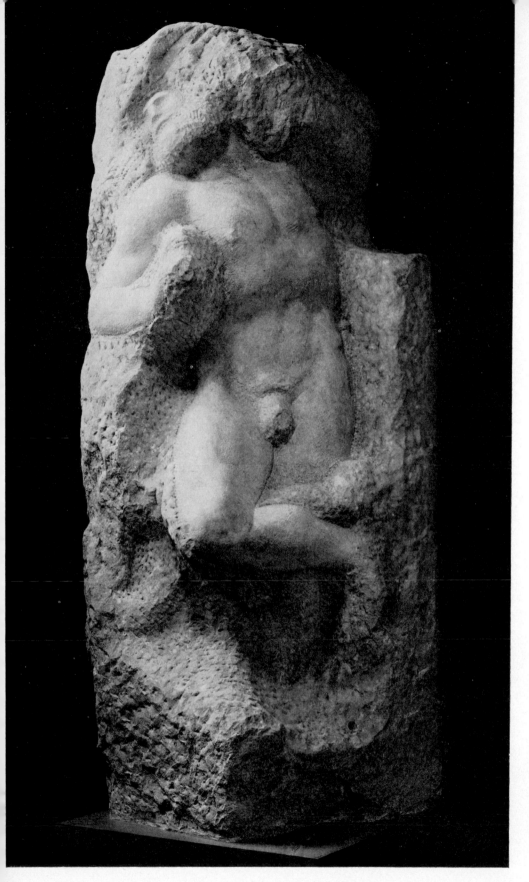

66 *Michelangelo.* CAPTIVE.
After 1519. Marble, h. 90½ in.
Accademia, Florence.
*Sir Kenneth Clark commenting on
the four slaves with this
'unfinished' effect* (The nude,
p. 238) *and on Michelangelo's
reasons for leaving so many of his
works in this condition, says* 'one
at least of the explanations is
connected with his concept of the
nude as a vehicle of pathos.'

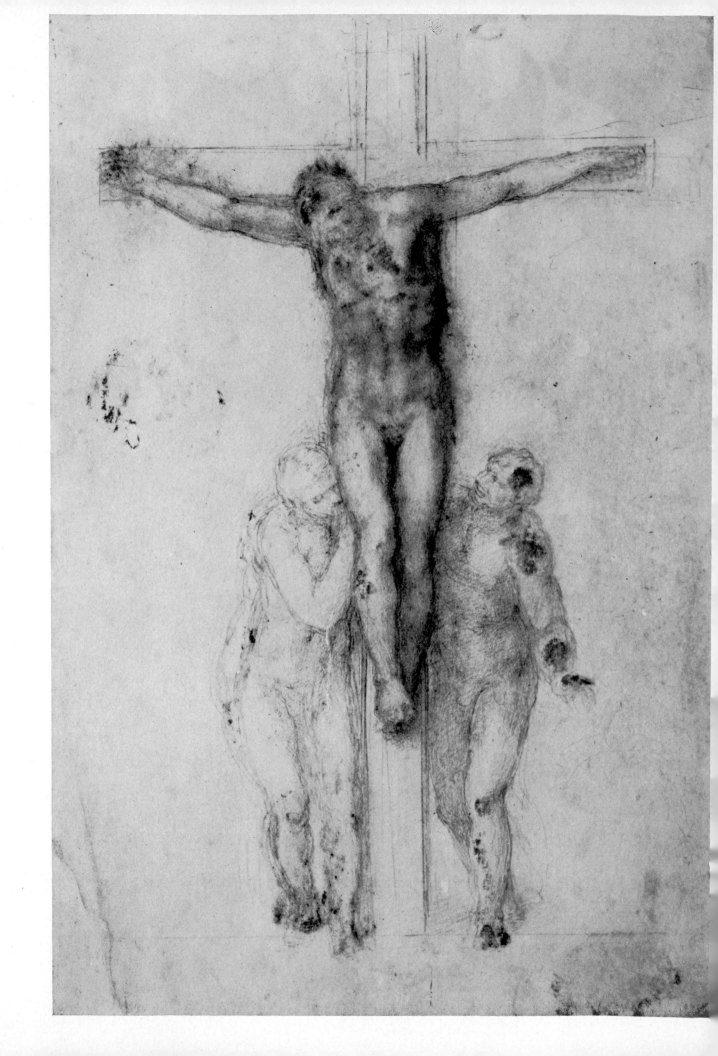

It does to me, because it's like finding the altered work of all old men a wreck. I think the explanation is perhaps that by this time Michelangelo knew he was near death and his values were more spiritual than they had been. I think also he came to know that, in a work of art, the expression of the spirit of the person – the expression of the artist's outlook on life – is what matters more than a finished or a beautiful or a perfect work of art.

I'm sure that had he taken away the nearly detached arm we should find it less moving because that part is near the new part. And undoubtedly, in my opinion, had he recarved the legs to have the same quality as the top, the whole work would have lost its point. This contrast, this disunity of style, brings together two of the Ages of Man, as it were.

It's not great in spite of its disunity but because of it?

For me it's great because the very things that a lot of art writers would find wrong in it are what give it its greatness. There's something of the same principle in his unfinished *Slaves* – so-called unfinished(**66**); I don't think they're unfinished, because though Michelangelo might have gone on a bit more, I can't conceive that he would ever have wanted to finish them in the high way he finished other works.

Here again it's that same contrast – a contrast between two opposites, like the rough and the smooth, the old and the new, the spiritual and the anatomic. Here in this *Pietà* is the thin expressionist work set against the realistic style of the arm. Why should that hand, which scarcely exists, be so expressive? Why should Michelangelo, out of nothing, achieve that feeling of somebody touching another body with such tenderness? I just don't know. But it comes, I think, from the spirit. And it seems to me to have something of the same quality as the late *Crucifixion* drawings (**67**).

They are certainly the other works by Michelangelo to which The Rondanini Pietà *relates. For one thing, they have the same stark up-and-down movement.*

Yes, I think that towards the end of his life he was someone who knew that a lot of the swagger didn't count. His values had changed to more deeply fundamental human values.

By the way, the arm that remains from the earlier state echoes the vertical movement of the group.

183

67 *Michelangelo.* CHRIST ON THE CROSS BETWEEN THE VIRGIN AND ST. JOHN.
Between 1538 and 1557. Black chalk, 16 × 10⅞ in. British Museum.

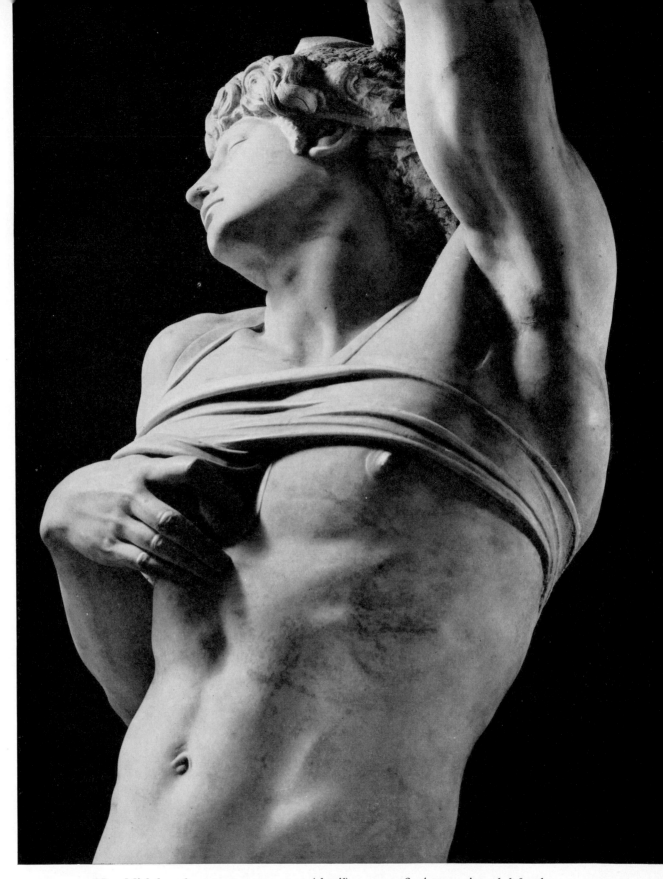

68 *Michelangelo.* THE DYING SLAVE *(detail). 1513–16. A statue intended for the tomb of Pope Julius II. About 1516. Marble, h. 90½ in. Louvre, Paris.*

Yes, that's maybe why he left it and didn't want to lose it. He wasn't dissatisfied. But I think there was no such conscious kind of design. I think that the parts he disliked he would alter and the parts he didn't dislike he'd leave.

And this is how artists work. It isn't that they work out – at least I don't – a theory, like saying 'This is upright and I'm going to leave it because it fits in with my new thing.' It's because you *see* it fits in that you leave it – you're satisfied with it. It's that you work from satisfaction and dissatisfaction. You alter the things that don't seem right and you leave the things that are more right to go on with sometime later.

But why does this kind of simplicity in Michelangelo produce such a different effect from the kind you get in archaic forms of sculpture?

Well, I think that if you do the opposite of something which you have a full experience of doing, the seeds of the previous thing will still be there. That is, nothing is ever lost, nothing is ever missing. The *Crucifixion* drawings are very simplified, without the twisting and turning of the earlier Michelangelo, yet they have a slight movement, a slight hang and turn that gives a sense of agonised weight. All his past experience is in them.

This is the kind of quality you get in the work of old men who are really great. They can simplify; they can leave out. Even someone like Matisse can just sit in his bed, ill and sick, nearly dying, and with a pair of scissors and so on he can cut out things – and why they're so good is because of the past history of Matisse. There's this little difference that he makes which some young man trying to imitate him would never make. And that's why I'd say that in the *Crucifixion* drawings and in *The Rondanini Pietà* there's the whole of Michelangelo's 89 years' life somewhere. This *Pietà* is by someone who knows the whole thing so well that he can use a chisel like someone else would use a pen.

Also, there is a fact, and for me a strange fact, about the really great artists of the past: in some way their late works become simplified and fragmentary, become imperfect and unfinished. The artists stop caring about beauty and such abstract ideas, and yet their works get greater.

You've emphasised the fragmentary character of this Pietà, *and likewise you prefer the so-called unfinished* Slaves *to the finished ones. Now this is very much something that modern taste likes: the fragment. But we'd like to think that this was something more than a fashionable cult.*

185

Yes, I'm pretty sure it isn't that. You see, I wouldn't call the *Crucifixion* drawings that we've been admiring fragmentary and unfinished. I think they have about them a wonderful existence in space. The figure on the Cross, the two figures at the side of the Cross – there is an atmosphere round them: they're realised tremendously in space, they're not sketches in the sense that they're just the beginnings of something which if it were carried further would have meant more.

But what is it that makes you like the unfinished Slaves *better than the finished ones?*

I prefer them because they have more power in them, to me, much more power than the finished ones (**68**). That one in the Louvre is much too weary and sleepy and lackadaisical.

Well, it's meant to be dying.

I know, but I mean you can have a thing that's dying and yet it has the vitality of the sculptor in it.

Maybe the more finished works are often less sympathetic just because they express Michelangelo's fantasy more clearly and we find certain things in his fantasy repellent. For instance, that leathery skin in the figure of Night. *With the unfinished* Slaves, *you don't refer them back in a literal way to life in the same way as you do the* Night.

No. And when one compares her breasts to a real woman's breasts, one finds them unpleasant. And I think in some of Michelangelo there can be a kind of melancholic lazy slowness. I admire that, but I don't like it, and that's perhaps why when he hasn't arrived at that, like in the unfinished *Slaves* – where that can't come in because he hasn't had the time to put it in – they appeal to one more.

But one still admires *Night*. I mean, this is still an unbelievable pose. The whole attitude of the figure, the grandeur, the magnificence of the conception is still a wonderful thing. In all his work – early, middle, late – there's no sculptor of more ability. He could do anything he wanted. [1964/Bibl. 52].

Renoir

La danseuse au tambourin and *La danseuse aux castagnettes*[1]

Whoever doesn't like those girls doesn't understand what Renoir was trying to do. The two pictures (**69** and **70**) must represent at least three or four months of continuous work at the best period of Renoir's life. A tremendous amount of application went into the painting of them, a great deal of real ambition; they represent a big effort to produce something worthy of the museums.

If you copy nature as it is, as Renoir was mainly doing during his earlier impressionist period, you can't really show the form that underlies appearances. Nature is too complicated, and to make a work of art out of it you have to simplify, to invent a system of vision. In painting, where you have to reduce everything to a flat surface with only colour and texture, you have, above all, to simplify the lighting. Renoir hit on this method of lighting the model, as it were, simply from his own eyes; so that all his surfaces are subject to a logical system of lighting which explains the form. In these pictures he has learned to fit his forms into space. The shapes of these two girls are melted into the background; so that what you see and feel about them comes from inside the forms, not just from the outlines, as it did earlier, in his hard-edge paintings.

And yet these rounded forms have a marvellous, supple rhythm, such as people are apt to associate only with outlines. What one likes about them is that, though they are so monumental, yet, if you compare them, for instance, with Maillol's sculptures, they have none of the stiffness which these are apt to have. They make me realise that Renoir was really a much greater sculptor than Maillol.

And, in addition, what lovely passages there are of delicious painting and wonderful colour! There are so many subtleties in the painting of them which one goes on discovering that I never know which I like the better of the two. One day it's one, another day it's the other.

1. These two pictures were painted by Renoir in 1909 for the dining-room of the apartment of Maurice Gangnat, one of the artist's most liberal patrons. They were acquired by the National Gallery in 1961.

69 *Renoir*. LA DANSEUSE AU
TAMBOURIN. *1909. Oil, 61 × 25½ in.*
National Gallery, London.

70 *Renoir*. LA DANSEUSE AUX
CASTAGNETTES. *1909. Oil, 61 × 25½ in.*
National Gallery, London.

One could say most of these things if these were 'abstract' pictures. But they are anything but that; Renoir tried to put into them all that he felt about women. The way he dressed them up is a key to this. For me their costumes only emphasise the sculptural grandeur of them, as Rembrandt wanted to do when he dressed up Saskia. Renoir didn't just paint these girls as he saw them about the house, as he did in so many of his smaller, more everyday pictures. When they came into his studio in the morning to pose, they didn't just take off their clothes either. The whole ceremony of getting dressed up would help to make the occasion important.

The pictures represent, I'm sure, a significant episode in Renoir's career, a special effort; that's why I think they are not just ordinary pictures for private collectors, why I believe they are the kind of pictures we should have in the National Gallery. [1962/Bibl. 63].

Cézanne

In my first year at College [the Royal College of Art] Raymond Coxon and I thought we'd like to see some original Cézannes, and so we asked if we could go to Paris for Whitsun week. Rothenstein said 'Yes, and I'll give you some introductions,' and he did give me one to Maillol, in fact, which I was too shy to use. I got to the door and I thought, 'Well, he's working and he won't want to be bothered,' and so I turned away.

But we did go to see the Pellerin collection and what had a tremendous impact on me was the big Cézanne,[1] the triangular bathing composition with the nudes in perspective, lying on the ground as if they'd been sliced out of mountain rock (**72**). For me this was like seeing Chartres Cathedral [1961/Bibl. 47].

I notice that you've only got one picture here in the studio.

Well, it's the only picture I ever wanted to own. It's a Cézanne (**71**) and the joy of my life. I saw it about a year ago in an exhibition and was stunned by it. I didn't sleep for two or three nights trying to decide whether to . . . To me it's marvellous. Monumental. It's only about a foot square, but for me it has all the monumentality of the bigger ones of Cézanne. The first, the very first composition I saw of Cézanne's was in 1921, on a visit to Paris, when I had an introduction to M. Pellerin and there in the entrance hall of his house was the big triangular composition *The Bathers*. For me, that represents the most ambitious, the biggest effort that Cézanne made in all his life. This one that I have has to me just as monumental a sense.

In this kind of composition I think that Cézanne was trying to compete with all the things he admired. He was trying to do all he knew in it. In some of his things he was trying to learn, trying to find out, and to reduce his problems to a single one. But in this, he is competing with everything in picture-making that he knew about.

1. *The Great Bathers*, 1898–1905. 82 × 99 inches. Now in the Philadelphia Museum of Art (Wilstach Collection).

71 *Cézanne.* TROIS BAIGNEUSES. *1873–77. Oil, 12 × 13 in. Henry Moore.*

72 *Cézanne.* GRANDES BAIGNEUSES. *1898–1905. Oil, 82 × 99 in.*
Philadelphia Museum of Art (Wilstach Collection).

It's not perfect, it's a sketch. But then I don't like absolute perfection. I believe one should make a struggle towards something one can't do rather than do the thing that comes easily.

Perhaps another reason why I fell for it is that the type of woman he portrays is the same kind as I like. Each of the figures I could turn into a piece of sculpture, very simply.

Not slips of girls.

Not young girls but that wide, broad, mature woman. Matronly. Look at the back view of the figure on the left. What a strength . . . almost like the back of a gorilla, that kind of flatness. But it has also this, this romantic idea of women. Four lots of long tresses, and the hair he has given them.

I imagine that 'romantic' is not a word that could be applied to your work?

Oh no, not at all – I think I have a very romantic idea of women.

Your earlier point about perfection. Do you want the struggle made clear to you in the final product?

Well I don't expect the problem to be solvable and so easy. In fact that's the thing about Cézanne: he was ready to pit himself against all that he admired, against the old masters. He wasn't satisfied with impressionism. He said 'I want to make impressionism an art of the museum' which it isn't – which means that when he went to the museums and saw Rubens and El Greco, Tintoretto, he knew there was something missing, something not wide enough – broad enough – deep enough – in impressionism. That is, his life was one monumental struggle and aim to extend himself and painting and art generally. [1962/Bibl. 54].

Jacob Epstein

I first met Jacob Epstein (who has died at the age of 78) in the mid-1920s, a time when I was unknown and he was the most famous sculptor in Britain, and I have two reasons to be grateful to him, both in a way personal, but one more personal than the other. He bought works of mine before ever I had had an exhibition, and he showed an excitement in my work,[1] as he did in everything else that he liked or loved, which was characteristic of the man, and which is perhaps not found as often as one might hope in the attitude of a famous artist towards his juniors.

This vital quality, this engagement of himself – I remember that on one occasion he jumped into a taxi with a piece of sculpture of mine he had just bought from me, even though I did not regard it as completely finished, because it was his and therefore he wanted it then and there – was perhaps one of the most attractive qualities of the man. He was strong and immediate in his likes, and also in his dislikes.

And this immediacy and strength drew forth a similar response. In the years before and just after the first world war, while he was perhaps the sculptor most admired by the perceptive, he was undoubtedly the most loathed by the philistines.

And that is the second, and slightly less personal, cause for my feeling of gratitude towards Epstein. He took the brickbats, he took the insults, he faced the howls of derision with which artists since Rembrandt have learned to become familiar. And as far as sculpture in this century is concerned, he took them first.

We of the generation that succeeded him were spared a great deal, simply because his sturdy personality and determination had taken so much. Sculpture always arouses more violent emotions than, say, painting, simply because it is three-dimensional. It cannot be ignored. It is there. And I believe that the sculptors who followed Epstein in this country would have been more insulted than they have been had the popular fury not partially spent itself on him, and had not the folly of that fury been revealed.

Why he should have aroused such anger it is hard now to see. His Strand figures,

1. Epstein wrote the foreword to the catalogue of Moore's second one-man show in London (his first at the Leicester Galleries) in 1931.

194

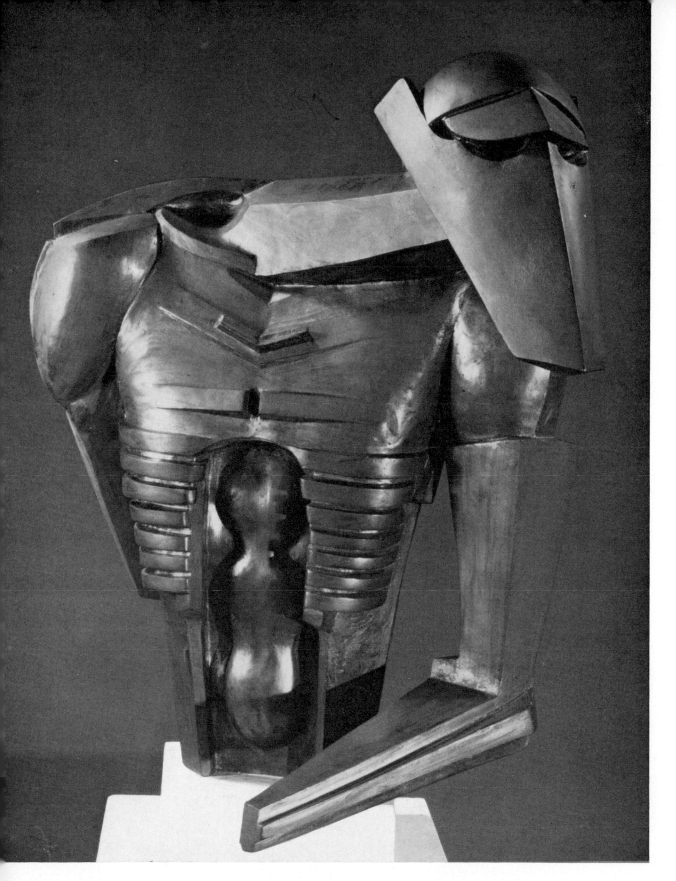

73 *Epstein*. THE ROCK DRILL. *1913. Bronze, h. 27¾ in.* Tate Gallery, London;
National Gallery of Canada, Ottawa.

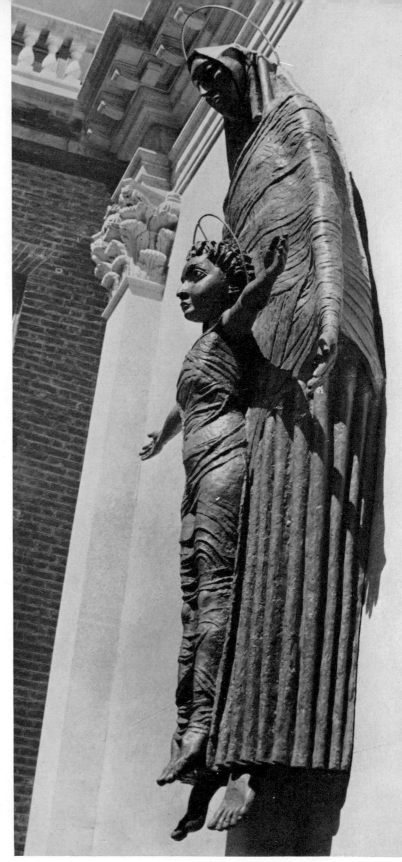

74 *Epstein*. MADONNA AND CHILD. *1952. Bronze, h. 160 in.* Convent of the Holy Child Jesus. *It hangs on the bridge connecting two buildings on the north side of Cavendish Square, London.*

carved in 1908, which in 1937 were removed from the façade of the building which had belonged to the British Medical Association, were in the direct tradition of European sculpture, and show more strongly than any other influence that of Rodin, at a time when Rodin was universally admired. His *Oscar Wilde*, which shows a strong Mexican combined with a certain Sumerian Assyrian influence, may have been tarred in Paris in 1912 for reasons not solely deriving from the work itself. Indeed, apart from his Paris period just before the first world war, when he was seeing a great deal of Modigliani and others (I am thinking of his *Rock Drill* period (**74**)) he was scarcely an innovator, let alone a revolutionary.

He was a modeller, rather than a carver. To put it in other terms, his was a visual rather than a mental art, and with him the emphasis was on subject rather than on form. He was an intensely warm man, who in his work transmitted that warmth, that vitality, that feeling for human beings immediately. His master was Donatello, rather than Michelangelo: and in Rembrandt, whom he also studied most carefully, it was the direct and personal warmth that affected him perhaps more than the formal side.

It was this quality of Epstein's, I think, that produced his greatest work, which I believe to have been his portraits (particularly his portraits of men, whom he saw with a greater objectivity than that which a man of his direct and personal vision could turn upon women) and also such pieces of sculpture as his *Madonna and Child*, one of his best and last works, that is now in Cavendish Square. Of the sculptor's media, his was surely clay.

Artists tend, perhaps inevitably, to be egotistical. Epstein was no exception, and there is nothing that he made that is not redolent with his own personality. But egotism is not synonymous with selfishness. And few men can have loved sculpture purely for its own sake more than Jacob Epstein. The wideness of his sympathies is shown in his own fine collection of sculpture, which included Negro, Egyptian, Chaldean work as well as much else, and in his collecting he was even more appreciative of carving than he was of modelling.

He was a broad-shouldered, fine, sturdy man. Insults and misunderstanding, which dogged him all his life, hurt him of course, but he shrugged them off. In his old age he even came to resemble Rembrandt physically. His warmth and his vitality and his courage will not be quickly forgotten. We have lost a great sculptor. [August 23, 1959/Bibl. 33].

Modern art

I think people often get muzzed by the use of the word 'beauty'. It's really a most misleading, misused and muddle-headed word in this context. People turn to it to avoid the issue and escape precise expression. When applied to sculpture it usually means either a copy of something 'beautiful' in Nature, like a pretty girl or a young animal, or something nicely finished off in a craftsmanlike way, or done in what they consider a 'beautiful' material, like white marble or alabaster.

And then we all have to fight our obsessions and prejudices and try to keep our eyes open to new forms. I know I do, for one. It's very difficult to see something that's new, and not a repetition of something you've already seen and responded to. But if you can get into the right kind of receptive and appreciative-creative way of seeing, then the whole world is full of new ideas and new possibilities. One of the things that modern art has done is to open people's eyes in that way.

But the obsessions and prejudices I spoke of are particularly strong when it comes to sculpture. There's no short cut to the enjoyment of sculpture. And, in fact, if people who rarely or never think about sculpture could immediately get the point of a new work it might well be that the sculptor was only externalising a commonplace point of view – whereas the great advances in modern sculpture have not been like that at all.

From when would you date those advances? What, for instance, would you say was the first modern sculpture?

I'd say it was a general contribution. Rodin and Medardo Rosso cleared the way. Then Brancusi, at one end of the scale, simplified form, got people to look at shape again for its own sake, and made a martyr of himself, really, for a single form, for the egg, or the egg-form, as the basis of a sculpture (**17**). And then much later a man like Gonzalez with his welding brought a lot of disparate elements together and made one single unified thing out of it. He was working from the opposite direction.

Then there were isolated pieces like Picasso's *Glass of Absinthe* in 1914 (**75**). Picasso realised that you could make poetry out of objects that everyone else had passed over,

75 *Picasso.* THE GLASS OF ABSINTHE. *1914. Painted bronze, h. 8¾ in.*
Philadelphia Museum of Art (A. E. Gallatin Collection). *Six casts were made:
each was painted differently.*

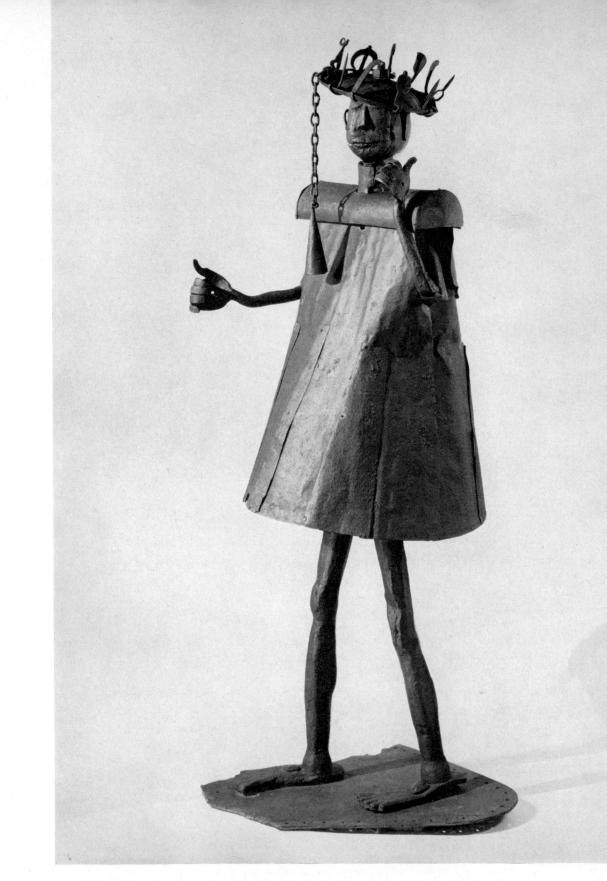

76 GOU, THE GOD OF ARMS AND WAR.
Fon (Dahomey). Iron, h. 64½ in. Musée de l'Homme, Paris.

and that is one of the fundamental inspirations of modern art. Then there was the idea of the found object, the re-interpretation of natural forms, the use of materials discarded from ordinary life. And then again there was, in my case, the possibility of seeing in the British Museum what had been done in sculpture in the whole history of mankind.

This new friendship, if you could call it that, between art and anthropology has been of fundamental importance to twentieth-century art. We know that Epstein and Derain and Picasso and Braque were influenced before 1914 by the Negro sculptures which are now in the Musée de l'Homme in Paris, and anyone who knows that museum and knows modern art can find evidence as he goes round it that some artist has been round before him. For instance, Gonzalez must have known that Negro figure that has the butcher's hooks and bits of chain hanging from its hat, and a skirt made of a bit of waste tin (**76**). That's the sort of thing that opened his eyes and taught him to look around.

You don't feel that all this hunting for new sources, new materials, new combinations has made the traditional ones obsolete?

Walter Gropius once told me that he had a man to lecture at the Bauhaus, in the 1920s, who told the students that oil painting and carving were worn-out, Stone Age procedures, and that the artists of the future would use the materials of their own day – plastics and so on, I suppose. And this so depressed the students that most of them gave up work altogether till they noticed that Klee, who'd also been at the lecture had just gone on painting as before, and then they recovered and thought it might be all right, after all.

And of course, like all liberations, the liberation from conventional materials has its overdone, destructive, gimmicky side. If an artist feels more free, more alive, with new materials, then his work may benefit. But a second-rater can't turn himself into a first-rater by changing his medium, or his style. He'd still have the same sensitivity, the same vision of form, the same human quality, and those are the things that make him good or bad, first-rate or second-rate.

And there are still sculptors with plenty to say in the traditional materials aren't there?

Giacometti, for one. In his surrealist period he showed a remarkable imagination in

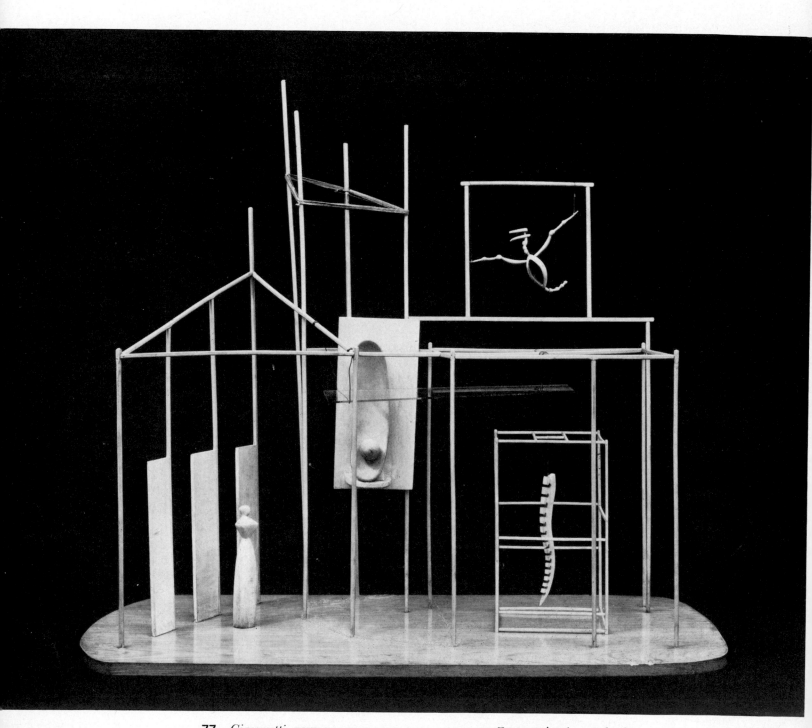

77 *Giacometti.* THE PALACE AT 4 A.M., *1932–33. Construction in wood, glass, wire and string, 25 × 28¼ in.* Museum of Modern Art, New York.

things (**77**) like his *The Palace at 4 a.m.*[1] – poetic, I mean, not literary – and later, when his feeling for Etruscan and Egyptian art came together with his understanding of, and particular excitement about Cézanne, he produced something very specially his own: a reality of the wraith, as it were. In Giacometti's work the armature has once again become the life-line of the sculpture, and also he's brought back to sculpture a nervous sensitivity which the 'pure carving' side of sculpture can lose sight of altogether. There had been a danger, when Giacometti was developing, of sculpture becoming just a matter of craftsmanship [1961/Bibl. 47].

Do you think that there are any recent painters who have had the authentic three-dimensional instinct? Any painter-sculptors?

Oh, yes – Picasso, for one. His sculptures are really three-dimensional, unlike those of, say, Braque, who does a painter's sculptures and gives them a two-dimensional quality. Picasso uses an object in its complete reality. He really aims to understand the form completely. Daumier is another who could draw in a three-dimensional way and had no difficulty in transferring his concepts into sculpture. I think the same applies to a great extent to Matisse. Matisse was tremendously influenced by sculpture – Rodin had a very strong effect on him – and that makes Matisse's sculpture real. He was interested in it right from the start. It wasn't just a painter having his fun. Degas was another who could do sculpture because he had a tremendous understanding of the human figure and just used the knowledge he'd gained in painting and drawing in a solid way. But I doubt if someone like Puvis de Chavannes could have done sculpture. He'd probably have made reliefs. [1962/Bibl. 48].

1. In 1925 Giacometti ceased working from the model for ten years and the highly original work of this experimental period reflects the influence of primitive and negro sculpture, cubism and surrealism. He too felt the need of opening his forms and hollowing out space. Of his various cage-like structures this is the most fantastic, "a very fragile palace of matchsticks" containing a spinal column, a skeleton bird, the statue of a woman in which he recognised his mother, and an object in front of a board which he identified with himself.

Abstract art

All art is abstract in one sense. Not to like abstract qualities or not to like reality, is to misunderstand what sculpture and art are about. Some artists are more visual, or get more excitement from nature in front of them, and then make a work of art from that. Other people do it from their insides, a more mental approach; the actual picture-making or picture-designing can be an exercise disconnected from a relationship to the outside world. But for me, I can't cut my sculpture off from living, and the forms that one sees in nature, in people, in trees, are reproduced or get mixed up with one's sculpture because they are all part of living. I have made semi-abstract experiments, like the string figures of 1938 to 1940 but in my mind many of these have an organic basis I see no reason why realistic art and purely abstract art can't exist in the world side by side at the same time, even in one artist at the same time. One isn't right and other wrong. [1960/Bibl. 8].

Some people set up a distinction between abstract and figurative and try to separate good from bad on that basis. It's a false distinction in any case, and generally an emotional one. Take Poussin, for instance, he's like a juggler, not with two or three balls, but with twenty, and keeping them all going. He is doing something much more difficult, and in that sense he has greater ability as an abstract artist when he keeps his figures and their relationships than Mondrian has when he reduces everything to squares and rectangles. [1962/Bibl. 13].

Do you think an abstract painter who never handles the human form directly could also take up sculpture?

Yes – for two reasons. First, the actual craftsmanship of painting. It's just common sense. Anyone can learn it. But, of course, the craftsmanship is a very secondary thing. It's not the craft that's difficult, it's the mental grasp – the conception. Second, there's no such thing as empty or meaningless form, if you know how to look at it. I contend

that every form, every shape, every little bit of natural object that you pick up, every chip off a sculpture has got a meaning, if you can find it.

I sometimes begin work in the morning with a bit of plaster or a bit of clay and if a form comes about it may have some sort of lasting interest for me. If it does, I go on trying to find out exactly what it 'means'. In fact, I often think I could be even freer than I am from the tie of what the thing might 'mean'. I'd like to be able to carry the form as far as possible without having to define its significance. And there *are* one or two of my recent pieces that I simply can't explain. I don't know quite what they are. They just came about. . . .

We're getting to a state in which everything is allowed and everybody is about as good as everybody else. When anything and everything is allowed both artist and public are going to get bored. Someone will have to take up the challenge of what has been done before. You've got to be ready to break the rules but not to throw them all over unthinkingly. Great art comes from great human beings, apart from everything else, and great human beings aren't satisfied with change that's made for change's sake. [1962/Bibl. 48].

Individual works by Henry Moore

Stringed figures, 1937-39

At one period just before the war, in 1938,[1] I began the most abstract side of my work – the stringed figures. . . . I had gone one day to the Science Museum at South Kensington and had been greatly intrigued by some of the mathematical models; you know, those hyperbolic paraboloids and groins and so on, developed by Lagrange[2] in Paris, that have geometric figures at the ends with coloured threads from one to the other to show what the form between would be. I saw the sculptural possibilities of them and did some. I could have done hundreds. They were fun, but too much in the nature of experiments to be really satisfying. That's a different thing from expressing some deep human experience one might have had. When the war came I gave up this type of thing. Others, like Gabo and Barbara Hepworth have gone on doing it. It becomes a matter of ingenuity rather than a fundamental human experience. [1962/Bibl. 14].

Even my most abstract forms, my stringed figures of 1938, are based on living creatures. This one [*Bird-basket*] has a head and a tail (**78**). It's basically a bird. [1960/Bibl. 45].

1. The first fully developed string figure was in fact made in 1937.
2. Joseph Louis Lagrange (1736–1813). He settled in Paris in 1784.

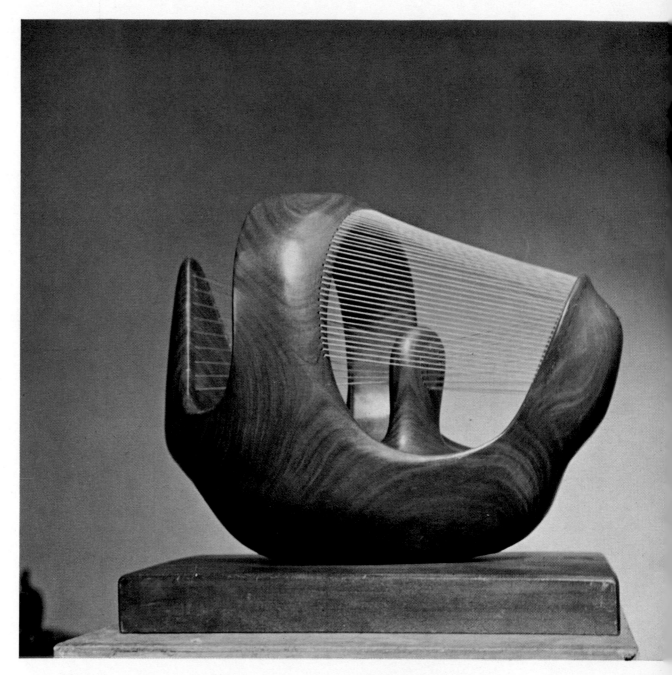

78 BIRD BASKET, *1939. Lignum vitae and string, l. 16¼ in.* Mrs. Irina Moore.

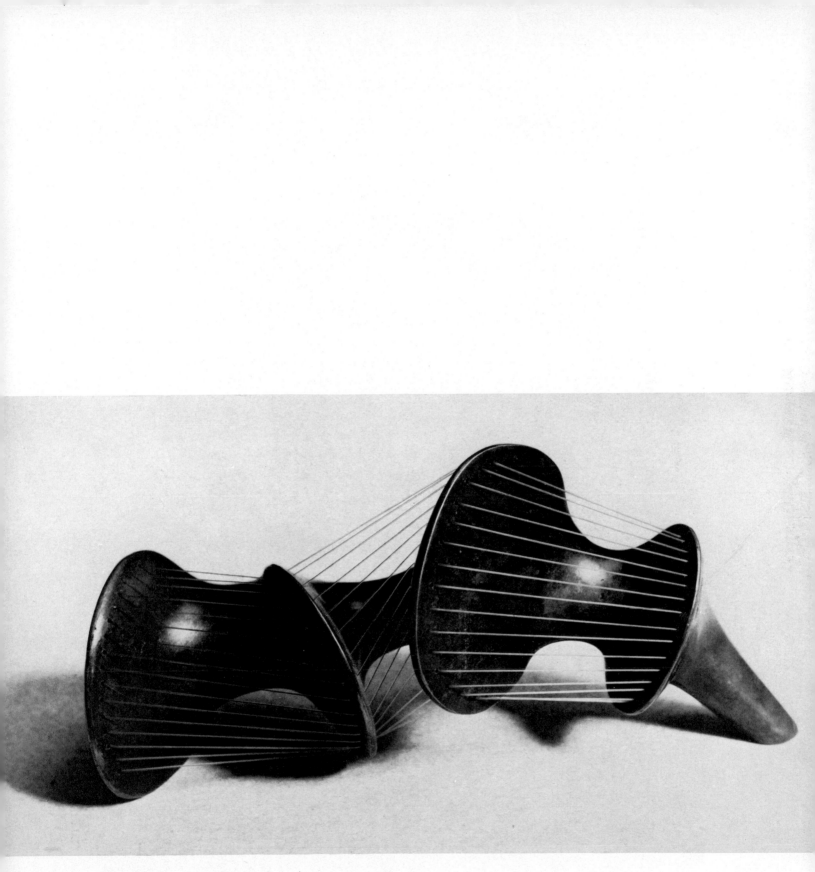

79 FIGURE, *1939. Bronze, l. 10 in.*
o*

Shelter drawings

At the outbreak of the war I had a studio in Kent, not far from Dover. And for the first months of the war I continued to work there undisturbed. In fact, up to the fall of France there were no difficulties in doing sculpture just as before. During those first months, however, nothing happened in the art world of London, no exhibitions or anything of the sort. Then the code gradually became 'to live as usual'. And in 1940 I exhibited the large reclining figure in elm wood, which now belongs to Elizabeth Onslow-Ford,[1] and several small lead figures at the Leicester Galleries. But when France fell and a German invasion of England seemed more than probable, like many others I thought the only thing to do was to try to help directly. I moved back to London and applied at the Chelsea Polytechnic for training in precision-tool making. But the training classes were so few in proportion to the numbers of applications that several weeks went by and I heard nothing. Still I felt it was silly to start a large sculpture when at any moment I might have to give it up. So I took up drawing. Months went by, waiting; I went on drawing. Then the air-raids began – and the war from being an awful worry became a real experience. Quite against what I expected I found myself strangely excited by the bombed buildings, but more still by the unbelievable scenes and life of the underground shelters. [1946/Bibl. 37 and 50].

I went into London two or three days a week to do my shelter drawings. It's curious how all that started. The official shelters were insufficient. People had taken to rolling their blankets about eight or nine o'clock in the evening, going down into the tube stations and settling on the platforms. The authorities could do nothing about it. Later on, the government began to organise things better. They put in lavatories and coffee-bars down there and began building four-tiered bunks for the children. It was like a huge city in the bowels of the earth. When I first saw it quite by accident – I had gone into one of them during an air raid – I saw hundreds of Henry Moore

1. It now belongs to the Detroit Institute of Arts (**1**).

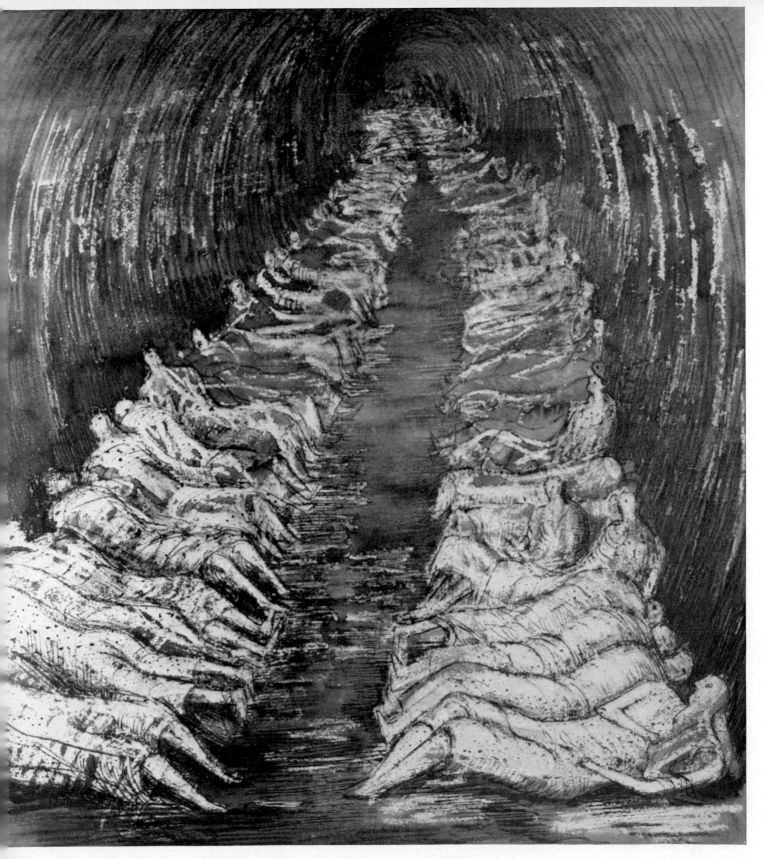

80 TUBE SHELTER PERSPECTIVE, *1941. Watercolour and pen,* $18\frac{3}{4} \times 17$ *in.*
Tate Gallery, London.

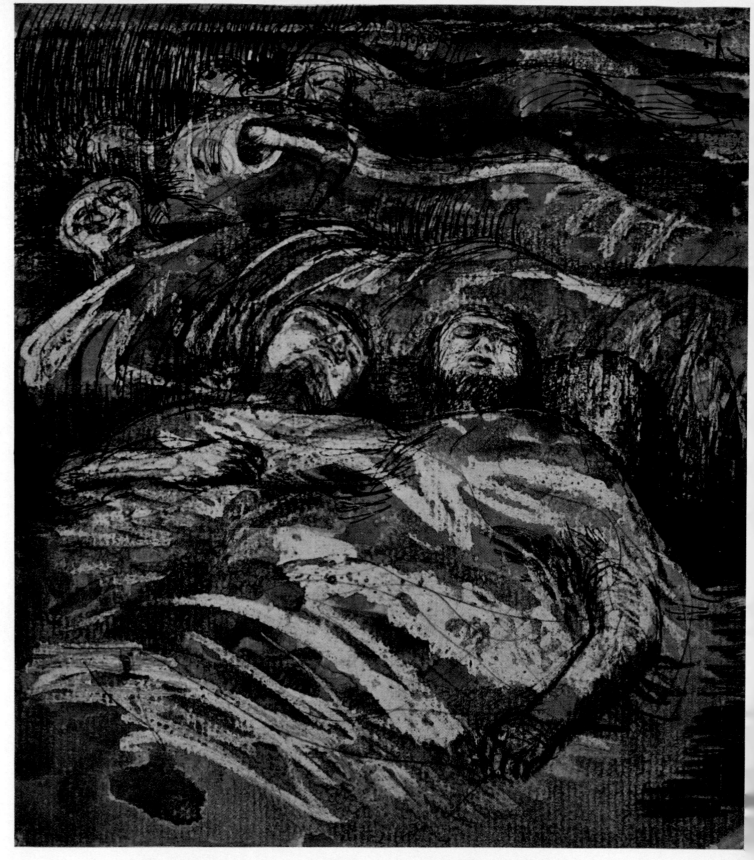

81 SLEEPERS IN THE TUBE, *1941. Page from a Shelter Sketchbook.* $7\frac{1}{2} \times 6\frac{1}{4}$ *in.*
Mrs. Irina Moore.

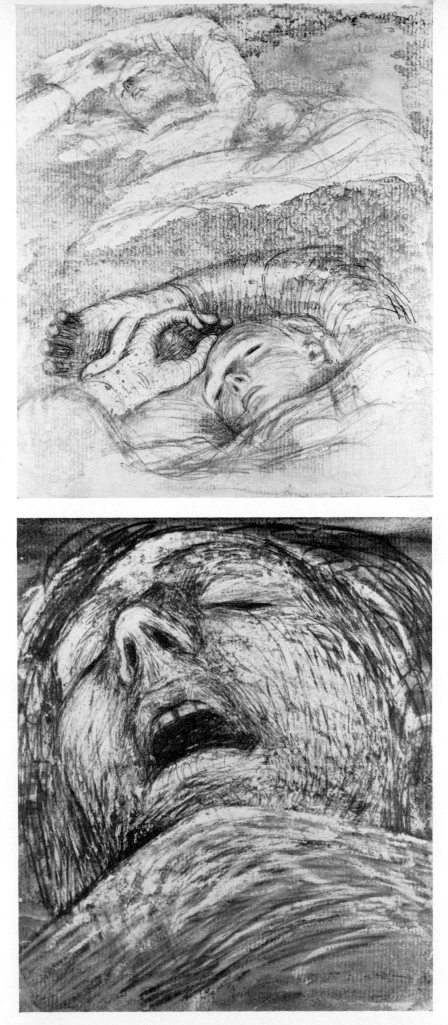

82 MOTHER AND CHILD
SLEEPING, *1941. Page from a
Shelter Sketchbook. 7½ × 6½ in.*
Mrs. Irina Moore.

83 HEAD OF A SLEEPING
FIGURE, *1941. Page from a
Shelter Sketchbook. 7½ × 6½ in.*
Mrs. Irina Moore.

Reclining Figures stretched along the platforms (**80**). I was fascinated, visually. I went back again and again. [1962/Bibl. 14].

I began filling a notebook with drawings – ideas based on London's shelter life. Naturally I could not draw in the shelter itself. I drew from memory on my return home. But the scenes of the shelter world, static figures (asleep) (**81**) – 'reclining figures' – remained vivid in my mind, I felt somehow drawn to it all. Here was something I couldn't help doing. I had previously refused a commission to do war pictures. Now Kenneth Clark saw these and at once got the War Artists Committee to commission ten. I did forty or fifty from which they made their choice. The Tate also took about ten. In all I did about a hundred large drawings and the two shelter sketch books in the Museum exhibition.[1] I was absorbed in the work for a whole year; I did nothing else.

Then at Herbert Read's suggestion I undertook to do drawings of miners at work (**84**) in the coal-mines – 'Britain's Underground Army', as they were called – another commission of the War Artists Committee. I went to my home town of Castleford and spent two or three weeks in all down the mine. Yet I did not find it as fruitful a subject as the shelters. The shelter drawings came about after first being moved by the experience of them, whereas the coal-mine drawings were more in the nature of a commission coldly approached. They represent two or three weeks of physical sweat seeing the subject and that number of months of mental sweat trying to be satisfied carrying them out.

It was difficult, but something I am glad to have done. I had never willingly drawn male figures before – only as a student in college. Everything I had willingly drawn was female. But here, through these coal-mine drawings, I discovered the male figure and the qualities of the figure in action. As a sculptor I had previously believed only in static forms, that is, forms in repose.

And in both these subjects I think I could have found sculptural motifs only, if I'd tried to; but at the time I felt a need to accept and interpret a more 'outward' attitude. And here, curiously enough, is where, in looking back, my Italian trip and the Mediterranean tradition came once more to the surface. There was no discarding of those other interests in archaic art and the art of primitive peoples, but rather a

1. The first exhibition of his work (1946) to be held in the United States at the Museum of Modern Art, New York.

84 PIT BOYS AT PITHEAD, *1942. Watercolour and ink,* $17\frac{1}{4} \times 24\frac{3}{4}$ *in.*
City Art Gallery, Wakefield.

clearer tension between this approach and the humanist emphasis. You will perhaps remember my writing you in 1943 that I didn't think that either my shelter or coal-mine drawings would have a very direct or obvious influence on my sculpture when I would get back to it – except, for instance, I might do sculpture using drapery, or perhaps do groups of two or three figures instead of one. As a matter of fact the *Madonna and Child* for Northampton and the later *Family Groups* actually have embodied these features. Still I sometimes wonder if both these and the wartime drawings were not perhaps a temporary resolution of that conflict which caused me those miserable first six months after I had left Masaccio behind in Florence and had once again come within the attraction of the archaic and primitive sculptures of the British Museum. [1946/Bibl. 50].

Certainly the shelter drawings did seem to get through to a much larger public than I'd ever reached before, and it did seem to me an extraordinary and fascinating and unique moment in history. There'd been air-raids in the other war, I know, but the only thing at all like those shelters that I could think of was the hold of a slave-ship on its way from Africa to America, full of hundreds and hundreds of people who were having things done to them that they were quite powerless to resist. And perhaps that did get through to the public and make a difference to our relationship; anyway it's from that moment that I didn't need to teach for a living. [1961/Bibl. 47].

I hit upon this technique by accident, sometimes before the war when doing a drawing to amuse a young niece of mine. I used some of the cheap wax crayons (which she had bought from Woolworth's) in combination with a wash of water-colour, and found, of course, that the water-colour did not 'take' on the wax, but only on the background.

I found also that if you use a light-coloured or even a white wax crayon, then a dark depth of background can easily be produced by painting with dark water-colour over the whole sheet of paper. Afterwards you can draw with India ink to give more definition to the forms. If the waxed surface is too greasy for the India ink to register it can be scraped down with a knife.

But a little experimenting with wax crayons and water-colour will show this technique's many possibilities – the danger is, of course, that it will become too tricky.

I was the first to use this technique – but I have explained it to many of my friends and it has come to be used by many English artists. [1964/Bibl. 60].

218

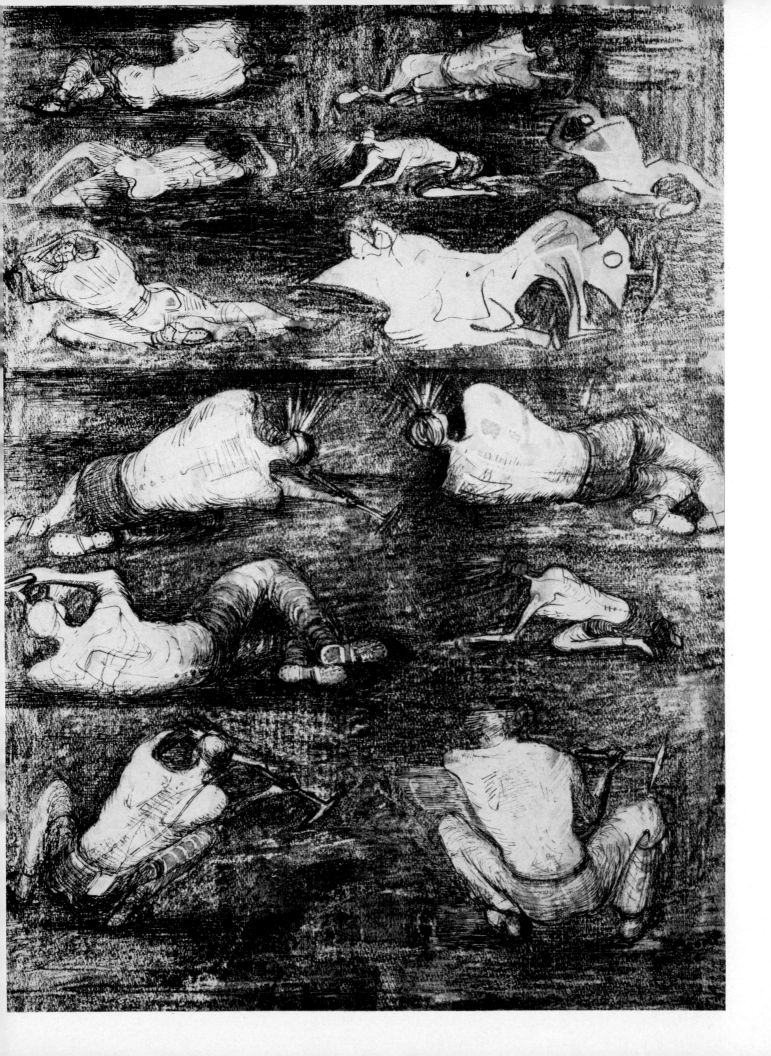

Madonna and Child (Northampton) 1943-44

When I was first asked to carve a *Madonna and Child* for St. Matthew's, although I was very interested I wasn't sure whether I could do it, or whether I even wanted to do it. One knows that religion has been the inspiration of most of Europe's greatest painting and sculpture, and that the church in the past has encouraged and employed the greatest artists; but the great tradition of religious art seems to have got lost completely in the present day, and the general level of church art has fallen very low (as anyone can see from the affected and sentimental prettinesses sold for church decoration in church art shops). Therefore I felt it was not a commission straightway and light-heartedly to agree to undertake, and I could only promise to make notebook drawings from which I would do small clay models, and only then should I be able to say whether I could produce something which would be satisfactory as sculpture and also satisfy my idea of the *Madonna and Child* theme as well.

There are two particular motives or subjects which I have constantly used in my sculpture in the last twenty years; they are the *Reclining Figure* idea and the *Mother and Child* idea. (Perhaps of the two the *Mother and Child* has been the more fundamental obsession.) I began thinking of the *Madonna and Child* for St. Matthew's by considering in what ways a *Madonna and Child* differs from a carving of just a Mother and Child – that is, by considering, how in my opinion religious art differs from secular art.

It's not easy to describe in words what this difference is, except by saying in general terms that the *Madonna and Child* should have an austerity and a nobility, and some touch of grandeur (even hieratic aloofness) which is missing in the everyday *Mother and Child* idea. Of the sketches and models I have done, the one chosen has, I think, a quiet dignity and gentleness. I have tried to give a sense of complete easiness and repose (**86**), as though the Madonna could stay in that position for ever (as, being in stone, she will have to do). The Madonna is seated on a low bench, so that the angle formed between her nearly upright body and her legs is somewhat less than a right angle, and in this angle of her lap, safe and protected, sits the Infant (**87**).

The Madonna's head is turned to face the direction from which the statue is first

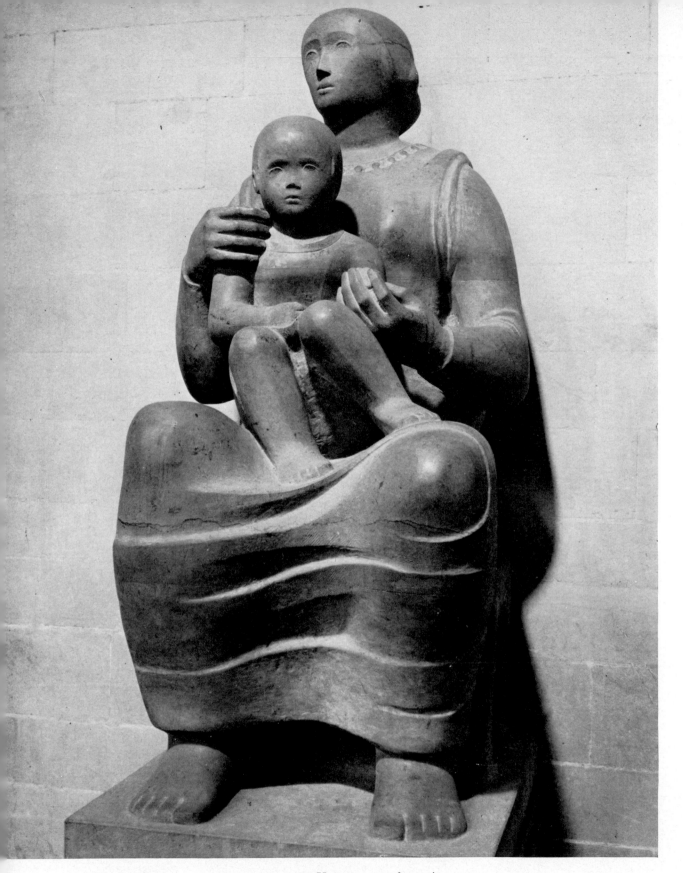

86 MADONNA AND CHILD, *1943–44. Hornton stone, h. 59 in.*
Church of St. Matthew, Northampton.

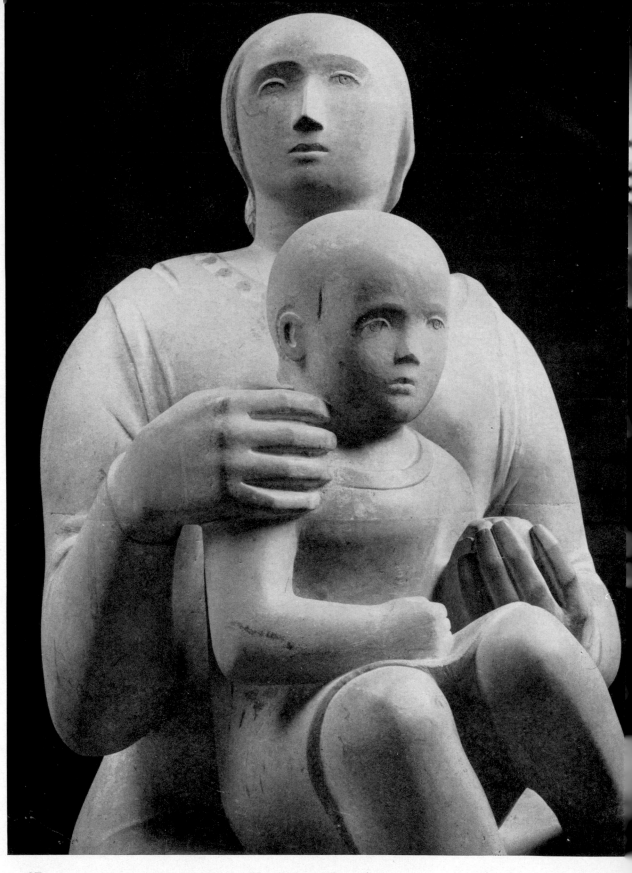

87 MADONNA AND CHILD, *1943–44. Hornton stone, h. 59 in.*
Church of St. Matthew, Northampton.

seen, in walking down the aisle, whereas one gets the front view of the Infant's head when standing directly in front of the statue.

In sculpture, which is related to architecture, actual life-size is always confusing, and as St. Matthew's is a large church, spacious and big in scale too, the *Madonna and Child* is slightly over life-size. But I did not think it should be much over life-size as the sculptor's real and full meaning is to be got only by looking at it from a rather nearer view, and if from nearby it seems too colossal it would conflict with the human feeling I wish to express. [1943/Bibl. 1, 2 and 26].

I couldn't have wished for a better foil to my *Madonna and Child* . . . than Graham Sutherland's *Crucifixion*. Both the tranquillity of the carving, and the passionate violence of the painting gain something by the contrast. The difference would have been too sudden, too dislocating if these two works had been side by side, but the fact that one cannot see them both together, but has to turn away from the one to see the other produces a kind of equilibrium. [1955/Bibl. 55].

Family Group, 1945-49

When Walter Gropius was working in England before the war he was asked by Henry Morris, Director for Education in Cambridgeshire to design a large school at Impington, near Cambridge. It was called a Village College and was meant to be different from other elementary schools because it was meant to put into practice lots of Henry Morris's ideas on education. Such as, that the children's parents should be catered for in the school, and that the school should be the centre of social life of the surrounding villages. The school had a lecture theatre, a hall where they could have plays and films – even sleeping accommodation for parents if they were held up there in winter evenings, etc. Gropius asked me to do a piece of sculpture for the school. We talked about it and I suggested that a family group would be the right subject. However, it never got further than that because there was no money. Henry Morris tried unsuccessfully to raise money by private subscription. Gropius left England for Harvard University. Later the war came and I heard no more about it until, about 1944, Henry Morris told me that he now thought he could get enough money together for the sculpture if I would still like to think of doing it. I said yes, because the idea right from the start had appealed to me and I began drawings in note book form of family groups. From these note book drawings I made a number of small maquettes, a dozen or more (some of which appear in the Lund Humphries book [Bibl. 41]). Some of the maquettes were ideas for bronze, but most of them were for stone because for the Impington school I felt stone would be the suitable material.

I must have worked for nine months or so on the *Family Group* themes and ideas, but again, Henry Morris found it difficult to raise money for the sculpture, and also my maquettes were not liked by the local Education authorities, and again nothing materialised. I carried out three or four of the six inch maquettes more fully in a slightly larger size for my own satisfaction, and then I went on with other work.

About two years later, 1947, John Newsom, the Director of Education in Hertfordshire, a friend of Henry Morris, and having similar progressive ideas on education, told me of a large school being built by Hertfordshire Education authorities. It was being designed by F. R. S. Yorke and Partners, very good architects. Newsom and Yorke knew of the projected Impington sculpture and now said as that had fallen

through would I be prepared to do a piece of sculpture at their new school at Stevenage. I agreed, for here was the chance of carrying through one of the ideas on a large scale which I had wanted to do. I went to see the school and chose from my previous ideas the one which I thought would be right for Stevenage and also one which I had wanted most to carry out on a life-size scale. This was a bronze idea (the one which the Museum[1] bought from my exhibition in 1945).

Again, though, money was a problem – eventually it was solved by me agreeing to do the sculpture at cost price (i.e. price of bronze casting, transport and materials etc.) if I could be allowed to make extra casts which I could dispose of myself.

So the explanation why you have a photograph with dates 1945–49 on the back is that the small version was made in 1945 and the large version in 1949. The main differences between the two are in the heads, especially in the head of the man. In the small version (**88**) the split head of the man gives a vitality and interest necessary to the composition, particularly as all three heads have only slight indications for features. When it came to the life-size version, the figures each became more obviously human and related to each other and the split head of the man became impossible for it was so unlike the woman and the child. (There is different connection between things which are three feet from each other, as the large heads are, and things which one sees in the same field of vision only two or three inches apart.)

The large sculpture was finished in 1949 and cast for Stevenage at a small bronze foundry here in England. The group was really too big for them to handle and they had lots of difficulties, in fact they took a whole year to do it, with a great deal of worry over it to me. That is why we are having the other casts made by Rudier in Paris. [1951/Bibl. 56].

The first cast of this *Family Group* (**89**) was made for the Barclay Secondary School at Stevenage, under the scheme brought in by the Hertfordshire County Council for spending a fraction of one per cent of the building estimates on pictures and sculptures for its new schools. (The scheme unfortunately has since been dropped.) The architect wanted a free-standing group out of doors, and had a position ready for it in his plans. I went out to Stevenage while the school was under construction and tried out a rough life-size silhouette made in cardboard of the *Family Group* just

1. Museum of Modern Art, New York.

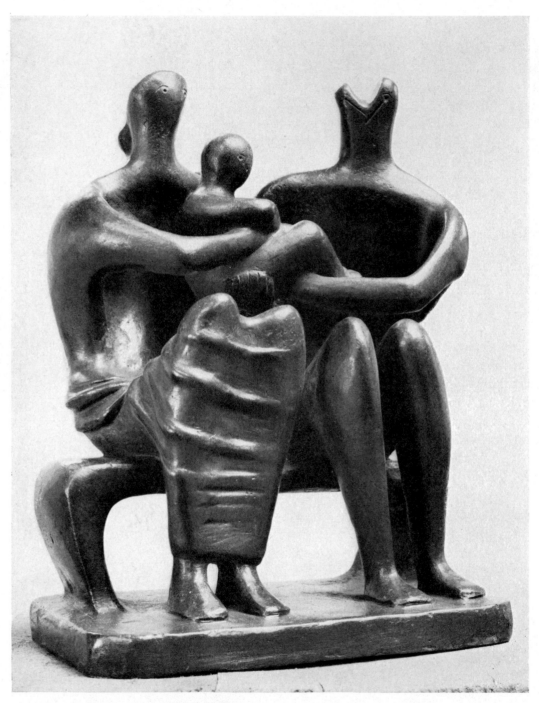

88 FAMILY GROUP, *1946. Bronze,
h. 10 in.* Museum of Modern Art,
New York.

89 FAMILY GROUP, *1948–49. Bronze, h. 60 in. Made after a maquette of 1945
for* Barclay School, Stevenage (**90**). *Additional casts were acquired by the Tate
Gallery, London, the Museum of Modern Art, New York, and Nelson D. Rockefeller.*

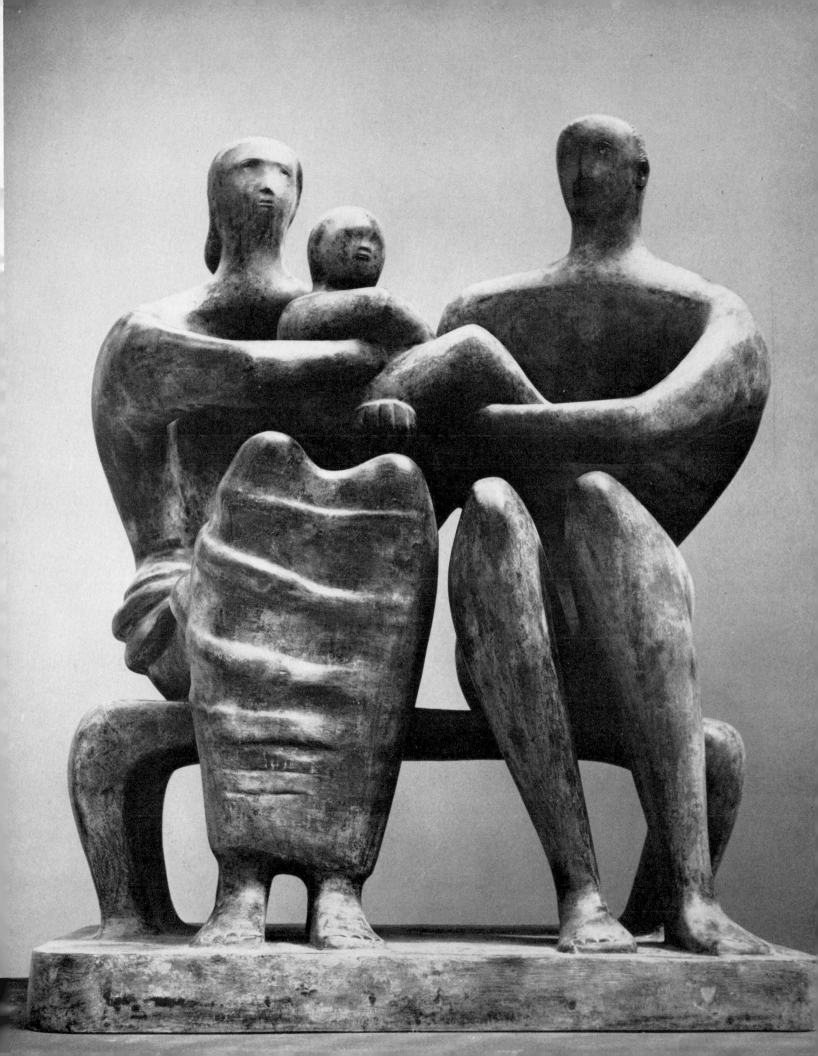

90 FAMILY GROUP, *1948–49, as sited at the Barclay School, Stevenage.*

for its scale. It was to be in front of a curved baffle-wall (**90**) about 20 ft. long by about 8 ft. high on the left of the main entrance, but the space between the sculpture and the baffle-wall is not great enough to tempt one to go round to the back of the sculpture. I realise that from the architect's point of view the position he had decided upon was the proper one. For the baffle-wall played a part in the architecture – it masked an awkward juncture of the building – and without sculpture in front of it, it might have seemed unjustifiable. The fact remains that it is a position that does not allow the *Family Group* to be, in the full sense of the term, free-standing. We stood it as far away from the wall as possible, but one can only see it from a limited number of views, one cannot get those sudden revelations that occur when one comes upon a sculpture from an unexpected angle. In such circumstances architects might consider the use of a turntable, not to keep the statue slowly turning – that would be a horrible idea – but to present another view of it every month or so. And if a sculptor knows that his work is going to be seen all round, it is a further impetus to sculpt all round.

When one has made two or three casts of a work, one has a chance to see it in different settings. To see one cast in a better setting than another teaches one something but there aren't any rules for discovering 'correct' settings.

The second cast of the Stevenage *Family Group* was set up for a time on the lawn by the entrance of the Tate Gallery. I was pleased to see the experiment. It was only a temporary position, and it was interesting to observe the drawbacks. Actually I prefer it in the large sculpture gallery of the Tate, where it stands now.

The third cast of the *Family Group* is in the garden of the Museum of Modern Art, New York, but I've only seen it there in an exhibition position, which has its own set of problems, quite distinct from the problems of arranging a permanent collection.

The fourth cast is in the garden of Nelson Rockefeller's country house, but I haven't seen it there. [1955/Bibl. 55].

Time-Life Screen and Reclining Figure 1952-53

I think architecture is the poorer for the absence of sculpture and I also think that the sculptor, by not collaborating with the architect misses opportunities of his work being used socially and being seen by a wider public. And it was feeling that the time is coming for architects and sculptors to work together again that brought me to do the double commission for the Time-Life building in Bond Street, of both the bronze *Draped Reclining Figure* for the terrace (**94**) and the carved stone screen (**95**) at the Bond Street end of the terrace. I was first asked to do only the *Reclining Figure*, and was glad to, as that fitted in with my idea of free-standing sculpture in relation to architecture. [1955/Bibl. 55].

Because this figure is placed on the terrace and stands free from the building it could therefore in my opinion be more an individual and complete work in its own right. In fact, being a more human and realistic work it would have a value as a contrast to the architecture of the building. [1954/Bibl. 19].

I knew that the figure would be seen from the Reception Room and it seemed to me that in cold weather a nude – even an abstractish one – might look incongruous to people looking out at her from a warm room. So I became absorbed by the problems of the draped figure, and for a time I was back in the period of the shelter drawings, whose themes had demanded a concentration on drapery. But gradually I evolved a treatment that exploited the fluidity of plaster. The treatment of drapery in my stone carvings was a matter of large, simple creases and folds but the modelling technique enabled me to build up large forms with a host of small crinklings and rucklings of the fabric.

This figure was made for a small terrace, but because the terrace is in the open air I made it over life-size; if it stood up it would be a figure about 7 ft. high. . . . On

230

every day that I worked upon the *Reclining Figure*, it was pushed out into the garden (**91**) before the light went, so that I could be sure that it was standing up to an open setting, and the scale was judged by greater distances than those that operate on the Time-Life terrace. So when the second cast was included in the Holland Park open-air exhibition last year [1954] I was not surprised to find that in this more open setting it looked larger than the cast on the terrace. The open setting gave it more breathing space and the forms achieved their proper amplitude. . . . [1955/Bibl. 55].

I have tried in this figure to use drapery from what I think is a sculptural point of view.

Drapery played a very important part in the shelter drawings I made in 1940 and 1941 and what I began to learn then about its function as form gave me the intention, sometime or other, to use drapery in sculpture in a more realistic way than I had ever tried to use it in my carved sculpture. – And my first visit to Greece in 1951 perhaps helped to strengthen this intention – So . . . I took the opportunity of making this draped figure in bronze.

Drapery can emphasise the tension in a figure, for where the form pushes outwards, such as on the shoulders, the thighs, the breasts, etc., it can be pulled tight across the form (almost like a bandage), and by contrast with the crumpled slackness of the drapery which lies between the salient points, the pressure from inside is intensified.

Drapery can also, by its direction over the form, make more obvious the section, that is, show shape. It need not be just a decorative addition, but can serve to stress the sculptural idea of the figure.

Also in my mind was to connect the contrast of the sizes of folds, here small, fine and delicate, in other places big and heavy, with the form of mountains, which are the crinkled skin of the earth (**92**). . . .

Although static, this figure is not meant to be in slack repose, but, as it were, alerted. [1954/Bibl. 19].

It was while thinking about this *Reclining Figure* that the architect approached me about the sculptured *Screen*, at the Bond Street end of the terrace (**95**), and I welcomed the chance of working simultaneously upon two such entirely different sculptural problems.

It seemed to me that the *Screen* should look as though it was part of the

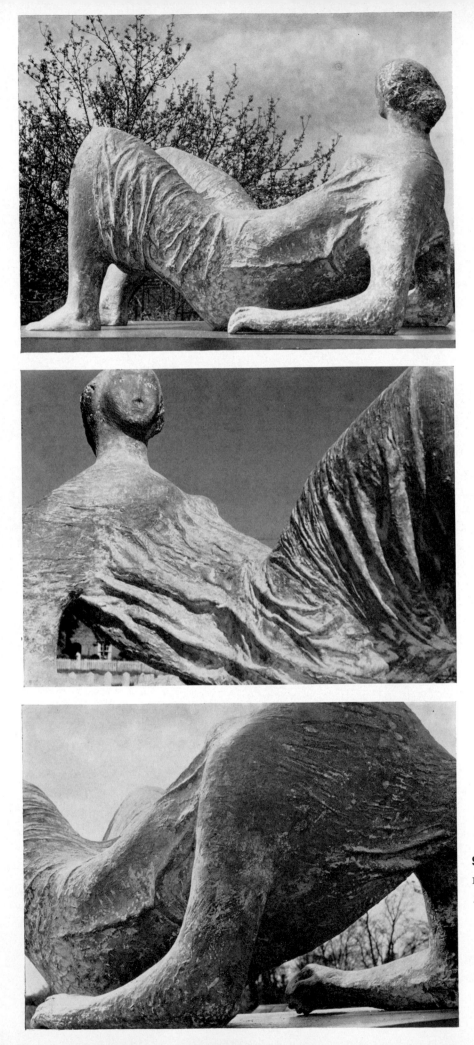

91–93 Details of DRAPED RECLINING FIGURE, *1952–53* (**94**).

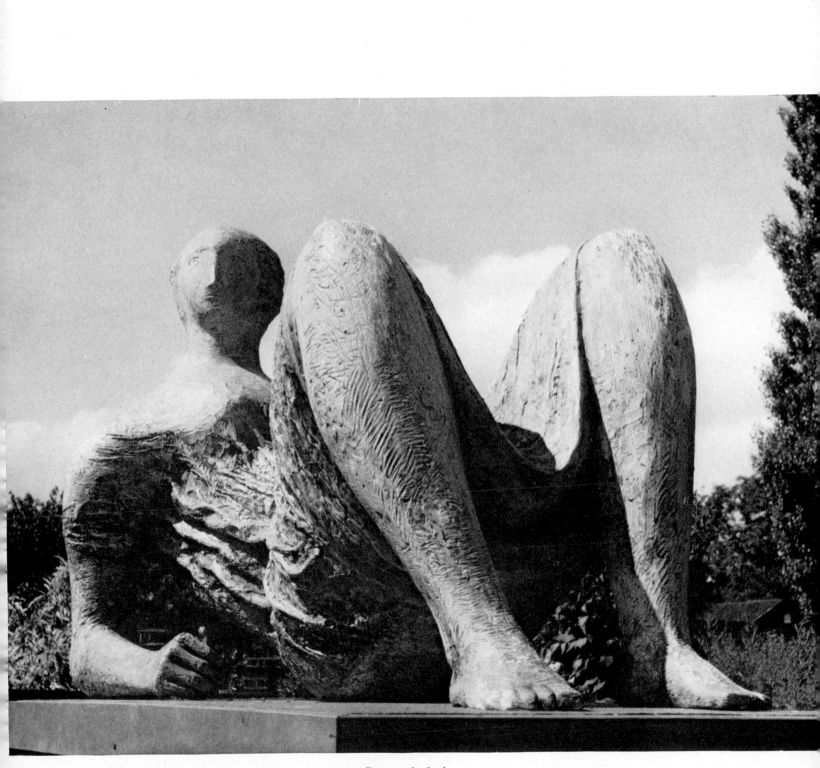

94 DRAPED RECLINING FIGURE, *1952–53. Bronze, l. 62 in.*
Time–Life Building, London.

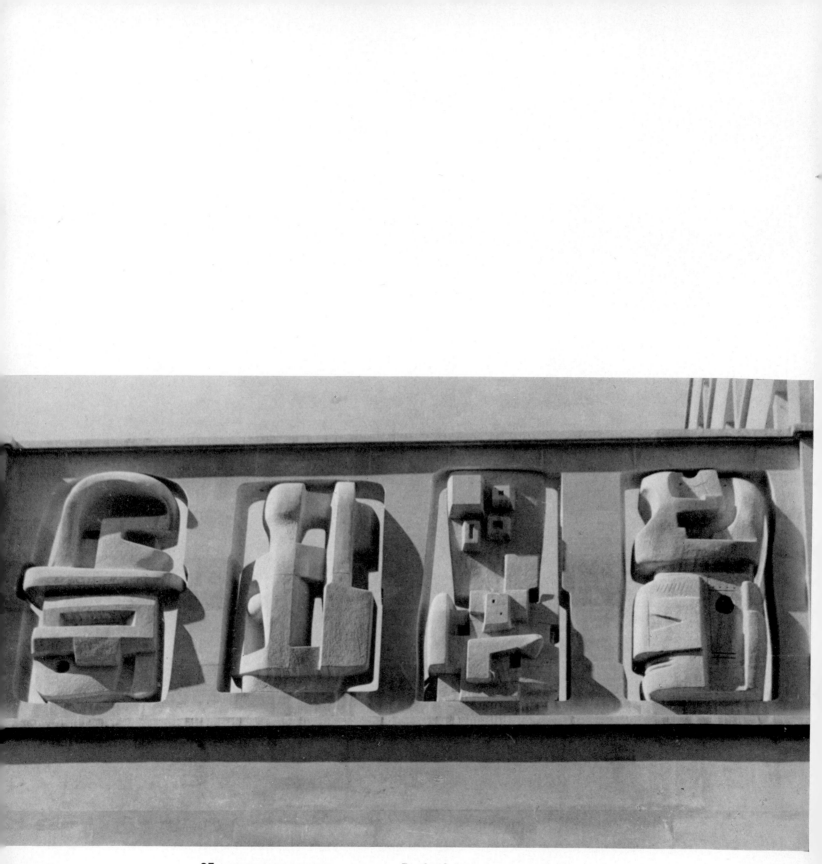

95 TIME-LIFE SCREEN, *1952–53. Portland stone, 120 × 318 in.* Time-Life Building, London.

architecture, for it is a continuation of the surface of the building – and is an obvious part of the building.

The fact that it is only a screen with space behind it, led me to carve it with a back as well as a front, and to pierce it, which gives an interesting penetration of light, and also from Bond Street makes it obvious that it is a screen and not a solid part of the building.

With the perspective sketch of the building beside me I made four maquettes and my aim was to give a rhythm to the spacing and sizes of the sculptural motives which should be in harmony with the architecture. I rejected the idea of a portrayal of some pictorial scene, for that would only be like hanging up a stone picture, like using the position only as a hoarding for sticking on a stone poster.

The first (**96**) of the four maquettes I rejected because I thought it too obvious and regular a repetition of the fenestration of the building.

In the second maquette (**97**) I tried to vary this and make it less symmetrical but in doing so the rhythms became too vertical.

In the third maquette (**98**) I tried to introduce a more horizontal rhythm but was dissatisfied with the monotony of the size of the forms.

The fourth maquette (**99**) I thought was better and more varied and so this became the definitive maquette, although a further working model produced other changes. [1954/Bibl. 19].

Long before the carvings themselves were ready I had to decide upon the shape and size of the openings of the screen, so that the architect could get it prepared and built into position before the carvings arrived on the site. The four big stones themselves were carved on a scaffolding erected in my garden – and, of course, without the stone frame screen round them. By the time I realised that they didn't really need a screen at all, the screen had been made and was in position on the building, and all I could do was to arrange for the openings to be made larger, that is to say as large as possible without weakening the structure of the screen. I found too that my project really demanded a turntable for each of the carvings, so that they could be turned, say, on the first of each month, each to a different view, and project from the building like some of those half animals that look as if they are escaping through the walls in Romanesque architecture. I wanted them to be like half-buried pebbles whose form one's eye instinctively completes. This is the idea behind Renaissance reliefs where the solid is suggested by perspective. The Renaissance relief is a pictorial

96–99 FOUR MAQUETTES FOR TIME-LIFE SCREEN (**92**), *1952.*
Plaster, 7 × 13 in. The artist.

conception really and not a sculptural one. Trial and error is essential to the creative process but unfortunately in the 20th century one cannot change one's mind on the job. I say in the 20th century because I'm sure that the people who built Chartres Cathedral were able to have second thoughts. The carrying out of the fully developed idea of the Time-Life *Screen* would have entailed elaborate reinforcement of the building and expense beyond the original estimates, but what has been done is the beginning of something, and the idea, particularly the turntable idea may yet bear fruit I hope in architectural sculpture of the future. [1955/Bibl. 55].

Draped Torso, 1953

A large work, like the *Draped Reclining Figure* (**94**), has to be cast in several pieces which are then welded together. That figure was cast in about five sections – the head, two arms, the torso and the legs. I have to see, of course, the sections in wax before they are cast and when I saw the torso part, separate from the rest, even I, who had done it, was very struck by its completeness and impressiveness just as a thing on its own. It was then that I thought of making that part, a work in its own right, as I pictured it as a piece standing on my own lawn. So after the whole figure had been cast in bronze I asked the foundry to make a wax of the torso part alone, cut off at just what points I thought out as most satisfactory. I then worked on the wax for quite a time and made some modifications. The design of it as a fragment (just where to end the arms, neck, etc., and deciding on their angle), and the poising of the torso upright, were all a problem to make it completely satisfactory in itself (**100**).

What pleased and surprised me about it was how Greek it looks and that it has a sense of scale and size quite equal to that of the whole figure.

When the final bronze was completed and came out to the studio I made a point of showing people who saw it, its connection with the *Reclining Figure*, and saying that my visit to Greece, three years ago, must have had a bigger influence than I had been aware of. In a sense I think one can say it is almost an independent conception, because the work I did on it in the wax, plus it being poised upright, makes it look completely different from the *Reclining Figure* (even indicates things about the *Reclining Figure* which would not otherwise be felt). Unless I had thought it was an impressive object in its own right I should not have shown it at the Leicester Galleries. Of course it may be that we are so used to seeing antique fragments that we now look upon torsos as complete works.

And the fact that this sculpture shows that some of my work has a definite traditional quality is an added reason that I would be happy for it to be in a public collection. [1954/Bibl. 57].

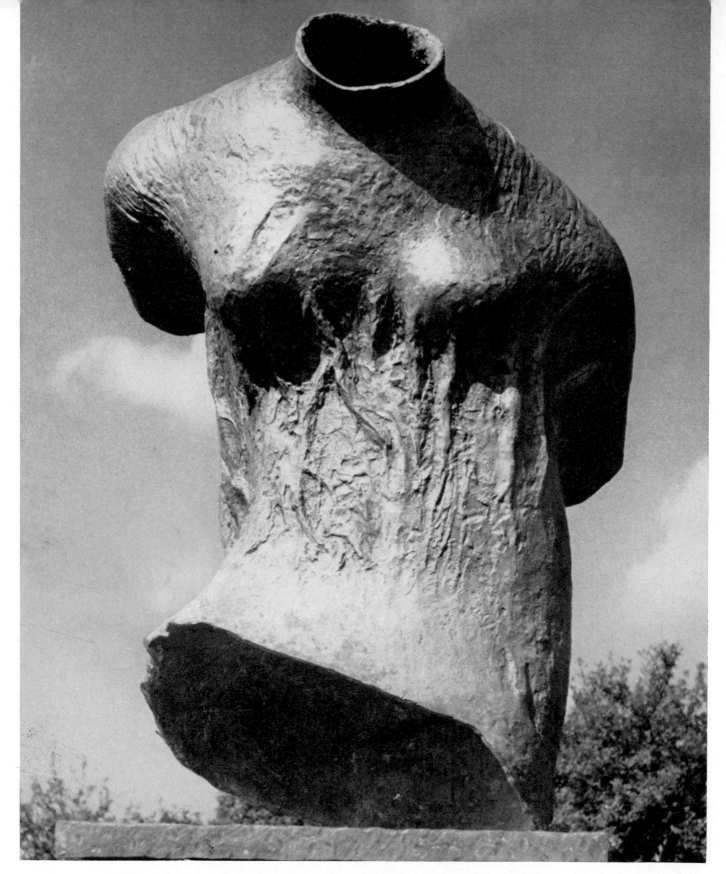

100 DRAPED TORSO, *1953. Bronze, h. 35 in.* Ferens Art Gallery, Hull.

King and Queen, 1952-53

Can you tell us something about conception of the 'King and Queen'?

The idea for the *King and Queen* was conceived by me with no particular setting in mind but with just my general feelings about sculpture in the open air.

 The first cast of the sculpture was purchased by the city of Antwerp and placed in the outdoor sculpture museum at Middelheim Park. A year or so later Mr. Keswick decided to buy the final cast of it for his estate at Glenkiln.

Were the figures modelled in clay over armature?

No. The figures were built up directly in plaster.

Is the rock base natural, or was it partly or wholly built?

There is a natural outcrop of rock. The site is a natural bump on the high ground with outcrop of rock and grass, which is now mown short by sheep and rabbits grazing. The actual base is partly built of large stones from nearby, in order to make a level platform for the *King and Queen*.

Who selected the site? You, Mr. Keswick, or the two of you together?

W. J. Keswick, inspired by Henry Moore, selected the site.

How long did it take to select the site once the idea of sculpture had come up?

The *King and Queen* was tried in two other sites before coming to rest in the present one. This process took at least nine months. Mr. Keswick spends most of his time at Glenkiln, when not shooting, selecting sites for sculpture on the property.

Are there more sculptures on the estate than the two you sent?

R

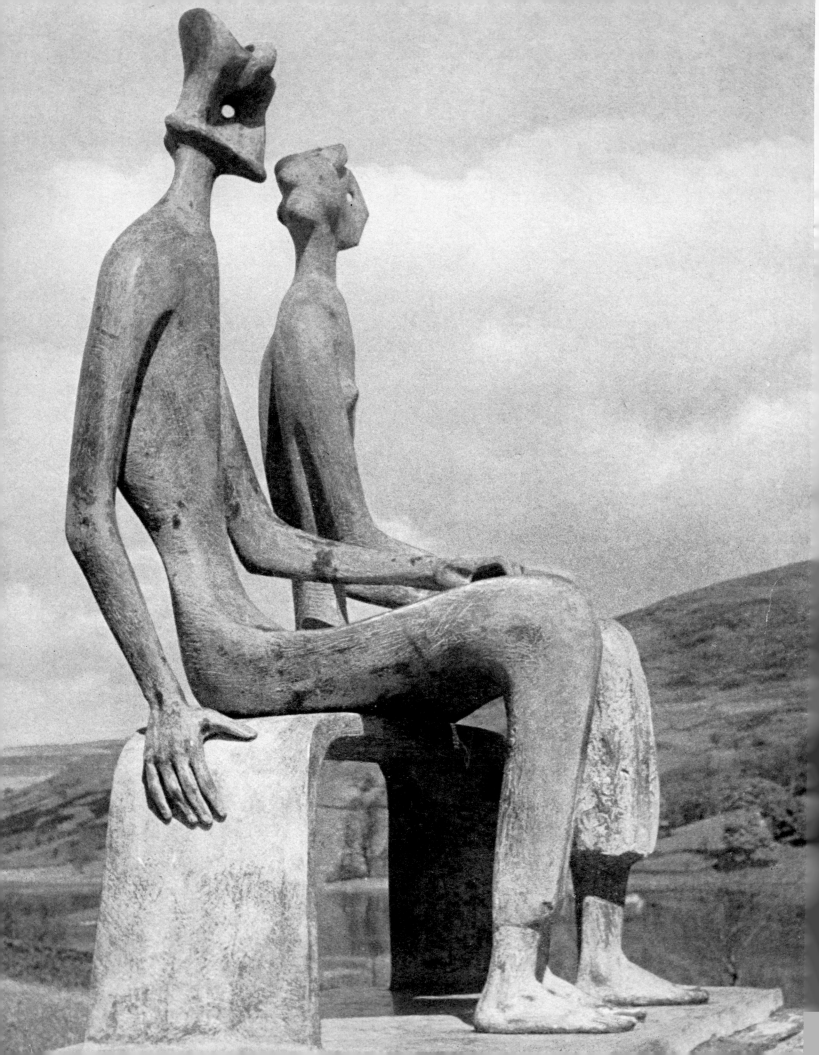

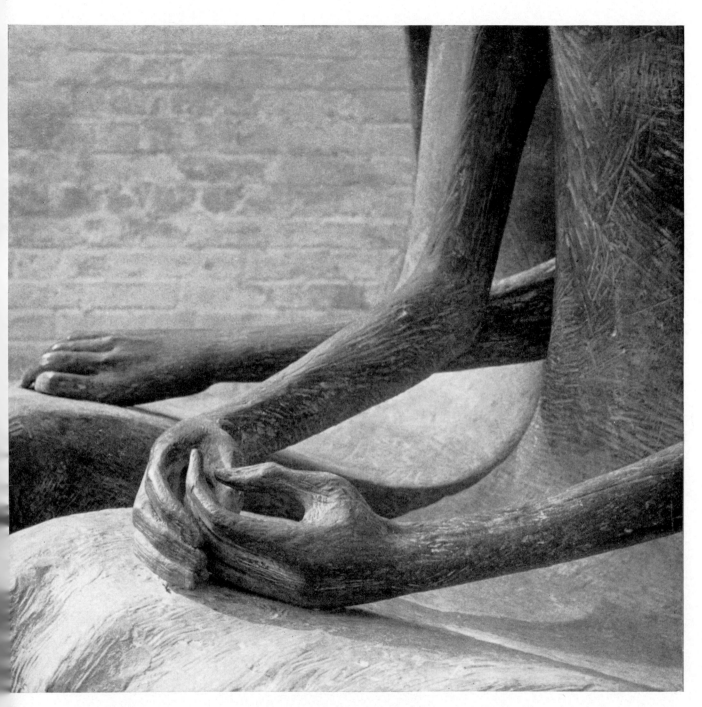

102 *Detail of* KING AND QUEEN *showing the Queen's hands*

01 KING AND QUEEN, *1952–53. Bronze, h. 64½ in.* W. J. Keswick.
On the owner's moor at Shawhead, Dumfries.

Sculptures on the estate are:

 Standing Figure by Henry Moore

 King and Queen by Henry Moore[1]

 The Visitation by Epstein

 Madame Renoir by Renoir

There are other smaller works, including a small Rodin.

Are there plans for more sculpture?

Nothing is planned. But, as and if Mr. Keswick has the means (which he is very doubtful) he hopes to go on with the idea of creating a large moorland 'gallery' for sculpture in 3000 acres of ground.

Can the two pieces of sculpture done by you be seen from each other?

No, they are not visible one from the other.

How far apart are they?

They are far apart. Not in sight of each other. Half a mile apart – or more. They possess their environment. The whole point is that they should not appear as a jumbled collection.

Is the 'King and Queen' visible from some room of the owner's house?

The figures are not visible from any room of the owner's house. They are placed up on wild moorland and are quite alone. Possibly too much alone.

How much walking distance between first seeing the 'King and Queen' and reaching them?

From half a mile to one mile distance walking across the hill or along the hill roads – ten minutes or so, walking time.

1. Since this statement was written the *Glenkiln Cross* (**109**) and the *Two-Piece Reclining Figure* No. 1 (**117**) have been added.

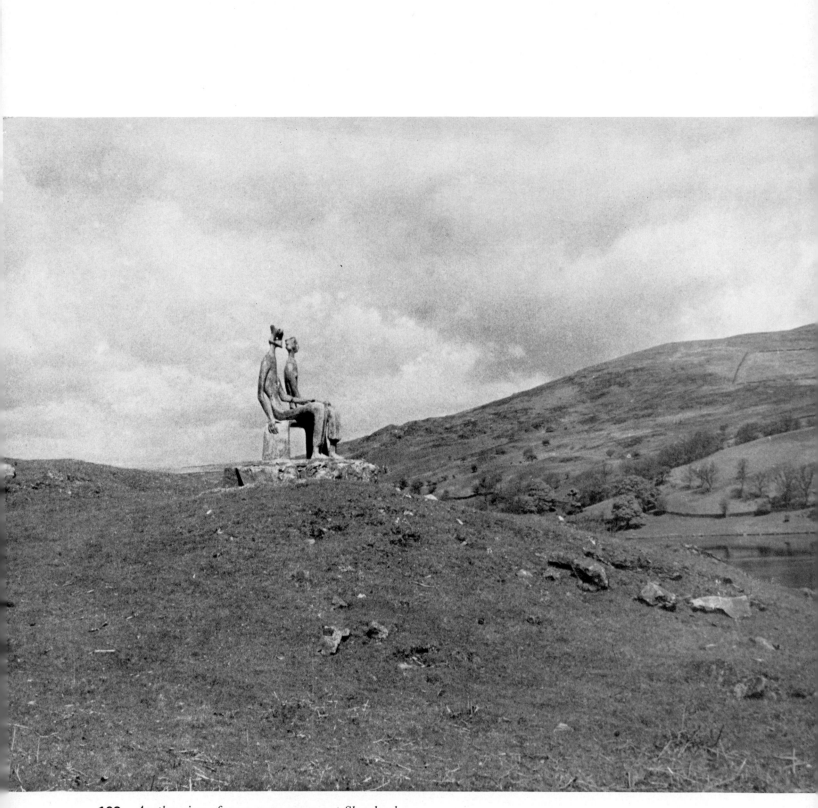

103 *Another view of* KING AND QUEEN *at Shawhead.*

Do they look in the direction of a specific object, house, hill or lake?

They look out on the hills and over Glenkiln Loch. The *King and Queen* have a magnificent view over the loch looking out toward England over the border fifty miles away (**103**).

In making and placing 'King and Queen', did you consider the changing light and shadows cast by the sun?

Yes. They face south and slightly west.

What is the reason for what from the photographs seems a differentiation of treatment (in terms of naturalism) between the King's hand – particularly noticeable in the rear view – and his face?

Perhaps the 'clue' to the group is the King's head, which is a combination of a crown, beard and face symbolising a mixture of primitive kingship and a kind of animal, Pan-like quality. The King is more relaxed and assured in pose than the Queen, who is more upright and consciously queenly. When I came to do the hands and feet of the figures they gave me a chance to express my ideas further by making them more realistic (**102**) – to bring out the contrast between human grace and the concept of power in primitive kingship. [1956/Bibl. 35].

How the group came about I don't know, unless it may be that in the last year or two I have read stories to my daughter in which Kings and Queens have appeared a lot and this might have made one's mind open to such a subject. [1954/Bibl. 36].

Internal and External Forms, 1953-54

The first maquette for the wood Interior Exterior Forms was produced in 1951, later the same year I made the working model (24½ in. high), which was cast into bronze. The idea was always intended to be worked out over life-size, and to be in wood. But large and sound pieces of wood are not easily found, and it was after trying unsuccessfully for a year to find a suitable piece of wood that I decided I should have to make it in plaster for bronze, and this I did (6 ft. 7 in. high). This was completed and about to be sent to the bronze foundry for casting when my local timber merchant informed me he had a large elm tree just come in which he thought would be exactly what I wanted. It was a magnificent tree, newly cut down, five feet in diameter at its base, and looked very sound. I bought it, and decided not to go on with the bronze version but to carry out the idea as originally intended as a wood sculpture. (**104**).

I am very pleased this happened because I am sure that elm wood, in particular, with its large-sized grain, varied, big and bold, makes it ideal in scale for large work (**105**). It was necessary for the upright carving to be in wood, which is alive and warm and gives a sense of growth. Wood is a natural and living material, unlike plaster or metal which are built up by man.

These qualities were in harmony with the idea, which is a sort of embryo being protected by an outer form, a mother and child idea, or the stamen in a flower, that is, something young and growing being protected by an outer shell.

The large wood version was started in early 1953, only about a week after the tree had been cut down. Such a piece of wood, five feet in diameter, would have taken thirty years of special care and treatment to be seasoned, as on the average, wood seasons in a natural way one inch per year. Therefore, a sixty inch block takes thirty years to dry out to the middle. But by carving it slowly over a period of two years, and because its final form has no part more than five inches thick, it is now fully seasoned, and the seasoning has been less precarious, and more thorough. The hole at the base of the carving has been hollowed out from beneath. [1955/Bibl. 58].

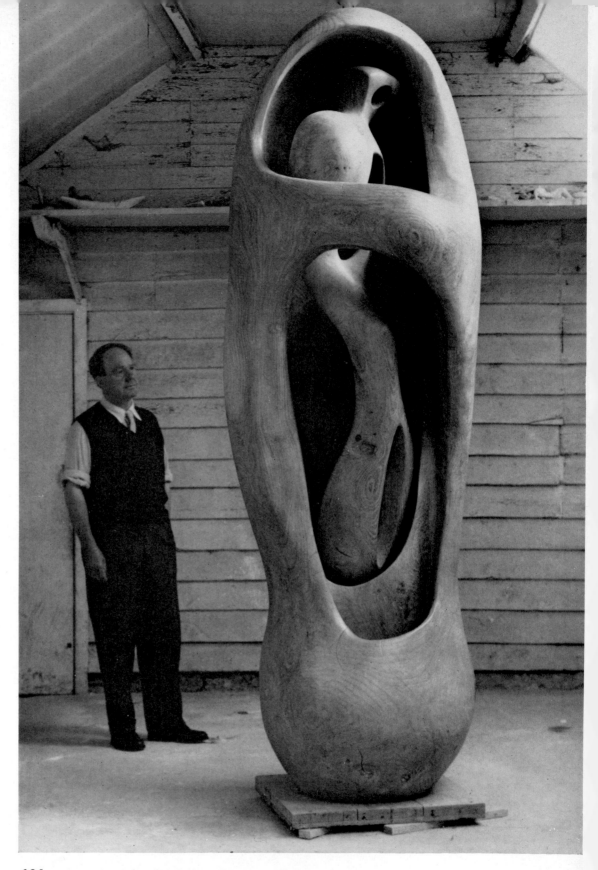

104 INTERNAL AND EXTERNAL FORMS, *1953–54.*
Elm wood, h. 103 in. Albright-Knox Art Gallery, Buffalo.

105 *Detail of* INTERNAL AND EXTERNAL FORMS, *1953–54.*

Warrior with Shield, 1953-54

The idea for *The Warrior* (**106**) came to me at the end of 1952 or very early in 1953. It was evolved from a pebble I found on the seashore in the summer of 1952, and which reminded me of the stump of a leg, amputated at the hip. Just as Leonardo says somewhere in his notebooks that a painter can find a battle scene in the lichen marks on a wall, so this gave me the start of *The Warrior* idea. First I added the body, leg and one arm and it became a wounded warrior, but at first the figure was reclining. A day or two later I added a shield and altered its position and arrangement into a seated figure and so it changed from an inactive pose into a figure which, though wounded, is still defiant (**107**).

The head has a blunted and bull-like power but also a sort of dumb animal acceptance and forbearance of pain.

The figure may be emotionally connected (as one critic has suggested) with one's feelings and thoughts about England during the crucial and early part of the last war. The position of the shield and its angle gives protection from above. The distance of the shield from the body and the rectangular shape of the space enclosed between the inside surface of the shield and the concave front of the body is important.

Except for a short period when I did coal-mining drawings as a war artist, nearly all my figure sculpture and drawings, since being a student, has been of the female, except for the Family Groups, but there the man was part of the group.

This sculpture is the first single and separate male figure that I have done in sculpture and carrying it out in its final large scale was almost like the discovery of a new subject matter; the bony, edgy, tense forms were a great excitement to make.

Like the bronze *Draped Reclining Figure* of 1952-53 I think *The Warrior* has some Greek influence, not consciously wished for but perhaps the result of my visit to Athens and other parts of Greece in 1951. [1955/Bibl. 59].

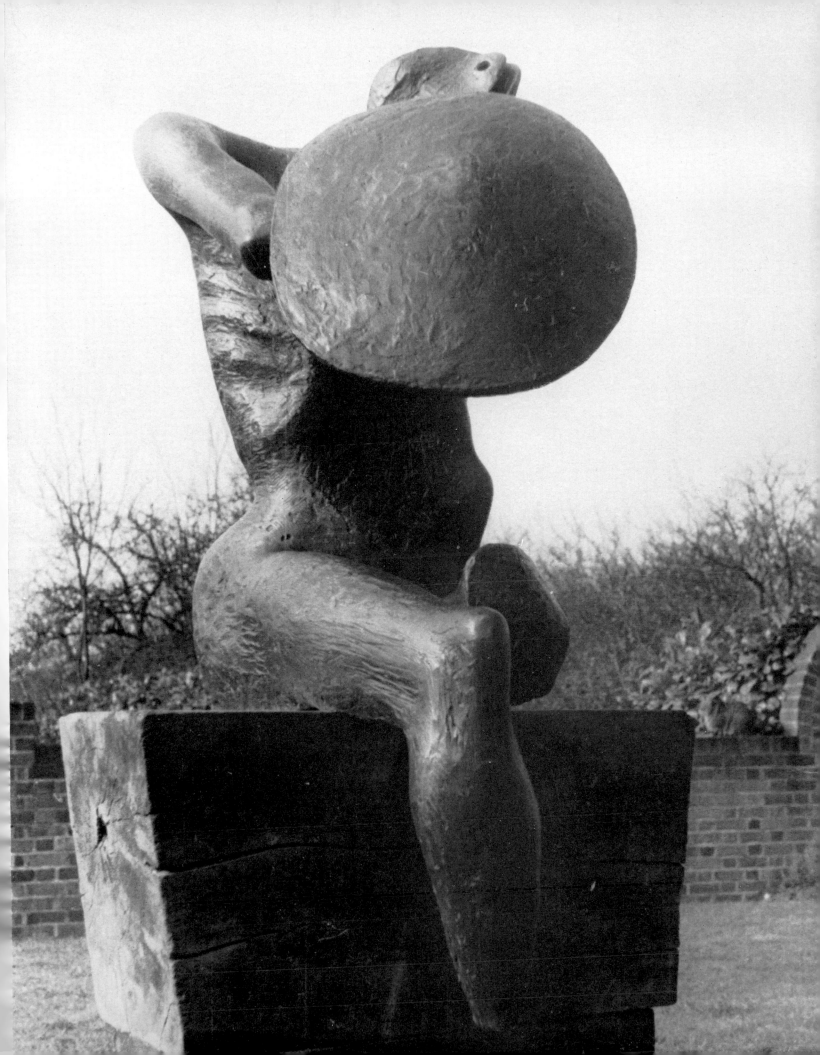

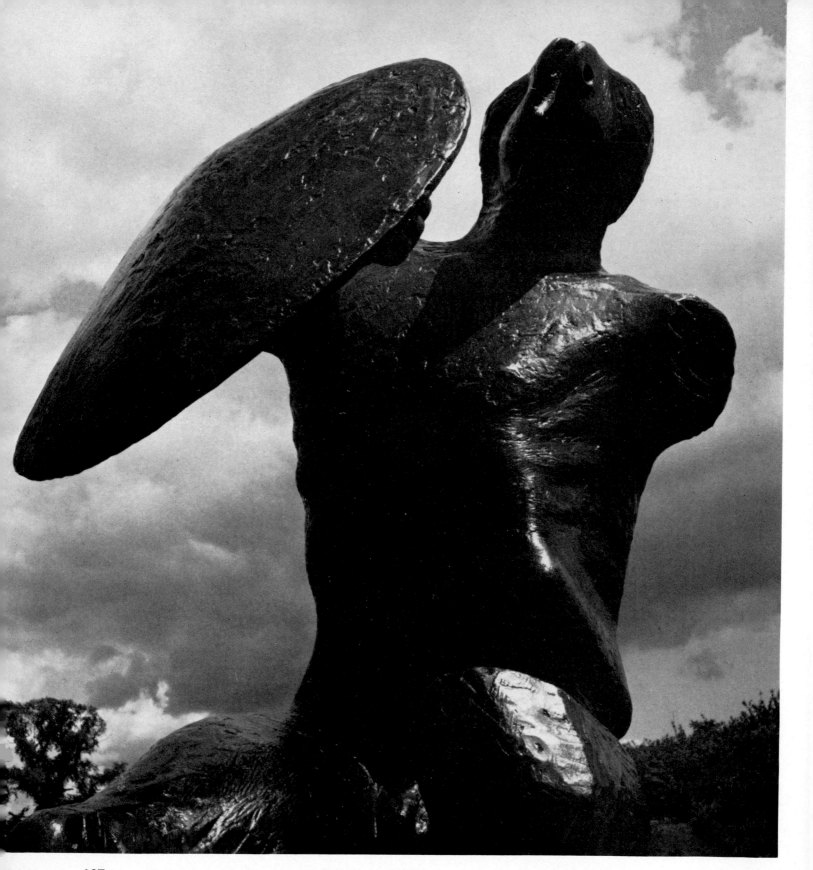

107 WARRIOR WITH SHIELD, *1953–54, Bronze, h. 60 in.*

Upright Motives (including the Glenkiln Cross) 1955-56

In 1954 I was asked to do a sculpture for the courtyard of Olivetti's new office building in Milan. I went out to Milan and met the architect and we looked together at the building then in construction. We both agreed that, for contrast, any sculpture done in relation to the building should have an upright rhythm rather than a horizontal or squarish proportion. [1960/Bibl. 21].

A lone Lombardy poplar growing behind the building convinced me that a vertical work would act as the correct counterfoil to the horizontal rhythm of the building. This idea grew ultimately into the *Upright Motives* [1965/Bibl. 38].

A few months later I made a series of small maquettes between nine and twelve inches high but, of course, in my mind was a final height of between eight and twelve feet. With some of the maquettes I stopped being primarily concerned with the Olivetti building and thought of them in their own rights. I then carried out a number of them[1] in their full size purely for my own satisfaction [1960/Bibl. 21].

I started by balancing different forms one above the other – with results rather like the Northwest American totem poles – but as I continued the attempt gained more unity also perhaps became more organic – and then one in particular (later to be named the *Glenkiln Cross*) took on the shape of a crucifix – a kind of worn-down body and a cross merged into one (**109**). [1965/Bibl. 38].

1. Five out of eight, nos. 1, 2, 5, 7 and 8 were carried out in full size. Of these the *Glenkiln Cross* was no. 1.

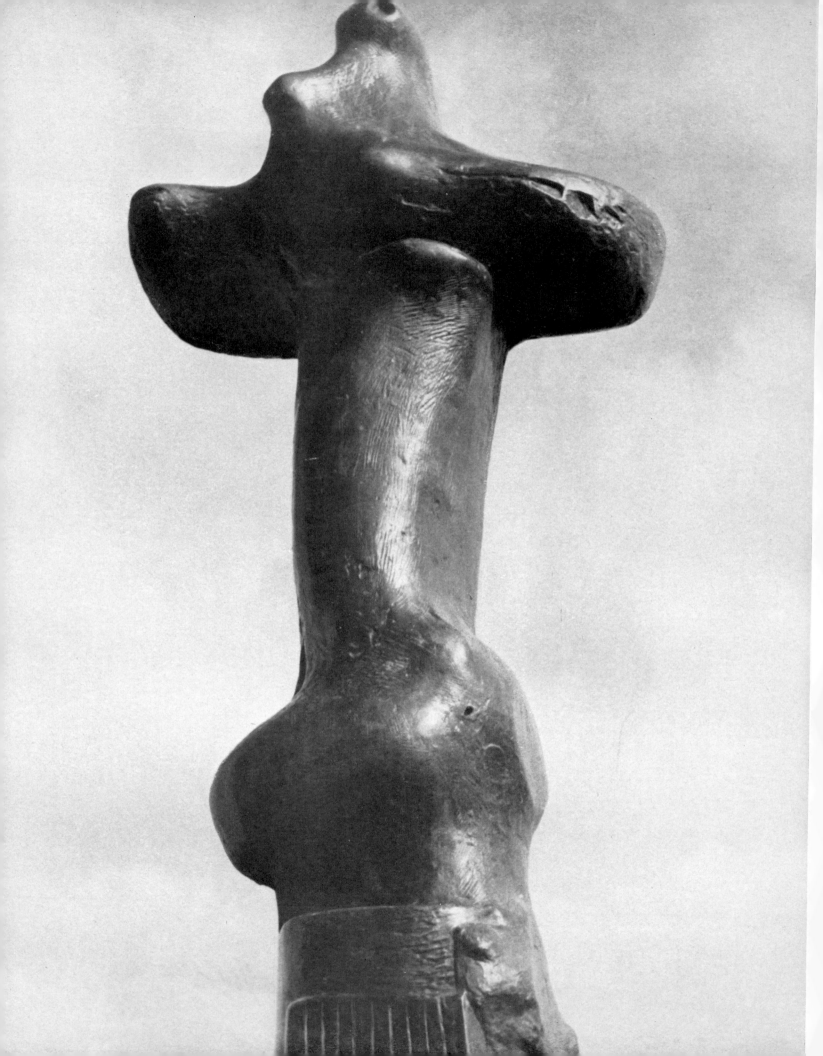

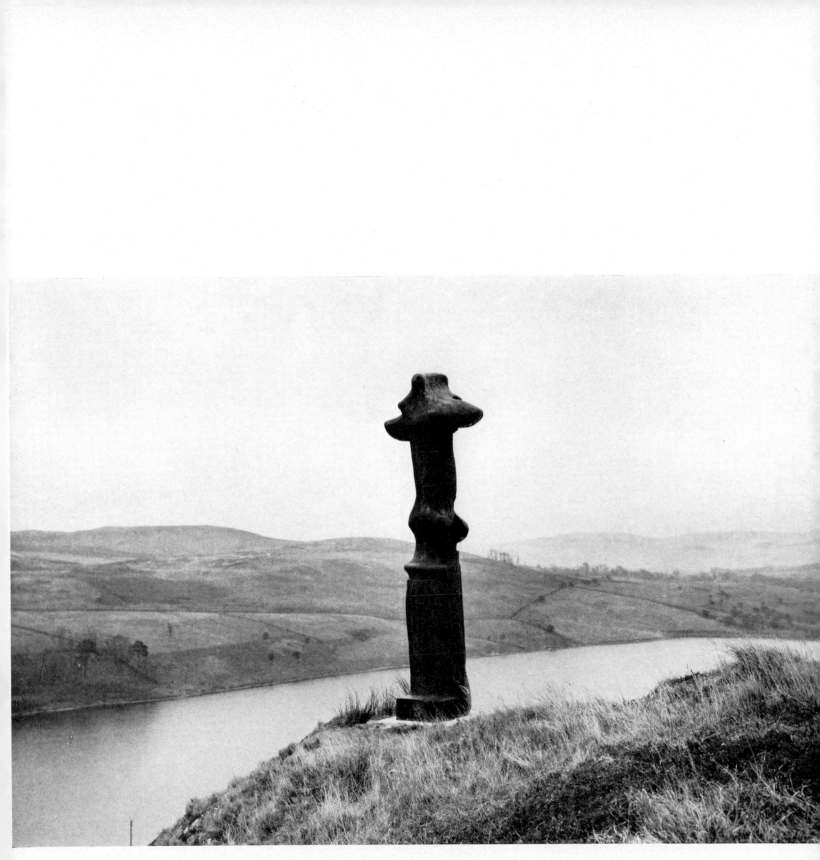

109 UPRIGHT MOTIVE NO. I. (GLENKILN CROSS.) *Bronze, h. 132 in.*
1955–56. W. J. Keswick. *On a hillside above a loch at Glenkiln Farm, Shawhead,*
Dumfries.

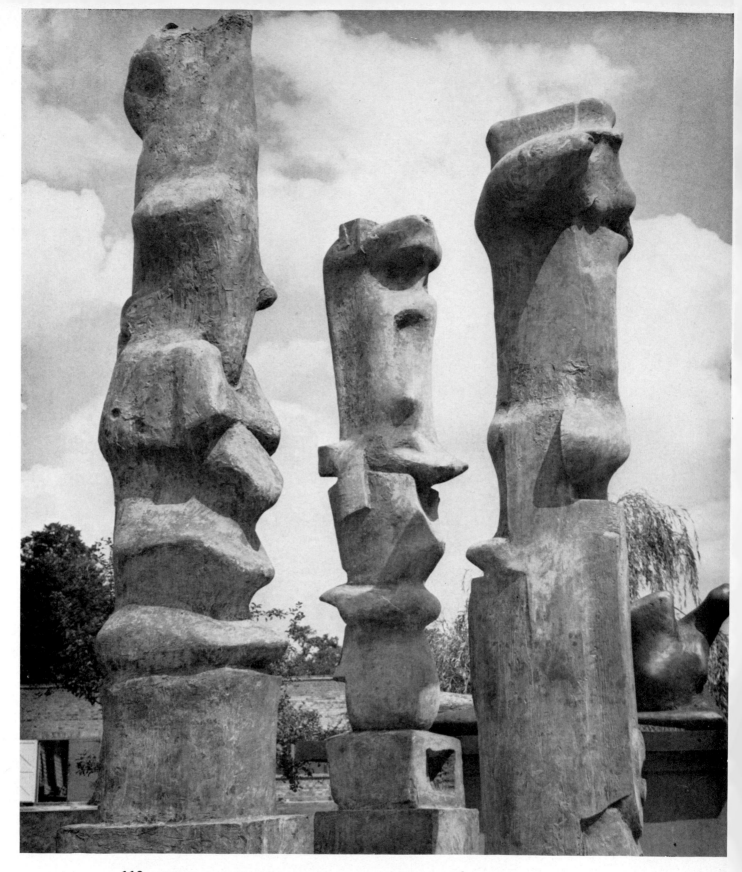

110 THREE UPRIGHT MOTIVES, NOS. 1, 2 AND 7, 1955–56.
Bronze, h. 126 in. The Glenkiln Cross (No. 1) is on the right.

Because the first cast of this sculpture was placed on a hill-side at Glenkiln Farm, Shawhead, in Scotland – and because it is so beautifully sited there (**109**) – it has now come to have the name *Glenkiln Cross* [1960/Bibl. 21].

When I came to carry out some of these maquettes in their final full size, three of them grouped themselves together,[1] and in my mind, assumed the aspect of a Crucifixion scene (**110**), as though framed against the sky above Golgotha. But I do not especially expect others to find this symbolism in the group. In its great periods sculpture has been an outdoor art and not an art only for drawing-rooms and museums. And I am very happy that this group is placed at Otterlo[2] to be seen in relation to landscape and silhouetted against the Dutch sky – that sky whose vastness Rembrandt evoked even in his slightest landscape sketch. [1965/Bibl. 38].

1. Nos. 1 (the *Glenkiln Cross*), 2 and 7. In the illustration here the *Cross* is on the right, seen from the side.
2. In the open-air sculpture park of the Kröller-Müller Museum where Moore's *Two-Piece Reclining Figure no. 2* (1960) is also on view.

Reclining Figure (Unesco) 1957-58

The London press has in recent weeks quoted or misquoted you very widely and stated that before starting work on your Unesco assignment, you spent three or four months meditating the meaning of Unesco

The press has very much exaggerated this aspect of my approach to the Unesco assignment. My friend Julian Huxley, the first Director-General of Unesco, told me what he considered to be the purpose and meaning of Unesco, and this was, of course, a help to me in first formulating my thoughts on the subject.

To me, it all sounds like a nineteenth-century assignment to design an allegorical group to be set above the main entrance of the building. I mean something like: 'The United Nations coordinating the efforts of Education, Science and Culture and guiding Mankind in its search for Peace.' I'm quite surprised you didn't finally plump for a draped figure with a lantern held high, at arm's length, above its head.

Eventually, after discarding many preliminary studies I decided on a reclining figure that seeks to tell no story at all. I wanted to avoid any kind of allegorical interpretation that is now trite. This particular reclining figure has perhaps turned out to be one of those that Sir Philip Hendy has called 'wild ones'[1] . . . Sculptures which are inspired by general considerations of nature, but which are less dominated by representational considerations, and in which I use forms and their relationships quite freely. [1960/Bibl. 45].

When I worked out the details I realised the job was too big to do here, and so I went to Italy with the plaster model and worked there. The finished piece consists of four blocks of Roman travertine, excluding the pedestal base, of course. It is over

1. P. Hendy, *Humanism and wild ones*, article in *New Statesman*, 13th December, 1958.

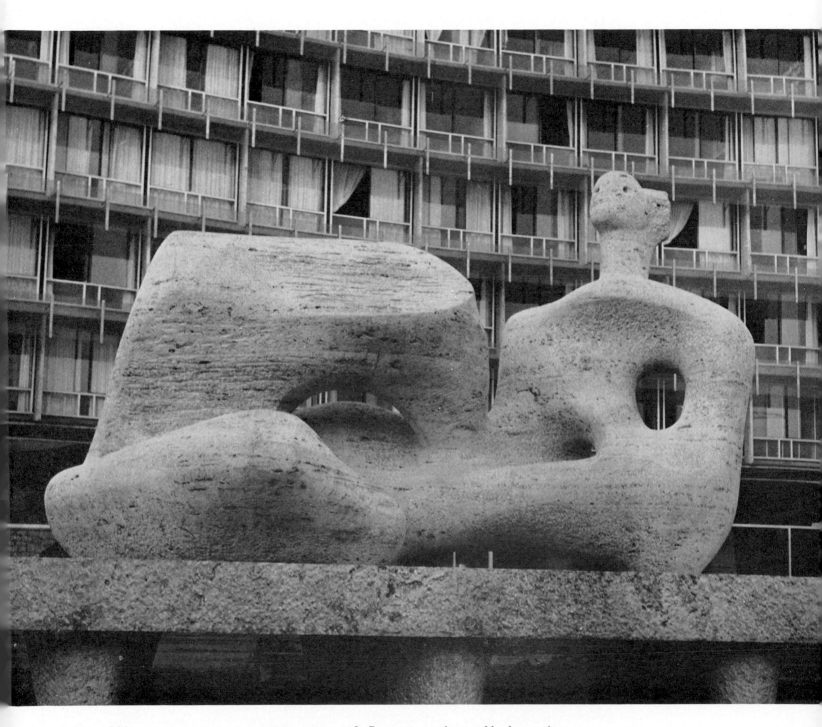

111 UNESCO RECLINING FIGURE, *1957–58. Roman travertine marble, l. 200 in.*
UNESCO, Paris. *Many other ideas for this commission were considered and realised in three dimensions (see bibl. 43, nos. 418–40) but this was the sculptor's final choice.*

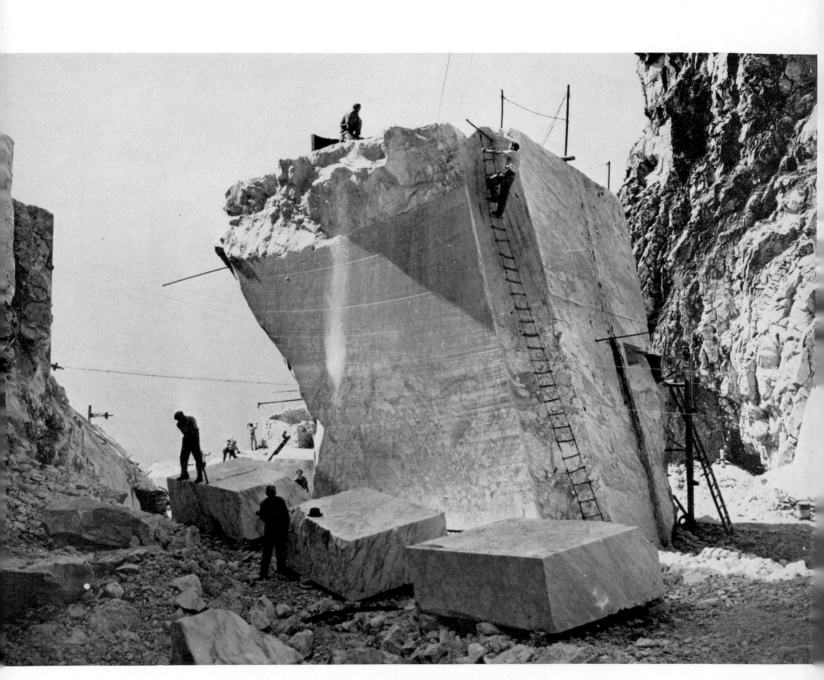

112 STONE QUARRY AT QUERCETA. *Owned by the firm of Henraux who supplied the stone for the Unesco figure.*

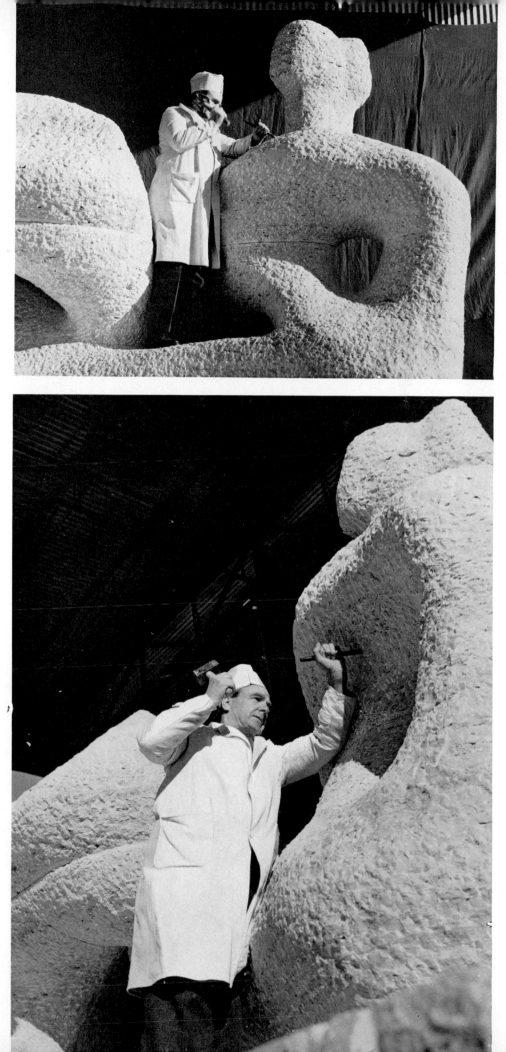

113 *and* 114 *The sculptor*
at work on the UNESCO
RECLINING FIGURE
in the open air in the
stone-works at Querceta.

115 *A close-up detail of* UNESCO RECLINING FIGURE.

116 *Another view of* UNESCO RECLINING FIGURE.

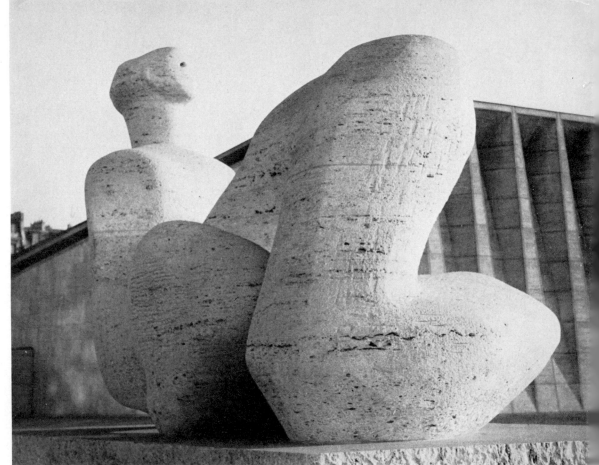

sixteen feet long and weighs thirty-nine tons, but the original blocks weighed something like sixty tons before I went to work on them. That size and weight, of course, would have made it impossible to have done the carving here in my studio. Transport expenses alone would have been enormous, and I wouldn't have been able to handle such weights. I produced the full-size stone sculpture at Messrs. Henraux's stone and marble works (**112**) at Querceta, a small village at the foot of the Carrara Mountains, about a mile from Forte dei Marmi. The stone was quarried near Rome, but Messrs. Henraux brought it from the quarries to their works at Querceta for me. There they have a large overhead crane which simplified everything. But it took me nearly a year, with the help of two of Messrs. Henraux's stone-carvers (**113** and **114**).

Unesco originally asked me for a bronze. I did some drawings with that in mind, but as I thought about it, I realised that since bronze goes dark outdoors and the sculpture would have as its background a building that is mostly glass, which looks black, the fenestration would have been too much the same tone, and you would have lost the sculpture (**111**). So then I worked on the idea of siting the figure against a background of its own, but then, inside the building you wouldn't have had a view of the sculpture. Half the views would have been lost. So I finally decided the only solution was to use a light-coloured stone they've used for the top of the building – travertine. It's a beautiful stone. I'd always wanted to do a large piece in it. At the unveiling it looked too white – all newly carved stone has a white dust on it – but on my last trip to Paris, I went to Unesco, and saw that it's weathering nicely. In ten or twenty years' time with the washing of the Paris rain, it will be fine. Half of Rome is built of travertine.

Of course, it was a harder job than it would have been if I'd done it in bronze. When you carve, you're dealing with the absolute final piece. The practical problems are much greater than those you have with a large bronze. If I'd done it in bronze, the original would have been in plaster, and hollow. I'd have cut it up and shipped it off to the bronze founder, and the practical problems would have been his.

When I'm doing pieces for bronze I work occasionally in soft clay which has to be cast in plaster. Generally, though, I work directly in plaster, building it up on a wooden framework. I put it on with a trowel or a spatula. It hardens in a quarter of an hour, and I can cut it down and build it up again. [1962/Bibl. 14].

The Reclining Figure

There are three fundamental poses of the human figure. One is standing, the other is seated, and the third is lying down. Now if you like to carve the human figure in stone, as I do, the standing pose is no good. Stone is not so strong as bone, and the figure will break off at the ankles and topple over. The early Greeks solved this problem by draping the figure and covering the ankles. Later on they supported it against a silly tree trunk.

But with either the seated or the reclining figure one doesn't have this worry. And between them are enough variations to occupy any sculptor for a lifetime. In fact if I were told that from now on I should have stone only for seated figures I should not mind at all.

But of the three poses, the reclining figure gives the most freedom, compositionally and spatially. The seated figure has to have something to sit on. You can't free it from its pedestal. A reclining figure can recline on any surface. It is free and stable at the same time. It fits in with my belief that sculpture should be permanent, should last for eternity. Also, it has repose. And it suits me – if you know what I mean. [1947/ Bibl. 34].

The explanation why the 1936 elm figures are unlike any of the stonework of the same date lies, I think, in their material. I have always known and mentioned how much easier it is to open out wood forms than stone forms, so it was quite natural that the spatial opening-out idea of the reclining figure theme first appeared in wood, and it wasn't until two years later[1] that my freedom with stone had got far enough to open it out to that extent without the stone losing its structural strength. [1948/Bibl. 51].

1. In the *Reclining Figure* carved in Hornton stone for the architect Chermayeff (now in the Tate Gallery). See also p. 14.

The reclining figure is an absolute obsession with me, of course, and at one time the relationship of mother and child was another. I don't like to repeat an experience that I've once had in my work, but there are some that I can't get away from. I wake up in the morning and there they are, day after day, until I do something about it.

But what I sometimes find is that if one's really as sensitive as one ought to be when one's doing sculpture, one gets into such a state of comprehension or apprehension of everything around one that it's just about impossible to go on living until you pick on one subject and get down to it.

I could get into such a state of looking that the whole of this room and every object in it could become the starting points for a new sculpture. Take those dahlias – you could do a sculpture based on the rhythm of their leaves, and an entirely different one based on that plant over there, and you, and that couch, and the tree outside, and your scarf on the chair . . . and that can be too much of a good thing. It starts too many conflicts at once when you try to turn the experience into just what you want.

You have to choose the one particular idea that will hold everything you want to do. It's not even so much the initial idea in the literary sense that counts. It's the amount you can put into it. It's like when a man decides to settle down and marry a certain girl; if he's the right sort of man and she's at all sympathetic they can make a life that's full and rich, instead of chopping and changing. But the choosing and the beginning can be very difficult. You know that when Mondrian had a studio with a beautiful view onto the Seine he had the windows boarded up so that he couldn't look out; well, I couldn't do that, but I understand why he did it. [1961/Bibl. 47].

Two-Piece Reclining Figures 1959 and 1960

The *Two-Piece Reclining Figures* must have been working around in the back of my mind for years, really.[1] As long ago as 1934 I had done a number of smaller pieces composed of separate forms, two and three-piece carvings in ironstone, ebony, alabaster and other materials. They were all more abstract than these. I don't think it was a conscious or intentional thing for me to break up the figures in this way, but I suppose those earlier works from the thirties had something to do with it. I didn't do any preliminary drawings for these. I wish now I had. I did the high one (**117**–**121**) first, then the more definitely reclining one (**122**–**124**). There's a third one, even larger, that's just gone off to the foundry. I did the first one in two pieces almost without intending to. But after I'd done it, then the second one became a conscious idea. I realised what an advantage a separated two-piece composition could have in relating figures to landscape. Knees and breasts are mountains. Once these two parts become separated you don't expect it to be a naturalistic figure; therefore, you can justifiably make it like a landscape or a rock. If it is a single figure, you can guess what it's going to be like. If it is in two pieces, there's a bigger surprise, you have more unexpected views; therefore the special advantage over painting – of having the possibility of many different views – is more fully exploited.

The front view doesn't enable one to foresee the back view. As you move round it, the two parts overlap or they open up and there's space between. Sculpture is like a journey. You have a different view as you return. The three-dimensional world is full of surprises in a way that a two-dimensional world could never be. . . .

The Upright *External/Internal Forms* I did[2] in 1952 and 1953 was a transitional stage from those early smaller pieces to these *Two-Piece Reclining Figures* it seems to me in

1. There can be little doubt that the 'leg' end of the 1959 figure was inspired by the sculptor's memories of a natural outcrop of rock at Adel, near Leeds (**119**), which he saw once when he was a boy.
2. See **104**.

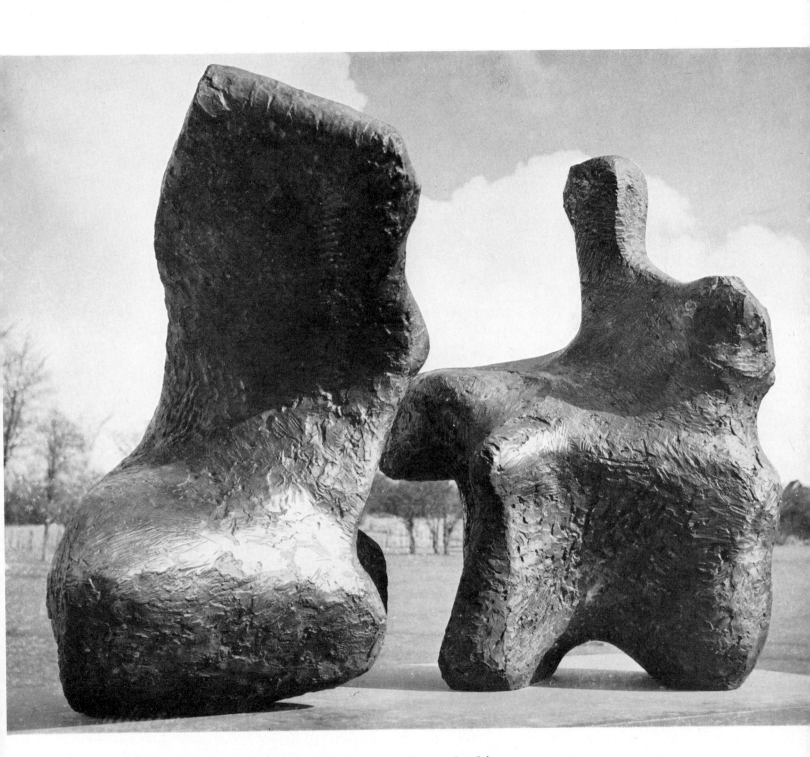

117 TWO-PIECE RECLINING FIGURE NO. I, *1959. Bronze, l. 76 in.*

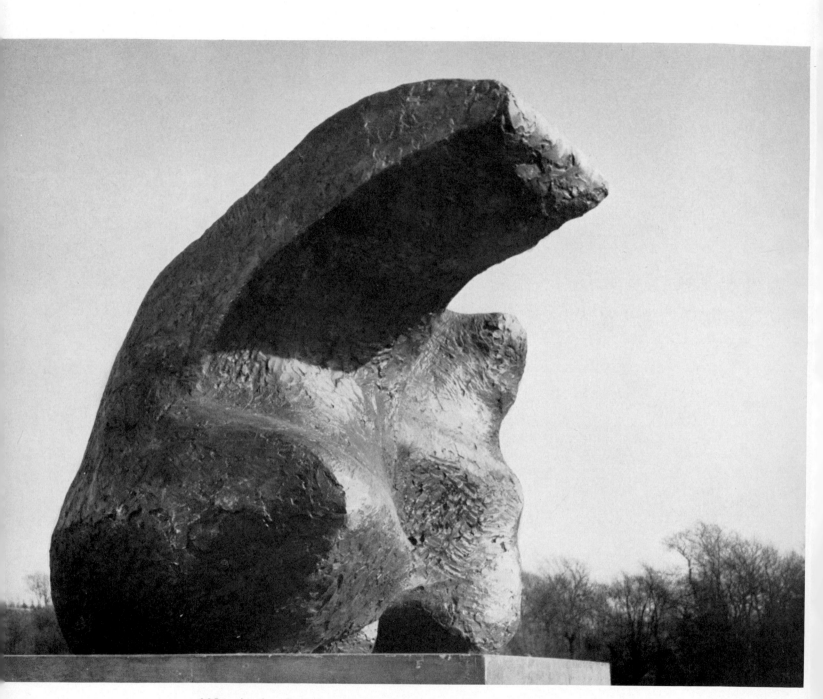

118 *Another view of* TWO-PIECE RECLINING FIGURE NO. I.

119 A ROCK AT ADEL *once
seen by the artist when about
10 years old.*

120 *Seurat.* LE BEC DU HOC *1885.
Oil, 25½ × 32⅛ in.* Tate Gallery,
London. *Formerly in the collection of
Sir Kenneth Clark when it was often
seen by the artist.*

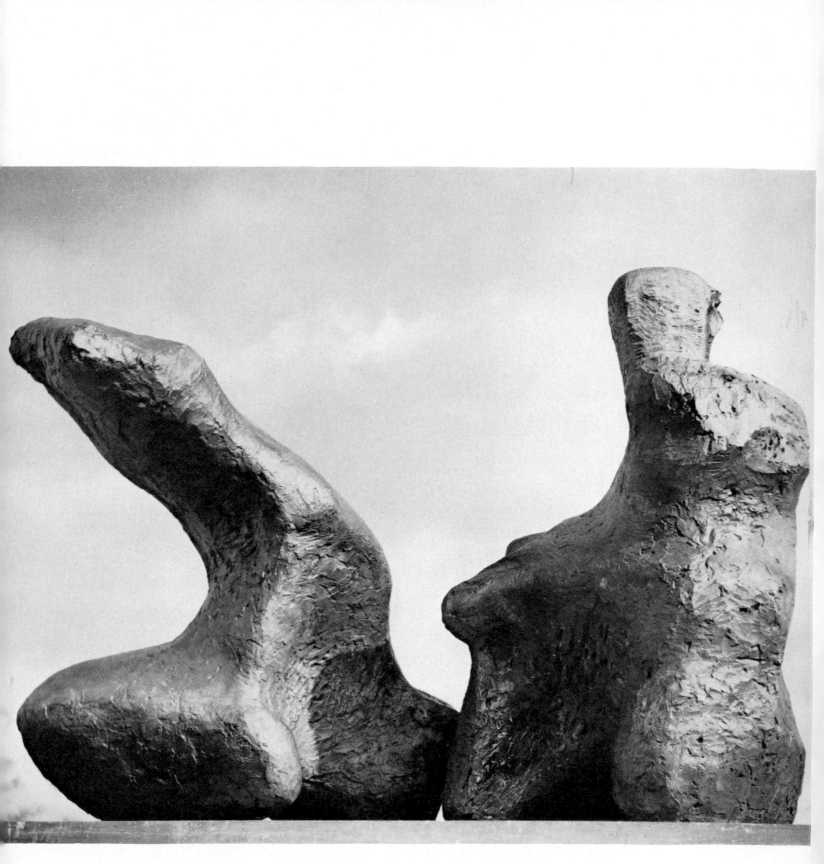

121 *Another view of* TWO-PIECE RECLINING FIGURE NO. I.

retrospect. I may do some that split into more than two parts.[1] They are still one unit, not two or three separate figures . . . If somebody moved one of these parts one inch, straightaway I'd know. The space would be different, the angles through here, there. All the relationships would be changed. [1962/Bibl. 14].

In both sculptures I realised that I was simplifying the essential elements of my reclining figure theme . . . In many of my reclining figures the head and neck part of the sculpture, sometimes the torso part too, is upright, giving contrast to the horizontal direction of the whole sculpture. Also in my reclining figures I have often made a sort of looming leg – the top leg in the sculpture projecting over the lower leg which gives a sense of thrust and power – as a large branch of a tree might move outwards from the main limb – or as a seaside cliff might overhang from below if you are on the beach. [1962/Bibl. 61].

In your most recent sculpture – the sculpture in two pieces, are the figures totally separate?

Well, it's made in two pieces. There's a head end and a leg end; and the space between them has a relationship to the rest of it. But perhaps one of the things which to some extent I'm pleased about in it, is that having made it in two pieces, I can turn it round on a turntable and one form gets in front of the other in ways that you can't guess; and so it has more variety of view from all round than probably any other piece of sculpture that I've done up to this date.

So that if this was in an exhibition you would either want us to move round it, or you'd want somebody at the exhibition to turn it for us.

Well, I would rather move round it. No, I think that sculpture should remain still and the person should go round it. The sculpture is a mixture of the human figure and landscape. From one point of view the leg end is like a mountain rock. As I

1. He had made two maquettes in three pieces in 1961 and 1962 and by the end of 1963 two full-scale *Three-Piece Reclining Figures* (see bibl. 43 pl. 141–48 and 163–66).

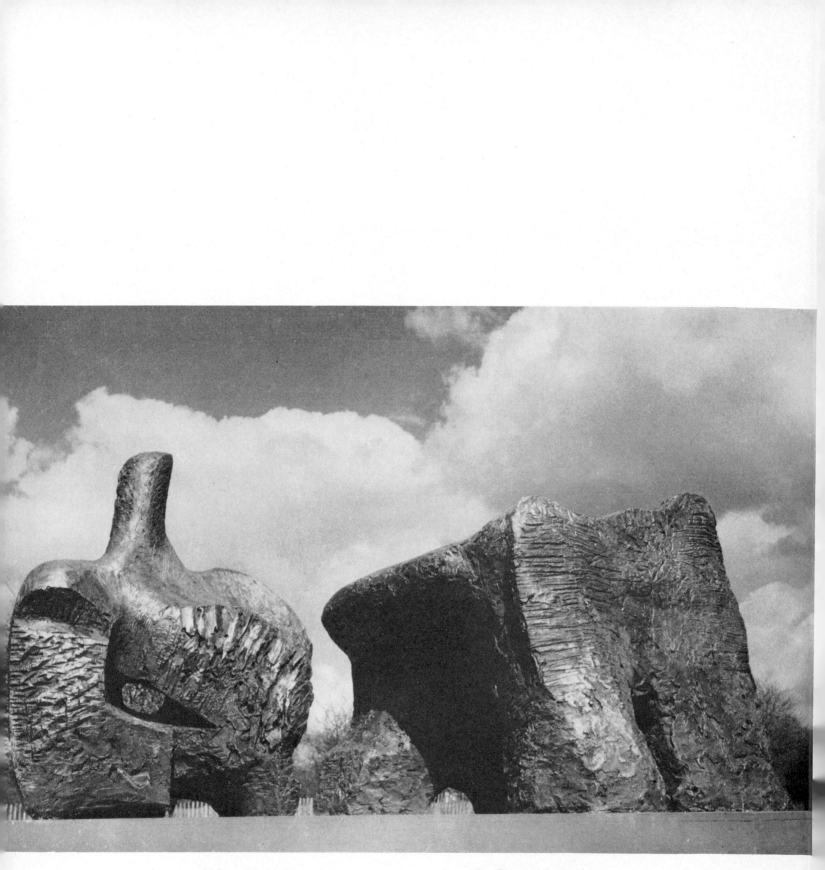

122 TWO-PIECE RECLINING FIGURE NO. 2, *1960. Bronze, l. 102 in.*

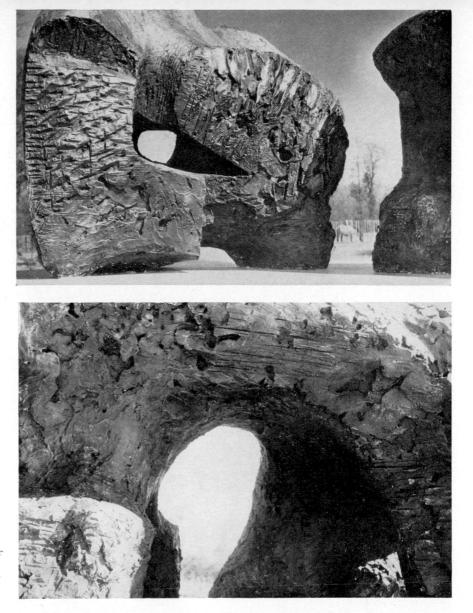

123 and **124**. *Details of*
TWO-PIECE RECLINING
FIGURE NO. 2.

125 *Monet.* CLIFF AT
ETRETAT, *1883. Oil,*
25¾ × 32 in. Metropolitan
Museum of Art, New York
(Bequest of William Church
Osborn, 1951). *The memory of*
*Seurat's picture (***120***) in*
connection with the first Two-piece
Reclining Figure *is matched by*
the artist's recollection of this
painting when he was doing the
second Two-piece Reclining
Figure *a year later as is indicated*
by his accidental attribution of
the Monet's title to the Seurat.

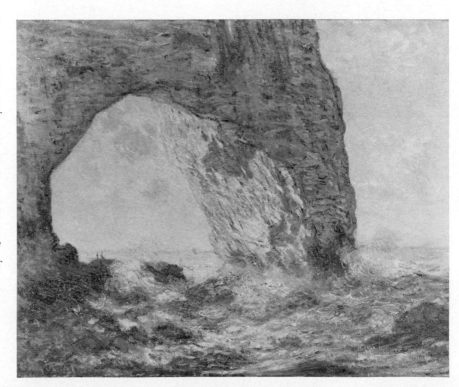

was doing it, I kept being reminded of *The Rock at Etretat*, the picture by Seurat[1] ... It is this mixture of figure and landscape. It's what I try in my sculpture. It's a metaphor of the human relationship with the earth, with mountains and landscape. Like in poetry you can say that the mountains skipped like rams. The sculpture itself is a metaphor like the poem. [1962/Bibl. 54].

1. He refers to Seurat's painting *Le Bec du Hoc, Grandcamp*, formerly in the collection of Sir Kenneth Clark and since 1952 in the Tate Gallery (**120**).

Relief No. 1, 1959

Renaissance sculptors used relief pictorially. They reduced depth almost mathematically. They had the same use of perspective as painters. For some time I've thought one might use relief in its own way, to exploit the projection and recession of form and make it more powerful in relief than in a realistic rendering of compressed representation. To make the chest more strong, to make it come out more, you send it back underneath (**126**). You bring the hips out more, and the umbilicus. One has made the projections and recessions for their own sakes rather than for a pictorial use of relief. That requires as big a sense of space as if one had made a whole sculpture in the round. Form is indivisible. The understanding of three-dimensional form involves all points of view about form – space, interior, and exterior form, pressure from within; they're all one and the same big problem. They're all mixed up with the human thing, with one's own body and how one thinks about everything. This talk of representational and non-representational art, spatial and non-spatial sculpture, is all nonsense. There's no cutting it up into separate compartments. It's all one. [1962/Bibl. 14].

I've always done reliefs from time to time because I feel one can't just cut out an aspect of sculpture which has existed right through from palaeolithic times. I had moments when I thought that the approach of even someone as great as Michelangelo was wrong from my point of view, because he would carve into one surface of a block and release it as a relief as he went inwards whereas I believed that sculpture meant walking around the stone and working into it from every side, gradually working out the sizes and the relationships of the masses in terms of centres of gravity and not of surfaces.

But then there's more than one way of doing a relief. You can take the Renaissance way, the way of Ghiberti or Donatello, where you have a fundamentally pictorial attitude, or you can use relief sculpture as a form in itself – and that's what I've

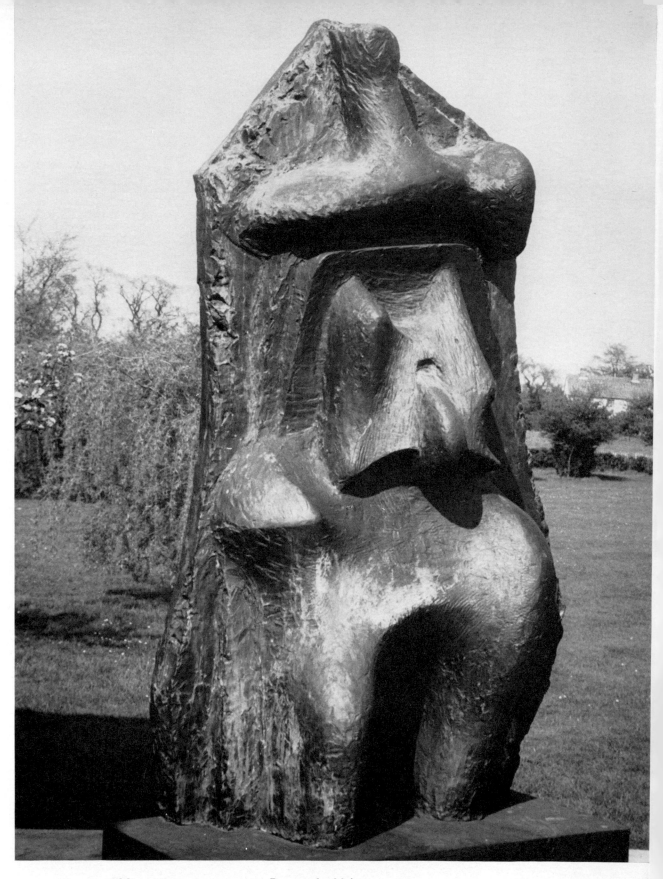

126 RELIEF NO. I, *1959. Bronze, h. 88 in.*

tried to do. You exploit the going in and the coming out, the projections and recessions, to give the forms a bigger richness and a bigger power. It's the reverse of the naturalistic or realistic approach to relief. [1962/Bibl. 48].

Standing Figure (Knife-edge), 1961

This sculpture (**127**) has been called *Standing Figure – Knife-Edge* also *Standing Figure – Bone* and again, *Winged Figure*. All three titles have some relevance to what it is, and how it came about.

Since my student days I have liked the shape of bones, and have drawn them, studied them in the Natural History Museum, found them on sea-shores and saved them out of the stewpot.

There are many structural, and sculptural principles to be learnt from bones, e.g. that in spite of their lightness they have great strength. Some bones, such as the breast bones of birds, have the lightweight fineness of a knife-blade. Finding such a bone led to me using this knife-edge thinness in 1961 in a sculpture *Seated Woman* (thin neck)[1]. In this figure the thin neck and head, by contrast with the width and bulk of the body, give more monumentality to the work. Later in 1961 I used this knife-edged thinness throughout a whole figure, and produced this *Standing Figure*.

Sculpture has some disadvantages compared with painting, but it can have one great advantage over painting – that it can be looked at from all round; and if this attitude is used and fully exploited then it can give to sculpture a continual, changing, never-ending surprise and interest.

In walking round this sculpture the width and flatness from the front (**128**) gradually change through the three-quarter views into the thin sharp edges of the side views, and then back again to the width seen from the back.

And the top half of the figure bends backwards, is angled towards the sky, opens itself to the light in a rising upward movement – and this may be why, at one time, I called it *Winged Figure*.

In a sculptor's work all sorts of past experiences and influences are fused and used – and somewhere in this work there is a connection with the so-called *Victory of Samothrace* in the Louvre – and I would like to think that others see something Greek in this *Standing Figure*. [1965/Bibl. 62].

1. Bibl. 43 pls. 116–17.

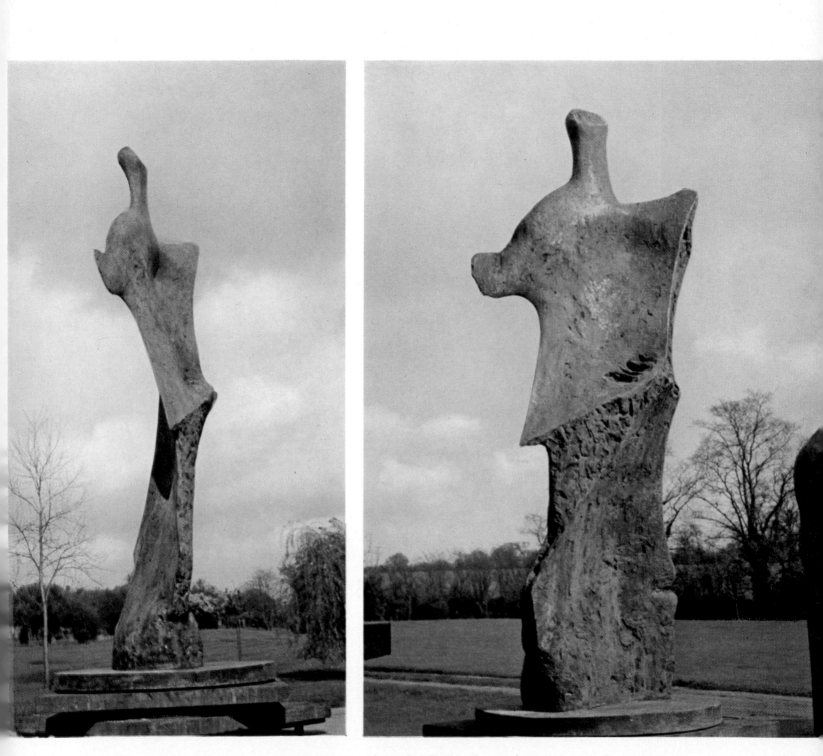

127 *and* **128** STANDING FIGURE (KNIFE-EDGE), *1962. Bronze, h. 112 in.*

Bibliography

This bibliography contains only the titles of books, articles and manuscripts in which the sculptor's statements, comments and interviews appear in a complete or substantially complete form. There are many other books and articles, too numerous to mention, which contain short quotations from the statements printed in this volume.

1 Anonymous · *Church of S. Matthew, Northampton. 1893–1943.* Northampton, 1943.
Statement (*Madonna and Child*) reprinted in bibl. 2 and 26.

2 Anonymous · *Henry Moore's Madonna and Child* (Northampton). Article in *Architectural Review*, Vol. XCV, May 1944, p. 189. London, 1944.
Statement also in bibl. 1 and 26.

3 Burnett, Hugh · *Face to face. Edited and introduced by H. B. Portraits by F. Topolski.* London (Cape), 1964.
Moore's contribution to the television programme *Face to Face.*

4 Circle: · *International survey of constructive art.* Editors: J. L. Martin, Ben Nicholson, N. Gabo. London (Faber), 1937.

5 Evans, Myfanwy · *The painter's object.* London (Howe), 1937.
Includes reprint of bibl. 24 with title *Notes on Sculpture.*

6 Forma, Warren · *Five British sculptors (work and talk).* New York (Grossman), 1964.

7 Ghiselin, Brewster · *The creative process.* Los Angeles (University of California Press), 1952.
Includes reprint of bibl. 24.

8 Grohmann, Will *The art of Henry Moore*. London (Thames & Hudson), 1960.

9 Hall, Donald *An interview with Henry Moore*. Article in *Horizon. A magazine of the arts*. November, 1960, vol. iii, no. 2. New York (American Horizon), 1960.

The printed version omits some passages which appear in the ms.

10 Hodin, J. P. *Henry Moore*. Article in *World Review*, August 1949. London, 1949.

Reprinted in HODIN, J. P. *The dilemma of being modern*. London, 1956.

11 Hodin, J. P. *Moore*. London (Zwemmer), 1958.

12 Hofmann, Werner *Henry Moore. Schriften und Skulpturen*. Frankfurt a.M. (Fischer Bucherei), 1959.

13 Hopkinson, Tom *How a sculptor works*. Article in *Books and Art*, November 1957. London, 1957.

14 Lake, Carlton *Henry Moore's world*. Article in *Atlantic Monthly*, vol. 209, No. 1, January 1962. Boston, 1962.

15 Lambert, R. S. *Art in England*. Harmondsworth (Penguin Books), 1938.

Includes reprint of bibl. 24.

16 Living Image, The: *Art and Life*. Discussion between V. S. Pritchett, Graham Sutherland, Sir Kenneth Clark and Henry Moore in *The Listener*, vol. XXVI, No. 670, 26th November 1941. London, 1941.

17 London: Architectural Association *Contemporary English sculptors. Henry Moore*. Statement in *Architectural Association Journal*, vol. XLV, pp. 408–13. London, 1930.

18 London: Arts Council of Great Britain SYLVESTER, A. D. B. *Sculpture and drawings by Henry Moore. Catalogue of an exhibition. May 2nd–July 29th, at the Tate Gallery*. London, 1951.

Ten notes. (1) reprinted from bibl. 17. (2) from bibl. 40. (3–5) from bibl. 24. (6) from bibl. 25.

19 London: London County Council
Sculpture in the open air. London County Council third international exhibition of sculpture, Holland Park, London. May to September, 1954. London, 1954.
Statement (*Time-Life Reclining Figure*) Reprinted in bibl. 42.

20 London: London County Council
Sculpture 1850 and 1950 . . . Exhibition at Holland Park, London, May to September, 1957. London, 1957.
Statement (*Warrior with Shield*): abbreviated version of bibl. 59.

21 London: London County Council
Exhibition 1960. Sculpture in the open air. May to September, Battersea Park. London, 1960.
Statement (*Glenkiln Cross*).

22 Man, H. Felix
Eight European artists. London (Heinemann), 1954.
Some notes on space and form in sculpture. Reprinted in bibl. 42.

23 Moore, Henry
Mesopotamian art. Review of *L'art en Mésopotamie* by C. Zervos in *The Listener*, vol. XIII, No. 334, 5th June 1935, pp. 944–6. London, 1935.

24 Moore, Henry
The sculptor speaks. Article in *The Listener*, vol. XVIII, No. 449, 18th August 1937, pp. 338–40. London, 1937.
Reprinted in bibl. 5, 7, 15; extracts in bibl. 18, 37, 44.

25 Moore, Henry
Primitive art. Article in *The Listener*, vol. XXV, No. 641, 24th August 1941, pp. 598–9. London, 1941.
Reprinted in bibl. 41.

26 Moore, Henry
Note on the Madonna and Child statue (Northampton). Article in *Transformation, Three*, pp. 132–3. London (1946).
Reprint from bibl. 1 and 2.

27 Moore, Henry
Message de la sculpture. Statement in *XXe siècle*, nouvelle série No. 1. Paris, 1951.

28 Moore, Henry *Tribal sculpture*. Recorded interview in *Man*, vol. LI, No. 165, July 1951, pp. 95–6. London (Royal Anthropological Institute), 1951.

29 Moore, Henry *Témoignage: l'espace*. Statement in *XXe siècle*, nouvelle série, No. 2, January 1952. Paris, 1952.

30 Moore, Henry *The sculptor in modern society*. Paper read at the International Congress of Artists, Venice, 22–28, September 1952, in *Art News*, vol. 5, No. 6, November 1952. New York, 1952.
Reprinted in bibl. 39.

31 Moore, Henry *The hidden struggle*. Article in *The Observer*, 29th November 1957. London, 1957.

32 Moore, Henry *Heads, figures and ideas. With a comment by G. Grigson*. London (Rainbird) and Greenwich, Conn. (New York Graphic Society), 1958.

33 Moore, Henry *Jacob Epstein*. Obituary notice in *The Sunday Times*, 23 August 1959, reprinted in *Encore. The Sunday Times book*. London (Joseph), 1962.

34 Morse, J. D. *Henry Moore comes to America*. Article in *Magazine of Art*, vol. 40, No. 3, March 1947, pp. 97–101. Washington D.C., 1947.
Quoted by permission of The American Federation of Arts.

35 Mundt, Ernest *King and Queen*. A questionnaire with replies by the sculptor in *Art and artist*. Berkeley and Los Angeles (University of California Press), 1956.

36 New York: Curt Valentin Gallery *Henry Moore*. November 2 – December 4, 1954. (Exhibition catalogue.) New York, 1954.
Part reprinted in bibl. 35.

37 New York: Museum of Modern Art SWEENEY, J. J. *Henry Moore* (Catalogue of H. Moore's first retrospective exhibition in U.S.A.) New York, 1946.
Biographical statement included in bibl. 50.

38 Otterlo: Rijksmuseum Kröller-Müller. | *Henry Moore. Drie staande motieven. Ter gelegenheid van de onthulling op 10 April 1965 in het Nationale Park de Hoge Veluwe.* (With essays by J. Russell and A. M. Hammacher.) Otterlo, 1965.

39 Paris: UNESCO | *The artist in modern society. International conference of artists, Venice, 22–28 September 1952.* Paris, 1954.
Reprint of bibl. 30.

40 Read, Herbert | *Unit 1: the modern movement in English architecture, painting and sculpture.* London (Cassell), 1934.
Reprinted in bibl. 41.

41 Read, Herbert | *Henry Moore: sculpture and drawings.* [Vol. 1]. London (Lund Humphries), 1944. 2 ed. 1946; 3 ed. revised and enlarged 1949; 4 ed. revised. Edited by D. Sylvester, 1957.
Includes reprints of bibl. 24, 25, and 40.

42 Read, Herbert | *Henry Moore. Vol. 2. Sculpture and drawings since 1948.* London (Lund Humphries), 1955. 2 ed. revised. *Sculpture and drawings 1948–54.* Edited by A. Bowness, 1965.
Includes reprints of bibl. 19 and 22.

43 Read, Herbert | *Henry Moore. Vol. 3. Sculpture 1955–64.* Edited by A. Bowness. London (Lund Humphries), 1965.

44 Ritchie, A. C. | *Sculpture of the twentieth century.* New York (Museum of Modern Art), 1952.
Extracts from bibl. 24.

45 Roditi, Edouard | *Dialogues on art.* London (Secker and Warburg), 1960.
Interview also printed in *The Observer*, 10th April 1960.

46 Rothenstein, John | *Modern English painters: Lewis to Moore.* London (Eyre & Spottiswoode), 1956.

47 Russell, John and Vera *Conversations with Henry Moore*. Articles in *The Sunday Times*, 17th and 24th December 1961. London, 1961.

48 Russell, John and Vera *Moore explains his universal shapes*. Article in *New York Times Magazine*, 11th November 1962. New York, 1962.

49 Sutton, Denys *Henry Moore: a sculptor's vision*. Article in *New York Times*, 23rd March 1959. New York, 1959.

50 Sweeney, J. J. *Henry Moore*. Statement in *Partisan Review*, vol. XIV, No. 2, March–April 1947. New York, 1947.

Extracts included in bibl. 46.

51 Sylvester, David *The evolution of Henry Moore's sculpture, I*. Article in *Burlington Magazine*, vol. XC, No. 543, June 1948. London, 1948.

52 Sylvester, David *The Michelangelo vision*. An interview with Henry Moore in *The Sunday Times Magazine*, 16th February 1964. London 1964.

53 Sylvester, David *Henry Moore talking. A conversation with D. Sylvester*. Article in *The Listener*, vol. LXX, no. 1796, 29th August 1963. London, 1963.

54 Wheldon, Huw *Monitor. An anthology*. London (Macdonald) 1962.

Manuscripts

55 London: British Council *Sculpture in the open air. A talk by Henry Moore on his sculpture and its placing in open-air sites. Edited by Robert Melville and specially recorded with accompanying illustrations, by the British Council*. London, 1955.

56 Moore, Henry *Family Group*. Letter to Dorothy Miller. 31st January 1951.

57 Moore, Henry *Draped torso*. Letter to S. D. Cleveland. 12th March 1954.

58 Moore, Henry *Upright Internal and External Forms, 1953–54.* Letter to Gordon Smith, Albright-Knox Art Gallery, Buffalo. 31st October 1955.

59 Moore, Henry *Warrior with shield.* Letter, 15th January 1955. Abbreviated version in bibl. 18.

60 Moore, Henry *Shelter drawings.* Letter to E. D. Averill, 11th December 1964.

61 Moore, Henry *Two-piece reclining figures, 1959 and 1960.* Statement sent to the Tate Gallery.

62 Moore, Henry *Standing figure, 1961.* Statement 1965.

63 Moore, Henry *Renoir.* 'La danseuse au tambourin' and 'La danseuse aux castagnettes'. Statement.

Index

Bold numbers denote illustrations

291